THE BL
COUNTESS

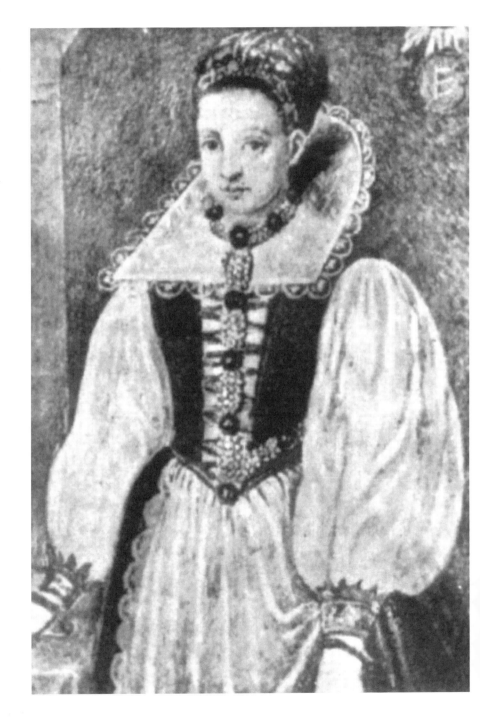

THE BLOODY COUNTESS
by
Valentine Penrose
Translated by:
Alexander Trocchi
ISBN-10: 0-97145-78-24
ISBN-13: 978-0-971-45782-9
Published by Solar Books 2006
in association with Creation Books
www.creationbooks.com
Copyright © Calder Publications 1970
Design, typesetting:
White Light/Tears Corpoaration

Contents

Introduction
5

Chapter One
9

Chapter Two
31

Chapter Three
40

Chapter Four
54

Chapter Five
62

Chapter Six
70

Chapter Seven
83

Chapter Eight
97

Chapter Nine
106

Chapter Ten
121

Appendix
149

Introduction

This is the story of the Countess who bathed in the blood of girls. An authentic story, hitherto unpublished in its horrific entirety anywhere. The documents concerning it are extremely difficult to get hold of, for it all happened more than three and a half centuries ago in a savage Hungary which today lies behind the Iron Curtain. Relevant documents passed from one archive to another. No one knows what has happened since 1956 to the Hungarian archives which were kept in Budapest Castle. Where would one go to see the sombre portrait with the haggard eyes of the very beautiful Erzsébet Báthory? For the last two hundred years Csejthe Castle has lain in ruins on its rocky spur of the Lesser Carpathians on the frontier of Slovalda. But the ghost and the vampires remain, and so does that earthenware pot which used to contain the blood which was about to be poured over the shoulders of the Countess; that is still there in a comer of the cellars.

The Beast of Csejthe, the bloody Countess, still shrieks in the night, in that very room whose door and windows were, and still remain, walled up.

There is every indication that she was a female Gilles de Rais; even the hasty trial in which, out of respect for a name illustrious since the birth of Hungary, and because of those services rendered by her family to the Hapsburgs, so many facts were suppressed. It was even judged imprudent to interrogate her personally.

The minutes of the trial were discovered in 1729 by a Jesuit Father, Laszló Turáczi, who wrote a monograph on Erzsébet Báthory, to be published in 1744. He gathered together a story that no one in the region of Csejthe has ever forgotten.

Moreover, Turáczi had access to documents first preserved in the archives of the Court of Vienna and then sent to Budapest, those relating to the interrogation conducted by the Palatine Thurzó at Bicse (then Bittsere) at the very beginning of January 1611, and was thus able to take into account the reasons adduced as well as the order for the execution of the

Countess's accomplices, dated 7th January.

Until the beginning of the twentieth century, this work in Latin was our only reference. Then, in 1908, a writer, himself born in Csejthe (now Csachtitz, six kilometres to the south-west of Vág-Ujhely... Neustadt), Dezsó Rexa, who had been a pupil at the local school and had played as a child around the haunted ruins, again took up the story of Erzsébet Báthory; it was published in Hungarian in Budapest, under the title *Báthory Erzsébet Nádasdy Ferencné* ("Erzsébet Báthory, wife of Ferencz Nádasdy"). He referred to the work of the Jesuit Father.

At the end of the book, Dezsó Rexa included a collection of letters: from Erzsébet to her husband; from the Palatine Thurzó to his wife, on the subject of the Countess's arrest; from the pastor of Csejthe, Ponikenus János, to one of his colleagues; from Erzsébet's son-in-law Miklós Zrinyi, to Thurzó, requesting leniency for his mother-in-law; from Erzsébet's son, Pál Nádasdy, asking for mercy for his mother. Thurzó's letter to King Mathias II is also to be found here, and the King's reply, as well as the address of the Royal Magyar Chamber to King Mathias.

The wills follow: that of 3rd September 1610, which the Countess wrote before being condemned, and her last will, made after she was walled up, a letter dated 31st July 1614, less than a month before her death. And finally the magical invocation in the direct language that was so dear to her.

The manuscripts relating to Ferencz Nádasdy, her husband, were reassembled by the Pastor of Csejthe. Those relating to Erzsébet became part of the collection of Bertalan von Revieczky.

The minutes of the trial, conserved originally in the archives of the Chapter of the town of Gran, were transferred to the National Archives in Budapest.

In 1894, before the work of Dezsó Rexa, a German, R. A. von Elsberg, published a very short but more elaborate biography in Breslau, *Die Blutgräfin, Elizabeth Bathory* ("The Blood Countess, Elizabeth Bathory") which, from the psychiatric point of view, laid special emphasis on the heredity of the ancient line of the Báthorys. At the end of this book there is to be found the interrogation and the reasons given by the judges for their verdict.

A dramatist, Garay, has written a modern play based on Erzsébet Báthory. An historical novel in German, *Tigerin Von Csejthe* ("The Tigress of Csejthe"), by Karl P. Szatmary has been published. Also, a novel in Slovak *Cachticka Pani*, by J. Niznanszy.

William Seabrook, in his book, *Witchcraft,* devoted a chapter to the Bloody Countess. Moreover, he used the documents from Dezsó Rexa

and R. A. von Elsberg.

In the middle of the nineteenth century, in England, Sabine Baring-Gould in his curious book, *The Book Of Werewolves*, gives a brief account of the deeds of the Bloody Countess, and describes how the idea of taking blood baths came to her. This writer found his material in an eighteenth century German work of philosophic anthropology, by Michael Wagener: *Beiträge Zur Philosophischen Antropologie* (Vienna, 1796). And, doubtless, in Hungary itself; for, at that time, around 1843, with the exception of some articles of a more or less fantastic nature in popular encyclopedias, such as those in the *Biographie Universelle* (Michaud, Paris, 1848) and the one in the *Dictionnaire Des Femmes Illustres*, nothing had been published on the subject of Erzsébet Báthory.

The books of Dezsó Rexa and von Elsberg are unobtainable in the libraries of France, and they cannot presently be obtained from Hungary. In his article on Erzsébet Báthory, Seabrook declared that he had come upon them in the library of a large town in the United States. Finally, there exists a very romanticised history of the Báthory family, written by Makkai Sandor, *The Devil's Chariot* (Ordog Zeker).

Some of the documentation used in the present work was kindly supplied by the following libraries, to whose governors and staff the author wishes to express her heartfelt thanks: *Bibliothèque de l'Institut Hongrois* in Paris, the Library of the British Museum, *Österreichische Nationalbibliothek* (*Karten, Handschriften, Porträt und Bildarchiv Slg.*), *Österreichisches Hof und Staatsarchiv*, and the *Universitätsbibliothek* of Vienna.

NB: In the English version translated from the French, the proper Hungarian spelling of the names of people and places has been substituted for the French renderings which appeared in the original.

Chapter One

It happened at a time when potentilla still retained its magic power, a time when shops in the towns sold mandragora plucked at the dead of night from under a gibbet. A time when children and virgins disappeared without anyone being too much concerned: much better not to get mixed up in this kind of thing. But their hearts, their blood, what happened to those? Did they become philtres, or perhaps were turned to gold? Here in the most primitive country of feudal Europe, where the nobility, black and red, was destined to make war against the glittering Turk.

A wandering artist happened to paint the portrait of Erzsébet Báthory, Countess Nádasdy, at the height of her beauty. She must have been almost twenty-five. Did he come from Italy, or did he come from Flanders, this nameless painter? Through whose workshops did he pass before going on from castle to castle to paint his stiff portraits? We have only the brown canvas to go by, with the big E of Erzsébet high up at the right. And this the initial of the selfsame living woman therein portrayed, constructed out of three cruel teeth of a wolf embedded in a vertical jawbone. And above, weighty rather than *volant,* an eagle's wings. Higher, one cannot see. And round about this female's oval escutcheon is coiled the ancient dragon of the Dacian Báthorys. Overlooked by griffons, wings and teeth, how erect she holds herself, in horrible gloom.

This woman was blonde, but only thanks to the subtle artifices fashionable in contemporary Italy, to repeated washes in cinder-water, over and over again, in a brew of dog-fennel or mayweed, and to much rinsing in the powerful ochre of Hungarian saffron. Erzsébet, her long dark brown tresses held high by retainers before huge flaming candles in winter, or close by a sunlit window in summer, her face carefully protected by creams and unguents, became blonde.

In her portrait, her curled hair, set quite high above her forehead, is scarcely visible, in keeping with a style already out of fashion in France. It is hidden by pearl droplets. These pearls came from Venice and from the cargoes of its ships, from the Turks especially, who occupied all the east and

the centre part of Hungary.

The court of the Valois in Paris, and in the various castles in the provinces, the English court, where Elizabeth, auburn and stiff, had her gorget encrusted with them, the arm-holes into which her sleeves were set and her gloves at the finger-joints stiffened with them; all the courts as far as that of Ivan the Terrible in the extreme east lived under the sign of the pure pearl.

To tell the truth, Erzsébet Báthory, when she came into the world, was far from being a complete human being. She was still akin to the treetrunk, the stone, and the wolf. Could it be that the destiny of her race had been decided at the precise moment of the blossoming of this particular flower? Was it the fruit of a time when the nerves were still coiling up through the mists of primitive savagery? What is certain is that there existed between Erzsébet and the external world something like a vacuum, like the padding in a madman's cell. The eyes of the portrait proclaim it; she wished to seize and couldn't touch. Then, the wish to be awake but not to be alive, that is what kindles the taste for blood, the blood of others; perhaps this was the hidden secret which, ever since her birth, had been obscured from her.

Meanwhile, she was certainly no dreamer. It is without exception beneath a conventional shell of commonplace anxieties that such a spirit comes to light; behind a jumble of futilities, vanities, domestic quarrels, and spiteful family differences, down there and glimmering at the very deepest level, this vast dark lake of cruelty stands and steams. Certainly Erzsébet was most seriously concerned with the proper upbringing of her three daughters, with all her innumerable relatives, and a thousand other details. Undoubtedly, she listened rather absentmindedly to the new music of Valentin Balassa and to rose romance poetry, to the bullfinches and skylarks. But if her own court musicians, who were gypsies, played some savage tune; if, on horseback in the forest, she came upon the scent of a bear or a fox, then the circle which isolated her would be broken for a moment. Later, she would return, pale and gloomy, to those court dances which she performed with accomplishment, even if a little too fast, in the Hungarian manner, with an air as absent and as cold as a clump of ivy.

Her looks would not have made one think of love, although she was very beautiful, with an excellent figure and no blemishes; for one sensed she was ripped out of time just as mandragora was plucked from the earth; and the seed from which she was fashioned was as malignant as that of a man hanged.

The Báthory family, from its earliest origins, was ever distinguished in good as well as evil. The two earliest known representatives,

from the time when the family still hadn't won its surname, that of *bájor* (or *báthor*, the brave), were two wild brothers, Guth and Keled, who came from Swabia, where Staufen (or Stef) Castle, which must also have been the original residence of the Hohenstaufens, was their birthplace; this even before the eleventh century, at the time of the Dacians with their prancing horses which used to hurl themselves into battle under a forest of lances surmounted with dragon-heads, trailing ribbon-like pennants fluttering in the wind, noisy and sounding their twin-pipes made out of the clawbones of cranes, and sometimes of eagles, joined together with cobbler's wax. In the year 1036, according to the illuminated Chronicle of Vienna, the emperor, Henry III, sent them at the head of a force of warriors into Hungary to bring aid to King Peter who was the reigning monarch there at the time. The rise of the family, whose original seat was situated at the village of Gut, took place at the time of King Salomos (1003) and Duke Gezá (1074). Acts of royal bounty, like the one of 1326, testify to the continual royal favour they enjoyed in the years to come.

Later on the family was to be divided into two branches: the one stretching towards the east of Hungary and Transylvania, the other moving west.

Peter Báthory, who was a Canon but who was never ordained and left the Church, was the ancestor of the Báthory-Ecsed branch, in the electorate of Száthmar in the north-east. There one can still see the ruins of the ancient castle of the Báthorys in the shadow of the great Carpathians. For a long time the authentic crown of Hungary was kept there, Saint Stephen's with the tilted cross. Johann Báthory was the founder of the Báthory Somlyó branch in the west, in the region of Lake Balaton. Both branches continued to grow in fame and fortune: Stephen III, Palatine of Hungary in the reign of Ferdinand I, Stephen IV, 'the Bigfooted'.

Erzsébet Báthory, daughter of György and Anna, belonged to the Ecsed branch: her Somlyó cousins were kings, King of Poland and King of Transylvania. Without exception they were spoiled, cruel and lecherous, temperamental and courageous.

The ancient land of the Dacians was still pagan, and its civilisation lagged two centuries behind that of occidental Europe. There, ruled by a mysterious goddess, Mielliki, reigned the countless forces of the great forest, while in the west only the mountain of Nadas was still inhabited by the wind. There was one god only, Isten, and the tree of Isten, the grass of Isten, the bird of Isten. It is he whom Erzsébet invokes at the very beginning of her incantation to the cloud. In the superstition-ridden Carpathians, there was in particular the devil, Ördög, waited on by witches themselves, assisted by dogs and black cats. And everything still derived

from the spirits of nature and the fairies of the elements; from Delibab, the moon-fairy and mother of mirages so loved by the wind, from the Tünders, sisters of all marvels, and from the virgin of the waterfall combing her watery hair. Within circles of sacred trees, the oaks and the fertile walnut trees, the ancient cults of sun and moon, of dawn, and of the black horse of the night, were all still secretly celebrated.

Imaginary or real, these animals used to inhabit the forest where at times the sorcerer would call them, the wolf, the dragon, the vampire who had withstood the exorcisms of the bishops. Black magic used to be practised all the time. As for the spirit, knowing neither remorse nor fear, it rode on horseback under the arch of death.

Erzsébet had been born there, in the East, within the mould of sorcery, in the shadow of the sacred crown of Hungary. In her there was nothing of the ordinary woman who, instinctively, would flee in panic before demons. The demons were already within her: in the gloomy depths of her huge black eyes; and her face was pallid from their ancient poison. Her mouth was sinuous as a little snake, and her forehead was high and proud as the former was unflinching. The chin, resting on that great flat ruff, had the flaccid curve of insanity, associated with this or that outlandish vice. She was quite like some of the Valois as drawn by Clouet, a female Henry III perhaps. Nothing characteristic of her self. In an ordinary portrait the woman comes forward to meet whoever looks at her, and tells her own story. But here, the real woman lurks a hundred leagues behind the equivocal gaze, entirely closed into herself, a plant rooted yet in the mysterious soil out of which it has come. Her hands with their delicate skin are exceedingly white; one sees very little of them, yet quite enough to ascertain that they are long; the wrists are encircled by golden cuffs above which, in the Hungarian fashion, the sleeves of her white linen blouse flare out. She wears a long, pointed corselet, intricately laced, and embroidered with strings of pearls in horizontal slats, and a skirt of garnet-coloured velvet against which the stark whiteness of the linen apron stands out in sharp contrast, rising slightly on one side, the insignia of women of quality of her country.

Erzsébet was born in 1560 in one of the castles belonging to the Ecsed branch. Her father was György Báthory, he too a soldier, to some extent the ally of Ferdinand I of Hapsburg, and to some extent the ally of Zapoly, Ferdinand's enemy. Her mother, Anna, had already been married twice and had borne other children.

Anna Báthory, daughter of István Báthory and Katalin Telegdy, was the sister of the King of Poland, Stephen Báthory. She belonged to the Somlyó branch of the family. Considering the age in which she was born,

she had received a considerable education: she used to read the Bible and the history of Hungary in Latin. Her parents had made of her a girl of some accomplishment, since few girls in those days knew how to read and write. In fact, the history of Hungary was brief enough; several fables on the ancient Onogours, the real descendants of Japhet; and some glorious legends. It was fabled, for example, how in a dream a sparrow hawk had known Princess Emesu, and how she had then seen, in prophecy, a torrent of famous kings burst forth from her. The original homeland of this family, where Almos (the sparrow hawk) was born, was savage Scythia, in the confines of the Meotid of Persia. Seven dukes, from whom the proud Báthorys were descended, had left this country at the head of seven tribes and had taken possession of Hungary for a white horse.

The moon on the left and the sun on the right appeared in the coat of arms of these kings of the seven tribes, the *Siebürger*, from whom Anna Báthory was descended. They were still to be found in the heraldic emblem of her daughter Erzsébet, where, on either side of the heavens, they became seals of the magic powers which dominated her life.

But Erzsébet's mother doesn't seem to have been very interested in occult matters; hers were the healthy preoccupations of marriage and social intercourse. Naturally, contestants for her hand abounded, but it was Gáspár Dragfy she chose, 'happy to become his wife, for he was tall and handsome'.

They lived happily together at Erdód, in the province of Szathmar in the north west of Hungary, very close to Transylvania. They were stubborn Protestants, and the pastor, called András Batizi, used to live at the castle. Part of their time they dedicated to the edifying task of converting the neighbourhood: the peasants, certainly, but also the family, beginning with Anna's brother-in-law and sister-in-law. In keeping with fashionable practice, they founded a school in Transylvania and brought in a young man from Wittenberg to teach there.

Anna Báthory had two sons, János and György. Her husband died in 1545.

It was greatly to the credit of a woman of that period, and certainly proof of Anna's abilities that she succeeded her husband, not only in the administration of the family wealth, but in public affairs also. It was from this first husband that she inherited the beautiful castle at Erdód, which remained part of her dowry when, later, she married György Báthory.

This young widow had no taste for solitude: with the same enthusiasm she took Antal Drugeth of Homonna as her second husband, which gentleman, in his turn, went quickly to his grave. But, because, in

spite of these successive bereavements, she was happy in the married state, she went straight ahead in 1553 and married her cousin of the Ecsed branch, György Báthory, by whom she had four children: in 1555, István, half-mad and very cruel, who became *judex curiae* and married Frusina Drugeth; then Erzsébet; after that, Zsofiá, future wife of András Figedyi, and Klara who married Michaelis de Kisvarda.

The Hungarian proverb 'the apple never falls far from the apple tree' didn't apply to Erzsébet. Considering the customs of the epoch, her two sisters Zsofiá and Klara left no trace in history of any exceptional cruelty.

Erzsébet's father died when the girl was ten years of age. It is for this reason, no doubt, that from 1571 onwards she was officially engaged to Ferencz Nádasdy; for her mother had still two other daughters to marry off.

Anna Báthory died piously at a ripe old age, greatly mourned and leaving to her children, besides the edifying example of her life, numerous houses and properties most prudently administered.

Gout was the hereditary illness of the family, a fact which need not surprise us considering it was an age when people were nourished on meat and game, highly spiced, and that theirs was a country in which the normal drink was the best and richest of wines. The other hereditary illness was epilepsy, which was known at that time as 'brain fever'. Despite the fact that he had recourse to all the arts of sorcery and to a host of contemporary alchemical remedies in the hope of combatting it, Stephen Báthory, King of Poland and Erzsébet's uncle, died of this disease. He had even tried to cure himself with the music of Palestrina. Another uncle, István, who aided the Hapsburgs in preventing the son of Mathias Corvin from becoming king, was illiterate, cruel, and a great liar; Palatine of Transylvania, he was forced to leave this province and he carried with him all the money of the land; even then, not having enough of it, he began to coin false money. Moreover, he managed to get the Turks to pay him too. His madness took the form of mistaking summer for winter and he had himself drawn about on a sleigh, as though on snow, along paths covered with white sand.

A cousin of the Somlyó branch, Gábor, King of Transylvania, was also very cruel and miserly; he met his end at the hands of an assassin in the mountains. His particular vice was an incestuous passion for his sister Anna, who returned his love. He left only two daughters who, like many children of the time, died at the ages of nine and twelve.

Another uncle still, also named Gábor, who lived at Ecsed, complained of being possessed by the devil. He had real fits of possession

during which he rolled about on the ground gnashing his teeth. Erzsébet's own brother, István, was a satyr who, even in those primitive times, shocked everyone. He was the last of the Báthory-Ecsed branch and died without issue. All these individuals were unbelievably cruel, and stopped at nothing in the satisfaction of their fantasies.

One of the most notorious members of the family was Erzsébet's paternal aunt, Klara Báthory, the daughter of András IV. This woman took four husbands and 'made herself unworthy of the name of Báthory'. It is said that she herself got rid of her first two husbands. It is certain that she had her second husband smothered in his bed. Then, in the most appalling circumstances, she allied herself to Johan Betko, later with Valentin Benko of Paly. Finally she took a very young lover and gave him a castle. This ended very badly, however: they were both captured by a pasha. Her lover was skewered and roasted on a spit. As for her, she was raped by the whole garrison. As she was still living at the end of her ordeal, her throat was slit. Naturally, of all her relatives, it was this aunt whom Erzsébet would have liked to have known better.

As for Sigismund Báthory, King of Transylvania in 1595, at the time of Sultan Mahommed III and Rudolph II, and Erzsébet's cousin, he was notorious for his inconsequential behaviour and for his fickleness amounting almost to madness. Without going into the details of all the twists and turns of his political life, of the sale of Transylvania first to Rudolph II and then to the Turks, of the forced gift of his kingdom to his cousin, András Báthory – a gift which was promptly taken back – it will be sufficient to speak of his relations with his wife, Marie-Christine, princess of Austria. He had married her on 6th August, 1595, at Wissembourg, to consolidate his alliance with the Austrian dynasty. On the pretext that his wife was so repulsive to him he couldn't help screaming at night when he found himself at her side, he made a public announcement that he wished to renounce the world. Raised by Jesuits, his Catholicism was of an intransigent kind. To attain his ends, he went so far as to declare, not perhaps without some reason, that he was impotent. Every night he would find himself surrounded by phantoms his wife could not see. He deposited her at Kovár two years after their marriage, and set off for Prague to discuss the location of his prospective retreat before Rudolph II. After several oscillations, he took his wife back, received the Order of the Golden Fleece from the hands of Phillip II of Spain, and escaped from his wife to Poland where he could be alone with his ghosts.

His cousin, András Báthory, who had for a while accepted the throne of Transylvania, died a tragic death. He was hacked to death on a glacier. His severed head was recovered; it was sewn back on again and the

body, its neck swathed in linen, was exhibited with much pomp and ceremony in the church of Gyulalehervár. A contemporary engraving shows this head with its regular features, placed on white linen, and very pale, wearing a black beard and bearing an axe wound above the left eye. Erzsébet was fascinating. And one never tires of being enthralled by a beauty so young and disquieting. A way of lowering her brown-lashed eyelids; a way of tilting her oval cheek against her great stiff ruff, and the line of that mouth; a line which, on the portrait, time has almost effaced. Whenever she appeared, those whom she confronted were seduced or intimidated. Other women were as nothing compared to her, witch that she was, and highborn wanton. If she had been happy, things would have turned out differently; but she spoke seldom, and then with defiance, imperiously, with heavy sarcasm. What is to be done with women of her kind beyond adoring them, swathing them in starched satin and pearls? No lover ever came to a tryst with Erzsébet. Only nurses and witches, faithful to their most primitive instincts and utterly devoted to a cult which implied nothing but scorn for the rest of humanity.

Yet Erzsébet was quite certain of her rights: rights based upon the dangerous and fatal magic of vegetable saps and human blood, rights born of the north star and against which men were powerless. The sorceresses of the forest brought her to live at the heart of a world which bore no relation to the world of ordinary men. Later, when she felt the lust to immolate them, her thoughts turned to girls: 'Their blood won't take them very far; it is I, now, who shall live through it, another I; I shall follow their path, the path of their youth which was bringing them to the wonderful freedom of being pleasing to others. By their path, out of which I trick them, I shall arrive at last at love. Keep me beautiful, ye juices of supple flowers!'

All cruel, all mad, and at the same time, all brave. The Palatine István fell at the battle of Varnó; György, the grandfather of Erzsébet, fought at Mohács. András was Cardinal of Varád. László, wiser, translated the Bible. This extraordinary line of descent, each individual bound to the other by a chain of malignity, attained its dark zenith in the person of Erzsébet.

They saw one another, met frequently, exchanged visits; and if Erzsébet, when events turned to her disadvantage, received no help from them, neither did she receive any blame; they saw her for one of their own.

Their houses covered the entire country, to the east towards Ecsed, to the west near the Austrian frontier at Somlyó. Having got there to one or another of these castles, one was obliged to stay for a considerable time. Sometimes Erzsébet would visit the home of her husband's sister, Káta Nádasdy, but she was received there with suspicion.

Only when they were all reunited at great banquets, with their puerile refinements and their heavy meats, did the Báthory clan whose ancient coat of arms depicted wolves' teeth, really feel at ease. On the other hand, this did not mean for a moment that their profound distrust of one another was in any way diluted.

Stiff and brilliant, Erzsébet held herself aloof even as she mingled with her relatives, her dark vices hidden, meanwhile, like shadowy fish beneath stagnant water. At this or that family reunion she was clothed all in immaculate white, her dress rippling with pearls and her hair coiled sleeky in the famous pearl-encrusted net. White on unrelieved white and nothing in contrast, save her enormous black-ringed eyes. White, all white and silent, like the swan floating between two reeds as depicted on the coat of arms of her lord Nádasdy. But down in the depths of her, at the very roots of her being, she was completely Báthory, utterly wanton. Alone, her sister-in-laws embarrassed her. And one day she had her revenge when she made her old nurse Jó Ilona kidnap the servants of one of them, for her own peculiar uses. And what, indeed, could the wife of István, Erzsébet's elder brother, do about it? For István, a veritable satyr, used to whisper in the ear of his sister such scandalous stories as he had heard from his French mistress. The latter was the wife of an officer who had been sent to Vienna. She had got round István Báthory by making eyes at him and flirting in a fashion quite foreign to the crude customs of his homelands. She had likewise instructed him in various practices she had become familiar with at the court of the Valois, tricks as licentious as they came, and which were quite inadmissible in the simplicity of the Hungarian conjugal bed.

Erzsébet would listen to all this without astonishment and a few weeks later would enter her coach to go back to Csejthe and rejoin her lord Ferencz, who, once more having covered himself with glory, had got leave of absence again.

Whereas the rather straightforward horoscope of her husband, Ferencz Nádasdy, has survived, that of Erzsébet has not; but one can more or less divine it. It would not have been necessary for any astrologer to be present at the moment of her birth, amidst the comings and goings of the nurses, the linen, and the slop pails, to establish the theme of her destiny. It is the Moon, under the evil influence of Mars and Mercury, which is at the bottom of her blood-thirsty sadism; and undoubtedly the latter was at that moment in some cruel sign such as Scorpio. Together with Mercury, the Moon produced the maniacal folly, the conscience darkly overcast, and the fits during which desire took hold of her with irresistible force. Venus, to whom she owed her sombre beauty, was either in conjunction with Saturn

or in a sign appertaining to Saturn, and this would account for her utter inability to enjoy herself, for her taciturnity, and for her endurance in suffering, and, indeed, in causing suffering. And that same Moon, whose secrets brooded over her, Erzsébet looked for always in those mad, solitary, nocturnal rides, when she went to meet the sorceress of the forest. The Countess saw her in the snow, saw her in herself, in the inner halo of her melancholy, and in her impotence to take hold of anything.

At this time *The Opusculum Of The Secrets Of The Moon* had appeared in print. It was neither a poem nor a book of spells; it was dedicated to the Moon, who inhabited the lofts of the night, and it dealt with the favourable and unfavourable influences of this planet. One could read, 'It is from the exalted marriage (of the Sun and the Moon) and the admirable union of the great cock of the golden plumage with the hen of silver that all things are born. Women will recognise the Moon as their pennant and guiding star, the Moon who is also clothed in shot silk and is full of that humidity which abounds in women; the whole in accordance with a sympathy and harmony concealed in the shrine of Mother Nature.' How tender! It was certainly not beneath *this* Moon that Erzsébet was born; more likely beneath that which 'makes the cynocephalus sad, which makes by turns the spots the fur of the spanish lynx enlarge and diminish in the form of a crescent, and which, when full, makes birds of prey fleeter, harsher, and more marauding'. Her star was that of all wounds caused beneath the light of the moon, and difficult to heal; vermin belong here, and folly also 'entering by some slit as in the instance of poor soldiers wounded in the head, and obliged to keep watch as sentinels beneath the beautiful covering tent of the Lady Diana, the Moon'.

Her pale, destructive star, which fades the curtains and ruins whatever is exposed to its light, which spoils the harvest and rots the faggots, escorted Erzsébet through nights peopled by sounds of jumps, grunts, gnawings... the endless mastication of beasts born under its influence, beasts which coursed through the woods, ate and slept in the fields and in the waters: ewes, hares, asses, wolves and nanny-goats, pigs, moles, crayfish, tortoises, frogs, slugs, toads, mice, dormice, rats, hedgehogs, cats, and owls in the windows of the granges. By her own moonlight, garnet and white, and embroidered with coats of arms depicting wolves' teeth, Erzsébet would wander into a clearing inundated with the black light of melancholy; that melancholy which, according to Avicenna, was 'the cause of sadness, solitude, suspicion, and fear, causing people to have long, painful and corrupt illusions.'

Melancholy was the sickness, the very air of the sixteenth century; Erzsébet breathed that air mingled with the Carolingian barbarity

of Hungary of that day, and with the cruelty of the Turks and feudal brutality.

Elsewhere madness, luxury, death, and blood abounded. Everywhere, queens and their favourites were beheaded or assassinated. The theatre was full of murders, books told of lechery; life was lived violently, accepted in its totality, in all its contradiction; for this reason magic was orientated towards love, which relishes and Perpetuates, and towards murder, which, invisibly, transfers to the living person the powers of the dead, phantoms being stirred up by horror. Erzsébet was different.

She never thought about her own end. Despite her moonstruck madness, she was predestined for life in this world before passing on to any distant heaven or hell. What she sought to seize, were the joys of this world, the crude pictures of her time and country – to appropriate them: beauty and love. At the moment of possession, however, everything burst asunder; the tempered steel would meet water only; all that sang and whirled around and moved was suddenly nothing more than still water and dead reflections.

Her supreme narcissism, at play in everything she did, held her back from contact with the earth. Maybe the savage music, the incantations in the sorceress's cabin, filled with the acrid smoke of belladonna leaves and of datura, which was burning there, and her dangerous hunts… maybe all these things set alight a really living flame in these eyes, which haunted another world. Or rather, just as the wolf lives the wolf's life, so Erzsébet pursued the path which had to be hers. She knew nothing about remorse. Never did she, like Gilles de Rais after his crimes, roll about in her bed, praying and weeping. Her madness was her birthright. If she fell, it was not because she played a role unworthy of herself. She never understood why she, being so highborn, had to suffer the humiliation of her last years.

'Thou, unhampered by tight bonds, in accord with thy own will (in the power which I have invested in thee) must define thine nature for thyself. I made thee neither celestial nor terrestrial, neither mortal nor immortal, so that thou, being, as it were, thy own maker and moulder shouldst fashion thyself in the way of thine own choosing.'

(Pico della Mirandola, *Oration On The Dignity Of Man*)

The Middle Ages had been full of those fine gestures of public repentance, melodramatic gestures spun out almost indefinitely. It was not to such ends that Erzsébet Báthory unfurled her splendours. She was a Protestant, yet without religion, and a witch, a sorceress, but never a mystic.

Erzsébet regarded life as the supreme good, and yet she was unable to adhere to it. Her cruelty was at once her revenge and her

adaptation.

In order to have confidence in herself, she had to have her beauty praised continually; five or six times a day she would change her dress, her adornment, her coiffure; she lived in front of her great gloomy mirror, the famous mirror for which she herself had drawn the model, and which was made in the form of a *pretzl* (a figure of eight), to allow her to slip her arms through it and remain leaning there without getting tired throughout the long hours, by day and by night, she spent in contemplating her own image. This was the only door she ever opened, the door into herself. And her taciturnity was such that in a mirror, where every woman smiles at her reflection, she struck at herself over and over again, hammering her own effigy at her dumb forge. No flame, no air. Clad in red velvet, adorned in white, in black or pearl, her face heavily made up beneath the large pale forehead. In the heart of her room, encircled by candelabras, nothing but herself; a self always unseizable, and whose many faces she was forever unable to assemble in a single look.

With Erzsébet Báthory, all these unions between cousins, the marriages between closely related parents which the law of the race had exacted for centuries, guarding the brood of the brave, had prepared the way for her sinister role, at this precise moment in time. The proof that very few such beings exist is the fact they are always mentioned with horror. Sometimes it happens that an entire country, involved in a collective idea, passes under the yoke of crime; that, history, even if the details are horrible, absorbs and blurs. But who can forget Gilles de Rais or Erzsébet Báthory?

The ill-starred Countess had another secret which revealed her nature at its most profound, one she owed to her heredity and to her stars, a secret always spoken of in whispers but never definitely confirmed; something she may have admitted to herself or ignored; an equivocal tendency which didn't trouble her, or again, a right she accorded herself along with all the other rights. She was thought to have been, amongst other things, a lesbian.

In matters of the female horoscope, every evil aspect which Mercury receives from the Moon — itself in conjunction with Mars — exacerbates the tendency towards homosexuality. That is why the lesbian is often sadistic too; the influx of the masculine and warlike Mars is at the bottom of this, and a woman born under this sign, influenced by the cruel spears of Mars, does not shrink from wounding, particularly in love, whatever is young, loving, and feminine. As for the Moon, she waters things down and renders insensible, casting a veil of horror over the event. Thus, according to the spell books, on the day of Mars and the Moon, iron

contracts in the blood of a mole and the deadening juice of hemlock.

The suspicion that Erzsébet was a lesbian originated with the fact that she assiduously frequented a certain aunt of hers, also a Báthory, whose adventures fill three volumes in the Vienna library. For her, everyone was fair game, from the woman sentinel at the keep to maids of honour, or girls brought in specially for this purpose, and in whose company she shattered furniture in the rooms of various inns. For, if they had the courage to show it, all the Báthorys manifested a marked taste for monstrous or unnatural acts of lust. Just like epilepsy and satyrism – from the time of the Saxon brothers, Guth and Keled, onwards – these were family traits perpetuated by inbreeding. Interminably, generation after generation, from castles in the east and from castles in the west, noble litters set out, bearing the same nine-year-old girls towards the hearts of the more or less distant cousins chosen as their husbands. The blood was not renewed.

When her warrior husband returned to the castle between battles, this meant great honour for Erzsébet; and distraction also. He brought a large entourage along with him; the sluggish domestics came to life, the horses were groomed and the favourite dogs welcomed their master boisterously. At the time when she had not yet borne children, the Countess would make her appearance, very young, very pale, and much adorned. In order to be whiter still, she had steeped herself in soothing calf's juice, and rubbed herself with an ointment compounded of sheeps' trotters. A little Turkish oil of jasmine or of rose, sent to her by her cousin Sigismund from Transylvania, effaced the smells of the knackery. The long table at which they dined groaned with massive dishes of fowl and entire carcasses of heavy beasts; the sauces were more spicy than ever; and, doubtless, some nurse or other, who had obtained from a sorcerer a powerful and sticky aphrodisiac mixed with intimate ingredients from the bedroom, would confide it to the cupbearer so that he could slip it into the master's cup at the right moment, in order to justify the equivocal sterility which reigned here. This was the way throughout ten years of marriage, and it was typical of the Hungarian of that period. The women were as warlike in behaviour and temperament as the men to whom they were united; there was no question of finesse in the relations between husband and wife. It was good manners to eat vast and enlarged mouthfuls, to dance with physical excess the dances of the country or those imported from France and Italy, to shout vigorously, in general to make a great din, and not to wash 'unless the face was spattered with mud from the flounderings of the horses'.

Indeed, it was Ferencz, who had always been afraid of Erzsébet. He adored his wife's beauty, but feared her young vampire pallor. The Eger

wine and the magic philtre made him forget everything. The Countess would waken up the next morning, honoured by her husband's attention, and despite her flower perfume, impregnated with the odour of leather from his three months' stay in the army camp. Her maids of honour and her servants replaced her linen headdress, denoting her married status, and tied her apron, which signified nobility in Hungary. She might be suffering then from a headache, or else she would be getting into one of those vicious tempers for which the Báthorys were famous; alternatively, wearing the silver plume of a marshland crane on the left side of her hat, and, of course, quite incapable of being still for long, she would set out in the company of her husband on a mad hunting trip, laying waste to whatever got in her way.

So much for her marital obligations. But she had another life... prowling, her very own. And neither time nor occasion was lacking between her husband's visits to satisfy these impulses. Being terribly bored always, she had surrounded herself with a court of wastrels and degenerates with whom she travelled from castle to castle. Because of this, she had acquired a bad reputation, for her husband's family was to some extent virtuous, even religious. She had been frequently without chaperone since the death of her mother-in-law, Orsolya Kanizsáy, the wife of György Nádasdy. The latter had brought up this hardy, bizarre, and morose child, who was destined to marry her son, no doubt becoming enthusiastic about her increasing beauty, but considerably less impressed by the cold and fiendish flame which flickered in those large black almond-shaped eyes.

Beautiful and imposing, very proud, loving herself only, and surrounded by flatterers, Erzsébet was in search of something: amorous pleasure to be sure, yet not that alone, but of something more outlandish; indeed, she knew not what. Her activities always wasted away into mist within her spirit, within her love-haunted flesh. Like those highly-bred greyhounds, she was perverse. And finicky. With her mind occupied by household matters, and giving orders impossible to carry out in the prescribed time, tablecloths to be folded and so on, she succeeded not in muddling everything, but in degrading everything. Without her savagery and her impetuosity, she would have been a wretched creature, almost commonplace, and, like many of her contemporaries, she would have found her amusement in little things: trifling petty acts, cruel and derisive laughter. Though more touchy than he, she really bore quite a resemblance to someone like Henry III of France playing a dirty trick in doubtful taste upon one of his favourites.

For her spirit was tortuous, superstitious. Ungoverned by normal

conventions, it was constantly fluctuating under the influence of the moon. Struck in the most profound part of her being by a subtle shaft of light, Erzsébet Báthory was seized by veritable fits of possession. It was impossible to know in advance when this would happen. It would come suddenly, with stabbing pains in her head and behind her eyes. The servants would bring sheaves of fresh sleep-inducing herbs, while, on a small stove, they boiled up a brew of soporific drugs, later to be sucked up by sponges or cotton made from sphagnum moss, then passed under the nostrils of the patient who, perhaps sitting up in bed and writing to her husband now, was forever complaining of her headaches. But does all this amount to epilepsy? The latter was an hereditary illness of the Báthorys. Even Stephen, King Of Poland, whose wisdom is still celebrated, did not escape it.

Despite the fact that the worthy chatelaines had to content themselves with rather crude embraces, the science of love flourished in the days of Erzsébet Báthory. Italian and French literature spread to Hungary, where Boccaccio, Aretino and Brantome, who loved Hungary so much that he planned to make a trip there in 1536, were greatly appreciated. Along with pearls and brocades from Venice came those 'instruments of consolation' made of glass and velvet.

Why did Erzsébet Báthory never sacrifice a single male to that Kali, of whom, at her epoch, she had never heard, but whose cult she celebrated unconsciously? One might imagine that, crossing her Hungarian savagery, some fantastic vein come from far away, from the distant Orient, or from Bengal where the great female unconscious reigns, had insinuated itself into her; Erzsébet herself had taken from this Mother of memories only her sensuality and her taste for blood. Foul stenches did not revolt her; the cellars of her castle stank of corpses; though lit by a lamp burning oil of jasmine, her room, its very floor at the foot of her bed, reeked of spilled blood. Like those ascetic sectarians of the universal Mother, who kept their hands impregnated with the smell of rotting skulls which the Ganges sometimes throws up upon its banks, she did not shrink from the odour of death; she merely covered it over with strong perfumes.

Girls only were offered up to that goddess, who was so intimately mingled with her own character that, in the end, she believed all crimes were permitted if they gave her pleasure. And, as for the young girls, she wished them tall and beautiful. In her notebook she notes opposite a forename, 'She was tiny'. This was a pejorative statement concerning a girl who disappeared into that horrific abyss into which numerous companions had preceded her.

This exclusively feminine universe within which Erzsébet evolved is surprising. Valets made up part of the castle staff, but never assisted at

executions. They passed through rooms while engrossed in their own household duties, surprising young seamstresses standing naked in dark corners, passing others, also quite naked, engaged in tying up faggots outside in the courtyard. Water and wood was carried into the torture chambers by women. Only women remained closeted with the Countess and her prospective victims.

As soon as Erzsébet arrived somewhere, her first concern was to find a convenient place to set up her torture chamber: it had to be secret so that the cries would be muffled. Just as a bird finds exactly the site it requires for its nest, Erzsébet, gliding through all the halls and cellars, knew where to find, in each and every one of her castles, these places which were the most suitable for her designs.

Erzsébet knew the vices of her Aunt Klara Báthory, for she saw her and received her quite frequently. Nothing we know of her character would lead us to suppose she did not share in these vices; rather the contrary. She even experimented with one of her valets, named Jezorlavy Ostok, known as 'Ironhead'. He was a powerfully built man of great stature, and audacious to such a degree that he gave himself up, in public, to 'jokes and voluptuous games' with his mistress. But he, too, was afraid, and disappeared somewhere in Hungary.

As for the child she is supposed to have had by a young peasant, the dates are so contradictory one doesn't know where to place the event in the life-history of Erzsébet Báthory. It is supposed to have taken place a little before her marriage. Erzsébet asked Orsolya Nádasdy for permission to go and say goodbye to her mother, and set out accompanied by one woman only. Anna Báthory deplored the incident, but nevertheless arranged things with circumspection. She feared the scandal and the breaking off of an honourable marriage contract, and so, in utmost secrecy, she must have taken her daughter off to one of her most distant castles, possibly in the direction of Transylvania, and perhaps put around the rumour that Erzsébet had caught some contagious illness. Aided by the woman from Csejthe and a midwife who had sworn to tell nothing, she herself took care of her. A little girl was born and was baptised Erzsébet. In consideration of a large pension, Anna Báthory gave her into the keeping of the woman who accompanied her daughter. This woman sent for her husband and they remained in Transylvania with the child. The midwife was sent to Rumania with ample means, but she was banished from Hungary for the rest of her life. Then Anna and Erzsébet went straight to Varannó, where they had decided to celebrate the wedding.

According to other sources, the girl was born when Erzsébet was forty-nine years of age, but this is most unlikely. It is possible, however, that

she gave birth to a natural child during one of the long absences of her husband. One fine day when there was a wedding in the village, had she not been accused of having seduced the young husband simply because she wished to test the power of her charms? The fiancée complained about losing 'such a handsome man'; but not too loudly, for her complaint would have involved persons too highly placed.

There was a mysterious woman, whose name no one has been able to ascertain, who came to see Erzsébet disguised as a boy. A servant told two men – they bore witness at the trial – that, quite unintentionally, she had surprised the young Countess alone with this unknown woman. They were torturing a young girl, whose arms were tied tightly and were so much covered in blood 'that one couldn't make them out any more'. It was not Ilona Kochiská, for she was well known to the servants of Csejthe. Besides, this female was a transvestite, but she was unmasked, and she seemed to belong to high society.

She appears several times, and always unexpectedly. Erzsébet was around forty-five at this time. Previously, she had had a peasant for a lover, and it is said she forced Ferencz Nádasdy to ennoble him. Then there was Ladislas Bende, a nobleman, but not virile enough, who disappeared mysteriously. There was also Thurzó; this was a very brief liaison between the two marriages of the Palatine. However, Erzsébet was surrounded, particularly at Pistyán, by a society which she took pleasure in choosing for its corruption, for its infinite variety in vice. She herself employed a vocabulary seldom used by women in society, particularly during her fits of sadistic eroticism, when she confronted young girls maddened by the pain of having needles stuck under their nails, or when her frantic lust moved her to burn a girl's sex with a candle. She talked and shouted throughout the tortures, pacing up and down her room like a rapacious animal, returning to her victim, whom her female acolytes, Dorkó and Jó Ilona, in utter compliance, held down, as required. She had a terrifying laugh, and her last words before sinking into the final swoon were always, 'More, more still, harder still!'

At about this time Erzsébet discovered that it was more exciting to join with another woman in torturing a naked girl, without witnesses. Her unknown companion must have shared her sentiments. And so, with the object of satisfying their cruel passion, together they applied themselves to the task of tearing the breasts of the girl to shreds. Such acts were done in an out-of-the-way room in the castle, the protagonists themselves unaware that once or twice at least they had been 'caught in the act' by the maid and the valet who took to flight without even asking for

the pay that was owing to them; and they waited until the trial before they spoke.

This visitor, to whom the word 'lady' is applied – was she a friend come down from some neighbouring castle to take part in these sadistic rites? An unknown friend who came intermittently anyway, because the people at Csejthe knew more or less all members of the nobility living in this particular part of the country? A foreigner perhaps? What, then, were her precise relations with Erzsébet? Were sadistic pleasures the only ones?

In Erzsébet's time, in the sacred wood of Zutibure, the cold shadow of Dziéwanna still reigned, the Artemis of the barbarian hordes, lingering to watch over the glossy hazel tree, friend of water, over the propitiatory walnut and over the saxon iris, the magic plant. The sorceress Erzsébet constantly employed as successor to Darvulia, and native of Miawa, used to go off in the direction of a confused huddle of primitive temples fallen to dust in the mountain range overlooking Csejthe. There she would gather the most powerful samples sprung from the seed of plants cultivated in the enclosure of The Old Man of the Mountain five centuries previously, magical herbs and plants which provoked trances, belladonna growing in utter solitude and encircled by a blue-violet halo of refracted light.

Jean le Laboureur, in his *Histoire et relation du voyage de la reine de Pologne et du retour de la maréchale de Guébriant par la Hongrie, Carinthie, Styrie, etc., en 1645*, describes the Hungarian countryside traversed by travellers, a land in which the customs had remained unchanged for more than half a century, a time when the Báthorys were at the height of their power.

'The Hungarian countryside,' Jean le Laboureur tells us, 'is more expansive than elsewhere. One wanders amongst fir trees and vineyards and flowing rivers, all enwrapped in great silence. A shepherd blows into a bark horn fifteen feet long raucous and crude in tone. The inhabitants of Arvá are drunkards and thieves and always carry a knife in the hand. Travellers are obliged to have many dealings with the inns, for practically every purpose, because the roads are impassable and guides are required to ferry them across the water. The trees are twisted into grotesque shapes and the roads are winding, melancholy, and primitive.'

They pass by the old castle of Puchorw which, before it became the property of the Ragóczi, had belonged to the Báthorys. The Vág carries down the Danube enormous columns of rock-salt extracted from the soil and cut up into pieces near Cracow. The columns are spread out on flat barges just like tree trunks. The woods and rocks are full of furry animals which provide the luxury clothing of the country. There are zibelines and panthers, snow leopards, beavers, martens, lynxes and bears. In those days

there were still some aurochs, the most dangerous and rarest of all hunted animals. Like stags, they were hunted with dogs.

In the year 107 of our era, Decebal, King of the Dacians (a people violently proud that the warriors married their own comrades at arms) committed suicide rather than give himself up to the cohorts of Trajan. Since that time all the people of the world had hurled themselves across the breadth of Hungary. The Scythians had been there, the Avars, the Huns. Then Arpad and his dynasty arrived, followed by the Anjous of Naples, bringing with them the Italian influence to Hungary. Then, at the beginning of the sixteenth century, in the time of Mathias Corvin, after years of real autonomy during which the country had taken shape and flourished, the Turks invaded Hungary. The disaster of Mohács in 1526 inaugurated the long occupation. Threequarters of the country, the central and eastern parts in particular, fell beneath the Ottoman yoke. Soon, in the west, newcomers made their appearance, that is, the Hapsburgs. They took over a doleful heritage after the death of King Louis II of Hungary at Mohács.

Some authentic Hungarians had, however, remained in the Marches created by Charlemagne. They were the descendants of the Magyars to whom Arnulf, Lord of Germany, had appealed in 894, thus launching a series of invasions. The representatives of the old race had encrusted themselves in the mountainous borderland. They were the true Hungarian nobility. And it was these people who constituted the real force of Hungary in the sixteenth century.

The Turks had established their capital at Buda, once the town of Mathias Corvin. Almost everything in the city had been burned, including the great library full of the scientific treasures of the age which had been assembled by the King. But this time it was no more than a large town into which the invader had transplanted Oriental customs. One found there a taste for luxury and the easy life of which the real Hungarian people knew nothing and which, indeed, they despised. Transylvania, nevertheless, having also come under the Ottoman influence, had less crude customs than the provincial towns of the west and the north.

The Hapsburgs took up residence in Vienna, in Presbourg, and in Prague. Presbourg remained the capital for a long time. The Hungarian nobles, however, remained in their own land, in their fiefs, where they had absolute power. They did not go to Buda because of the Turks, nor to Vienna because of the Hapsburgs.

And as if Hungary had not been divided enough already, the spate of Lutheran reform burst out between 1556 and 1572. As the House of Austria was of necessity Catholic, the greater part of its adversaries

embraced the new doctrine and regarded Islam with less disfavour in order to protest against an authority they felt to be far more durable than the Turkish occupation. In return, the Pashas invariably sustained the Protestants.

The Society of Jesus had arrived in Austria in 1551, and Ferdinand, from the moment of his coronation a few years later, gave it his active assistance. As always, the Jesuits left and returned later in 1580. Maximillian II was more or less tolerant of Protestantantism, but his successor, Rudolph II, educated as he was in Spain, was once again an intransigent Catholic.

Certain families, such as the Nádasdys, to which the husband of Erzsébet belonged, benefited, in spite of their Protestantism, from the indulgence and help of the Emperor, because it was their armed forces which held the Empire intact against Islam. Ferencz Nádasdy, from adolescence until his death, never ceased to make war against the Turks.

Anyway, religion was not of very great import to them, in spite of the fact that every castle had its own almoner, father or pastor. In general, women accepted the religion of their husbands on marriage.

The flowering of the arts came very late to Hungary. How could a country picked clean by invasions give birth to anything but artisan work concerned with the manufacture of those objects most necessary to daily life?

The Hungarians were a savage people who were inclined to be moody, like their music. The most ancient Hungarian text, *The Funeral Oration*, is a tragic one. Death is always present in Hungarian poetry, in that land where spring and the peony last just long enough to see the downfall of the young girl and her lover. The Hegedus and the Kobzós, descendants of Attila, used to sing their songs in the keys of the time, very dear to lute players, or, frequently, in a minor key with ancient notes originating in the distant and barbarous steppes.

The beauty of the Renaissance reached Hungary by way of Italy. It scarcely touched the nation itself, which continued to live as in medieval times. The women conducted themselves with a savagery comparable to that of the Dark Ages. A certain woman, Benigna, who was nevertheless very devout, assassinated her three husbands, one after another. Then, to efface the memory of her ghastly crimes, she presented the clergy with some beautiful gifts, throwing in for good luck an illuminated prayer book. At this time, monks, like sorcerers, had ready-made magical formulas of pardon, which, for a healthy consideration, might remain efficacious for the profitable murders of future husbands. As for funeral rights, instead of

shedding tears, the Hungarians slashed their skins in such a way as to leave scars everywhere. These lamentations around the corpses of the dead lasted at least a month until the most distant relatives had had a chance to arrive over the difficult Hungarian roads. At the court of King Mathias the tradition of oral narrative had been preserved: the true story of the unfortunate Klara Zach, a lengthy tragic ballad, the legend of Toldi, and other 'flower-stories', as the poetry was called, were all sung to the accompaniment of the long-necked guitar of the Hegdus by the local Hungarian troubadours in the presence of the King. For a very long time this was the only literature of the people and of the peasants. This living poetry prolonged the pagan traditions, together with national legends evoking past conquests and bewailing past defeats. These legends were declaimed in a monotonous way to the accompaniment of instruments of a plaintive note: the primitive violin, the bark cornet booming out intermittently, the flute made of eagle's bone, or crane's, the iron pot covered over with leather and made to resound by means of a wet stick placed inside. From the sixteenth century onwards, light music and popular songs were interpreted by the gypsies, each castle possessing its own orchestra to celebrate weddings, feast days, funerals, and to welcome important guests.

The Cistercians came to Hungary at the beginning of the thirteenth century, bringing with them the Gothic style. The master craftsman, Villard from Honnecourt, was summoned to build the cathedral of Kaschau. Soon, castles were constructed in the feudal style of the fourteenth century, those of Buda and Visigrad, amongst others, and likewise the castles of the nobility guarding the gorge. During the Renaissance, Mathias Corvin managed to get some architects to come from Italy, Benedetto de Majane, among others, and they reconstructed the castle of Buda and the palace of the Báthorys at Kolózvar. They decorated the castle façade with graffiti in the Italian style; but the motifs were copied and can be found in the work of goldsmiths and in Hungarian embroidery.

Unfortunately, not very long afterwards, everything was devastated by the Turks, and these Renaissance works hardly had time to penetrate into those distant provinces in the northwest of Hungary whose natural defence was the Carpathians. From time to time certain lords had their castles renovated, like that of Bittsere belonging to Thurzó, a place which, when she was invited there, Erzsébet found absolutely magnificent. In general, however, the castles were in the Hungarian style, with Polish and Oriental influences, while, in the provinces, the feudal style dominated completely. The most frequented city was Presbourg (Pozsóny), which was

the seat of justice and the Palatine assemblies, and where the University was located; it was also the commercial centre; there were markets for all trades there, in particular that of the goldsmith.

There was hardly a single lord who didn't possess a sword with a hilt of Hungarian enamel; scarcely a woman who didn't sparkle brilliantly with necklaces and bracelets of the same enamels. The deep colours of the local gems were set in gold and gleamed at the throat or hung down on golden chains on to the velvet of their bodices. As mysterious as the tints of the forest, and chiselled more delicately than young ferns' crooks, such jewellery was used to clasp the bristling furs of forest beasts to the shoulders, and to clip heron plumes to their caps. Despite the fact that the Benedictines of the Abbey of St Giles had already introduced the chased enamel of Limoges, the people of Hungary held on to their old Sassanid motifs, vine shoots bearing leaves and fruit, and curling pistils. In the fourteenth century, the studios of the goldsmiths of Transylvania were held in great repute.

Chapter Two

Hungary in the sixteenth century, was a completely feudal state. In Occidental Europe, where there was far more exchange of ideas, the atmosphere seemed fresh as springtime in comparison to Hungary; and above all, as compared to the region in the Carpathians where the feudal way of life was solidly implanted. Very little money existed there; only home produce was of any significance. This latter was, however, abundant, for the country was bountiful, with a predictable climate: icy in winter, torrid in summer. At that time the Turks seldom pushed their invasion far into the northwest, and that part of the country was rarely devastated, and even then more often by bandits. Therefore, the harvests were more or less certain.

Despite the day to day incidents, all the comings and goings from castle to castle, the frequent health cures in spas of hot mud which were to be found more or less all over the country, boredom was almost inevitable. Power meant total power: whether it was wielded well or badly depended entirely upon the discretion of the local lord... and his wife. The peasants were difficult to handle: fearful, quarrelsome, superstitious, and, at Csejthe where Erzsébet Báthory lived, they were more backward and stupid than elsewhere. At least, that is what she said. According to feudal law and custom, the lord protected them, engaging in war to defend a patrimony which comprised serfs in the same way as it comprised trees and brooks. Lords went to war against everyone: Turks, rebels, and Hapsburgs. The palatines and the countesses remained with their garrison and devoted domestics, sheltered in their castle behind moats and portcullises. When husbands had to attend, at diets, reconciliations or receptions, their womenfolk would go with them to Vienna or Presbourg. Everything in the latest Italian and French fashions which could be transported there was to be found in Vienna, as well as a wide variety of ornamental Hungarian work and jewellery. These precious stones and enamelled bracelets were to be found also at Presbourg, in addition to oriental perfumes and those strange spangled Turkish veils. In the sombre rooms of fortified castles, silks and

golden objects from the bazaars of Constantinople were quite a common sight. In the forecourts, on the other hand, young boys and girls could be seen waiting to be chosen for their beauty, for they had been brought secretly at very high prices in Hungary for export to the East, where they would eventually embellish Mussulman harems.

Hungarian castles were built high up on the rocks of the Carpathians just as frequently as they were situated on the plains. They were solid, and for the most part quite primitive. As one can verify by consulting the book published in 1731 at Augsburg by von Puerckenstein; they were designed to resemble the shape of flowers or stars fallen to the earth. The castles on the plains were sometimes built in the form of large quadrilaterals, such as that of Illáva, surrounded by ditches to prohibit a frontal attack. Those built more recently were subject to Byzantine influence, particularly noticeable in the bulbous roofs crowning the turrets. But the ancient feudal castles, those belonging to the Marches created by Charlemagne, built of grey stone, without water-filled moats, were perched on the slopes of the mountains. There were very few windows, square towers, and limited space for habitation; nevertheless, underneath, there were immense cellars with underground passages leading to different sides of the hill. Such was the castle where the Countess Báthory passed the most untroubled days of her life. She loved it for its wildness, for the thick walls which muffled every sound, for its low halls, and for the fact of its gloomy aspect set on the bare hillside. She owned many other castles, sixteen in all, belonging either to herself or to her husband, but it was always in those castles which were most out-of-the-way and which presented the grimmest exterior that she preferred to live. There were other reasons for choosing Csejthe and Bezcó: they were situated in neutral territory on the Austro-Hungarian frontier. What first drew her, and then held her at Csejthe, was undoubtedly some sinister appeal. Perhaps she found there the security which is the prerequisite of sorcery and crime at the beginning. Near as it was to woods dear to sorcerers and to werewolves, resounding with the howls of predatory beasts in the night, the cries of nightjars, Csejthe was to her a most satisfactory dwelling place. She stopped at Illáva or the other castles only when her dark lusts took her by surprise. Bezcó and Csejthe were the real dens of her sadism and voluptuousness.

Sometimes, under the cellars of a castle, at the precise spot where the first stone had been laid, the first hole dug, one might have been able to find the skeleton of a woman. The masons had seized the first young woman they came across and buried her there as a token of good luck and as an assurance of fertility and the birth of descendants in the future. And

so, century after century, the castle would stand upon such a frail skeleton. The nobility came and went from one of these residences to another. Sometimes, having to make a stand in the castles of the plain, the nobles would retreat to those other castles which rose up on their rocky perches in the Carpathians. The heat, too, accounted for some of these changes in residence. In summer the plain was so torrid that those lords who were not at war used to set out with their retinue in coaches and on horseback along these same roads which led them every year up into their highlands amongst fresh forests and glittering streams. Beneath the yellow harvest moon they hunted foxes and deer. The hunters were able to climb again up through the sloping vineyards which led them into the great dark forest — oaks and pines first, then birches and fir trees, between which bucks and stags fled, to drive back the last aurochs and bears as they emerged from their lairs.

The cellars and the underground passages of the castles were always immense, even in a residence of modest dimensions, in a country where vineyards formed an unbroken string at the foot of the slopes of the Carpathians, all over Hungary. Caves were used as cellars, and the peasants transported their home-grown foodstuffs there because they were airy and, in the event of attack, easily fortifiable, whereas the village at the foot of the hills had to bear the assaults of the Turks and of the Hungarians themselves, depending upon whether they did or did not accept Hapsburg domination.

The true Hungarians, especially those belonging to the old families, considered it a point of honour to lead a simple life in an atmosphere which was unsophisticated too, but which, for all that, could be regarded as their own peculiar form of luxury. Furniture consisted of massive wardrobes of dark oak sculpted by the local carpenter, and of great heavy linen chests lined up against the walls. The centre of the bedroom, which, with its two fireplaces, was the best heated room, contained a fourposter bed, heavy and springless, surrounded like a coach by curtains rustling in the breeze coming from the doorways. Specifically designed to keep out the cold, these thick curtains were frequently made of Genoan velvet, but more often of homespun cotton interwoven with threads of gold and silk. There were also all manner of looking glasses, with far-away reflections, framed in turned oak or with plaques of damascened metal in the Spanish style the Hapsburgs had introduced, a dynasty to which the epoch owed a great deal of its luxurious furnishings.

Up to the last century, one could still see on the walls of the castle of Sárvár near the Austrian frontier, a primitive huge broad fresco painted in 1593. It had been commissioned by Ferencz Nádasdy to commemorate

the Battle of Sissek in which he commanded the Hungarian army against the Turks. Nothing remains of this old fresco today. A century ago one could still recognise the figure of Nádasdy himself, dressed in a long green kaftan which, since the invasion of the Turks, had replaced the short Hungarian tunic. He was portrayed as still young, on the point of lancing a Turk who is spreadeagled on the ground. War was, in fact, his vocation; his *raison d'être*. He fought on the side of the Hapsburgs, as his father had done before him, winning by his courage and warlike ardour the nick-name 'Beg (The Lord) Black'. With a dark beard, dark eyes and dark skin, his was a commanding presence. Despite his angry growls when, on arriving back at the castle, he would pace to and fro along the corridors and staircases, Ferencz seems to have been a man of simple and straightforward disposition. He carried with him the smell and the habits of the army where – despite leather bathing tubs – men never washed, and where they ate quickly and greedily, and were harsh and brutal with their subordinates.

It was he who taught his wife how to revive servants who had epileptic or hysterical fits by putting oily paper between their toes and setting it alight. He used to employ this method with the best of intentions with his soldiers. Erzsébet was to remember this later. One day, on entering a tiny private garden on the castle grounds during a stroll with his wife, Nádasdy caught sight of one of his kinswomen, naked and in tears, tied to a tree, her body smothered in honey, and now a heaving mass of flies and ants. Knitting her brows, Erzsébet explained to him that this girl had stolen fruit. Her husband found it all very amusing. As far as ants were concerned, Nádasdy's soldiers were covered all year long with an equally tenacious kind of vermin, which neither louse-wort nor flea-bane could remove. He didn't concern himself with what Erzsébet did to her servants, providing she didn't worry him with such affairs during his rare visits. Like the good housekeeper she was, she didn't fail to keep him informed of all that went on, until he told her he had heard enough of domestic affairs, that she must do whatever she thought best, and talk to him of other matters – herself for example – for he loved and admired her. He was afraid of her too. From the very first this great warrior had sensed a sombre power in his beautiful young fifteen-year-old wife, a power of quite a different calibre from that rough and simple power he himself exerted in battle. And then, she stubbornly refused to have children; she surrounded herself with sorceresses and spent hours on end, her mind far away, in working out talismans for everything. There was forever spilling out of her room some parchment or other written in the blood of a black hen; tufted plumes lay in disorder on the table alongside her writing desk of chiselled horn, and precious little round bones lay on dry herbs at the bottom of boxes. From

all that emanated a foul smell.

Ferencz Nádasdy was born on the 6th of October 1555. He belonged to a family more than 900 years old; his genealogy could be traced as far back as the reign of Edward I of England (the country of its origin). His ancestors had been summoned or invited to come to Hungary to fight some enemy or other, and they had remained there in the western part of the country, close to the Austrian frontier near Sárvár and Eger.

The most famous of all the Nádasdys had been Tomás, the Great Palatine (1498–1562), who had defended Buda against the Turks and who had contributed to the election of the Emperor Ferdinand. From that time on, the Hapsburgs were always indebted to the Nádasdys. Tomás was poor and he made his fortune in serving them at a time when most Hungarians preferred the domination of the Turks to that of the Holy Roman Empire.

Tomás Nádasdy was born in an epoch, that of the Renaissance, in which the young nobles grew up in a culture that was relatively advanced. Following the new custom, he went to study at the universities of Graz and Bologna. In 1536 he married a very young girl, Orsolya Kanizsáy, whose ancient family possessed vast wealth. By this marriage he became one of the richest lords in Hungary. At the age of fourteen, nevertheless, Orsolya could neither read nor write. Tomás, who loved her tenderly, undertook her education himself and had learned people come to the castle to instruct her. Both of them gave help to the poor: a rare phenomenon at this time. And, what was much more customary, husband and wife wrote to each other every day they were separated. We possess one of Tomás' letters to his wife. Dated 1554, this letter, after referring to his nomination in the Palatinate, is full of affection. Tomás Nádasdy always protected men of learning. It was he who, in 1537 at Sárvár, was responsible for the printing of the first book in the Hungarian language, a copy of which is still in the possession of the National Museum in Budapest.

Orsolya Nádasdy prepared for the marriage of her son for a long time in advance. Having herself been very happy in her marriage, she thought that it would be good for Ferencz to follow her example. She scarcely ever saw this son of hers, occupied as he already was at military exercises near Güns by the Austrian frontier. The Turks had never been able to take this little town, which was defended by Saint Martin himself, who had been seen coming down out of the heavens to make combat against Mussulman forces. As for György and Anna Báthory of Ecsed: ever since they had attained the height of their power they had always wished to ally their family to the glorious family of the Nádasdys. Thus was the destiny of an eleven-year-old girl already decided, a girl who carried within her the knowledge of her beauty and of her desire to shine at the court of Vienna

amongst her fellow nobles in the presence of the Emperor. Meanwhile, however, she had to live under the careful eye of Orsolya Kanizsáy, a good woman, but very austere and puritanical. From the moment Erzsébet arrived in the four-horse carriage of her father, her fate was sealed. In the castle of her parents she lived in freedom; the days used to pass gaily, with great banquets and feasts, with everyone doing as he pleased. And now her every step was controlled by the rigid routine of this austere life of prayer in which amusements were few and far between. From the very beginning, Erzsébet detested Orsolya, who forced her to work, never left her alone, constantly advised her, decided what costumes she should wear, supervised everything she did, and even tried to penetrate her most secret thoughts. Not the slightest flight of imagination was permitted her; she was bored. There were lighter moments, when Tomás Nádasdy came back to the house between battles. On his arrival, the castle came back to life again and Orsolya had no longer the time to concern herself with her future daughter-in-law. Young noblemen arrived unexpectedly with the Palatine, young men who loved to amuse themselves; then Erzsébet was able to get some idea of the pleasures of the Viennese court. But this didn't last. Erzsébet tried to break free; she wrote secretly to her parents. Anna replied beseeching her to put up with her boredom until her marriage, assuring her that after that everything would be different. But to waste her youth and her beauty in this way in household chores, Erzsébet found revolting, and ideas of revenge were born in her untamed and already evil mind. And thus when, with her husband away hunting Turks or busy with public affairs in Vienna or Presbourg, she had to stay on as mistress of Csejthe, the authoritarian and cruel elements in her character could not but be accentuated.

Orsolya decided to take Erzsébet to the castle of Léká in the middle of the savage Tatras. There, Erzsébet continued to lead a rather dreary childhood, galloping along foreign paths and impregnating herself with the obscure forces of nature. Needless to say Orsolya Nádasdy possessed a large number of other residences of which the most beautiful was Sárvár; but this castle was, as it were, flattened down in the scorching plain. Orsolya was somewhat fragile, suffering from some malady to which in those days they paid very little attention, and she bore the climate with great difficulty. The air at Léká was better; it was high up, exposed to the wind, and so difficult to reach, that once established there, to leave it again involved a full-scale expedition. Anyway, one tended to remain there. The Nádasdys are even interred there. To this day their double statue in dark red marble, representing a couple kneeling, is to be seen.

Ferencz Nádasdy wished to live alone. He had plenty of other

things to do besides getting married; but he was the only male child of the line. Orsolya could see no possible happiness outside marriage; obstinately, she kept and brought up Erzsébet in her castle, training her in the thousand subtleties of how to give orders to have the cupboards kept clean, the linen well saffroned, bleached and pressed in as small squares as possible. At that time it was the custom for the mother-in-law to undertake the education of the future daughter-in-law. She also taught her future daughter-in-law to read and write, just as her husband had done for her. All in all, she went to great pains to make of this silent child a daughter-in-law after her own heart.

When her dear Ferkó returned to Léká, or, in winter, to Sárvár, he would see a pale little girl with disquieting black eyes which stared at him; he didn't feel particularly reassured, but he had heard it said his mother needed someone to keep her company, that she wouldn't live much longer as her health was very poor (this proved true – she died shortly after his marriage); and, above all, that marriage was a prerequisite of happiness. After a while Ferencz would go off again. And Erzsébet, insolent and seething with anger, would go on learning, though unwillingly, her duties as mistress of the household, but acquiring very readily indeed the more amazon virtues: romping around with the local lads or, without a thought in her head for others, galloping across sown fields like a true chieftain's daughter.

And so it went on up to that day in 1571 when Ilosvai Benedictus of Cracow recited the following verses to the young people: '*Epithalamion conjunquit Dominum Franciscum Nadasdy et Dominam Helisabeth de Bathor'*, which signified their official betrothal. She was eleven and he, seventeen. Then, once again he set off.

Erzsébet was not required to change her religion, in the first place because it was not of very great importance, and in the second because she belonged to a branch of the Báthorys which had recently become Protestant. The Nádasdys too were Protestant, despite the help Ferencz gave to the Catholic Hapsburgs, despite also the fact, that later in life he even founded a monastery.

A poet, the most eminent doctor Palius Fabricius, had, at the birth of Ferencz penned a dithyramb in which he predicted he would be a great scourge of the Turks; that he would be a patron of poetry and the arts... all of which turned out to be quite true. It also happened, as predicted, that he had trouble with his head and neck, and suffered from frequent colds. The Moon and Mercury in the sign of the Scales predisposed him to a love of literature and signified that he would have a beautiful wife; this too didn't fail to come about. It seems that the poets

said all this to please Ferencz's father; had he known also what would become of Erzsébet whom the young man was to marry, he might have spoken more equivocally.

It was customary for Protestants to send their children to Wittenburg, where Luther lived and where there was a Protestant University. Six hundred young Hungarians studied there, and it was considered good form to return home with a private tutor from that seat of learning. Ferencz Nádasdy was brought up by one of them, György Mürakoczy, who came to teach at Sárvár and made the reputation of the town school. The Bible was the essential part of studies there; apart from that, pupils were taught scarcely anything else save the use of arms, and the skills of riding and hunting.

Throughout this period one finds traces of the dashing bravery of Ferencz Nádasdy as he battled against the Turks or against those Hungarian lords who sided with them, and were known as the 'rebels'. In Volume VII of the *History Of Hungary*, written in German by J. A. Fessler, the name of Ferencz Nádasdy is mentioned in connection with every battle fought against the Sultan Amurat III, son of Suliman II, a king so cruel that he had all his nineteen brothers strangled; cast ten women, pregnant by his father, into the sea; impaled entire garrisons and burnt their chieftains at the stake. Nevertheless, the Hungarians were almost as ferocious as the Turks, and with very good reason, since everyone plundered their land and bore off their sons and daughters to captivity. Sometimes it was other Hungarians who sold them to the Turks, such as the girl sold by her mother-in-law mentioned in the old ballad of Boriska:

Out in my garden and strewn all round
My flowers, my flowers, fade into the ground
So that all the world may see
You weep for me, you weep for me.

In my little room, thrown on the bed
My dresses, my dresses, lie limp and dead
That all the world may see
You mourn for me, you mourn for me.

The peasants couldn't go to work in the fields without a sword by their side and their horses saddled, ready to flee at a moment's notice. As soon as they saw horsemen surging across the horizon they would make a rapid count: if they were equally matched they fought, giving no quarter; but if the enemy outnumbered them, they would fly, for the Turks would take them

into slavery and hold them for ransom. All the Protestants were proud of their 'Black Lord', who exterminated the accursed breed of Turks wherever he encountered them. Ferencz, unlike most other warriors of his time, was relatively chaste and sober. He neither ate nor drank too much, even at banquets celebrating victory. On Saturdays, he fasted until evening, and on the eve of a feast day, the entire day through. He was more and more drawn towards religion as he grew in years and power.

In 1601, being in Pozsóny, he was confined to his room with a bad leg, unable to walk at all. By summer he was much better. But all the spells of his wife Erzsébet, which procured his immunity on the field of battle, couldn't combat the illness of which he was destined to die at Csejthe in January, 1604, when he was only forty-nine years of age.

Chapter Three

The Nádasdys had exchanged and sold several of their castles in order to obtain the one at Csejthe. It had previously belonged to Mathias Corvin and to Maximillian I of Austria, who sold it to Orsolya Kanizsáy and Ferencz Nádasdy for the sum of 86,000 Austrian florins. At the same time they bought seventeen other castles and villages.

Csejthe, built in the thirteenth century, had always belonged to the Crown of Hungary and Bohemia. Before the Nádasdys, the proprietor had been Count Christofer Országh of Giath, counsellor to the Emperor. At the death of Erzsébet Báthory, Csejthe passed into the hands of her children and, later on, the royal family sold it along with Beckó to Count Erdódi for 210,000 florins. From 1707 onwards the imperial army occupied the castle, and in 1708 it fell into the hands of Ferencz Rakózci.[1]

It was customary to choose the most beautiful and the most comfortable place for a marriage. Almost inaccessible in mountainous country, Léká and Csejthe were scarcely of that order. And so, everyone went down to the nearby Varannó which was situated at the edge of the plain, to celebrate the marriage of Ferencz Nádasdy and Erzsébet Báthory. On the 8th of May 1575, this great event for which Erzsébet had been destined almost from her birth took place. She was nearly fifteen years of age.

On this lovely springtime day many peasants from the village, the girls wearing enormous coronets of flowers and yellow beads twisted into the shape of the sun, celebrated their own marriages. A song praising their beauty was sung. 'Know thou wert born of no earthly mother, thou camest forth on the dew of the rose of Pentecost.'

The girl who stood waiting in the castle of Varannó had nothing about her of a Pentecostal rose, nor of the colour of any other living flower.

[1] In 1708 a French officer, called de La Motte, seized the castle, which was finally burned in the nineteenth century.

It was not customary amongst noble ladies of Hungary to use make-up. Erzsébet was dressed all in pearl-encrusted white, strikingly pale beneath her dark hair and the gaze of her great black eyes seemed born of the smouldering depth of her pride. Undoubtedly, that very morning, she had had a hundred pretexts to fly into one of her habitual rages during all the fussing about of her maids of honour as they adjusted her great bridal gown, which was neither entirely Hungarian nor entirely oriental in style, with its pompous spread, the satin swelling out between the stiff lozenges of seed pearls. Other pearls, huge and very long, made into earrings and a belt, adorned her while the starched silver ruff around the neck of this young bride seemed to accentuate the black lead tint and the shadowy circles of her eyes.

Erzsébet's hands, softened with perfumed pomade, jutted out of the tight-fitting cuffs terminating the sleeves. Lining all the clothes, even in the most diverse places, talismans had been embroidered: that she should be loved, that she should be fecund, that she should please, that she should please always, that her beauty should remain as majestic as that day it surely was.

When the spring night filtered in through the lighted windows of the castle of Varannó, whilst down below the dance went on, undoubtedly there she was, motionless in the great four-columned bed, its curtains drawn, with her great dark eyes wide open… a demon indeed was this woman whom Ferencz Nádasdy held in his warrior's embrace; a white demon, nevertheless. He had always been slightly afraid of this girl whom, each time he returned home, his mother's home, he found more grown-up and more beautiful still. And, the fact is that although she was only a child of fifteen, he could not tame her.

Notwithstanding the fact that this was a union of two of the greatest Hungarian families, very few details about it have been left for posterity.

The Emperor Maximillian had sent his approval from Prague. The letter, signed in his own hand, has been preserved. Apart from that, however, no other documents exist except one describing the presents which were sent. Unable to come personally, but represented nevertheless, Maximillian, for his part, sent a great golden jar filled with a very rare wine, as well as a gift of two hundred thalers in gold. The Empress sent a very handsome goblet of beaten gold, that the married couple might drink the precious wine from the same cup, as well as oriental carpets of silk and gold. Rudolph, King of the Magyars, sent other beautiful presents.

It was a traditional marriage between members of families of the Hungarian nobility. There was a greet deal to eat and drink; there were all

manner of bright lights, gay dances, and gypsy orchestras in the halls as well as in the courtyards outside. It lasted for a long time, for more than a month.

Sometimes Erzsébet would make an appearance, more haughty and withdrawn than usual, quite magnificent amongst her ladies-in-waiting, but inwardly restless. They set off, Ferencz and she, to establish themselves at Csejthe. It was she who had chosen that spot, driven by some secret desire for solitude, attracted by some mysterious summons.

A valley, gorge of a secondary tributary of the Vág, at the base of the lesser Carpathians. On the slopes, vineyards which produced a red wine similar to Bordeaux; halfway down the hillside, the village with its white houses, wooden balconies, their roofs covered by sheets of wood. Corn swaying in the breeze, and a very ancient church with a simple square tower. At one end of the village was a path which led up towards the castle, high up on the hillside. This hill had always been devoid of trees; rocky boulders and stones only, bare plants wasted by winter, looking from a distance like dead hair.

Higher up, there was the forest, full of lynxes, wolves, foxes and martens, beasts that were brown in summer and white in winter.

Open to the wind, Csejthe was a relatively small castle, very strongly built to withstand attacks, but entirely uncomfortable. The foundations dated from before the fourteenth century, and the subterranean passages constituted a terrifying labyrinth. On the smoke-blackened walls of these cellars one can still make out graffiti: dates and crosses. They are said to be the signatures of the girls who were imprisoned there, and the peasants still cross themselves as they pass these crumbling walls which to this day seem to resound with cries of agony.

It was there, that Erzsébet installed herself after the wedding with two maids of honour chosen by her mother-in-law, her own servants, and Orsolya Nádasdy herself. Ferencz had gone off to the wars again, and the young bride was well aware that from now on her duty consisted in bearing children for him. Yet, in spite of the fiery nights at Varannó, she could only shake her head negatively when her mother-in-law questioned her on this subject. She was scarcely very pleased at being treated in this way, like some brood mare. She stalked about her castle, interested in nothing, unable to use make-up because Orsolya looked on this practice with great disapproval, and she was bored to death.

'She was always bored,' writes Turóczi. She knew how to read and write in Hungarian, in German, and in Latin, her mother-in-law having instructed her in these things. But few books came this far, and those which were admitted to the castle contained only psalms and sermons, and

pertained only to the punishment of sins; alternatively, they were full of stories about battles against the Turks and long lamentations on the horrors of war.

And so, five or six times a day, she would have her jewels out and change her clothes again and again, putting on one after another all the dresses she possessed.

From time to time Ferencz arrived at his castle. She welcomed him dutifully and begged him to provide her with some distraction; but Orsolya, who was ill, demanded that her daughter-in-law should stay at her side. Anyway, why should she wish to go to Vienna? Why look so far away for diversion? Did she not have to keep house, supervise expenses, prepare in advance for the coming of guests to family banquets and to the feasts of Christmas and Easter? But, at this period of Erzsébet's life, the guests were not very amusing. The extravagant and dangerous Báthorys were kept at a distance as much as possible, for they would have disrupted the household routine; in particular, Aunt Klara, that madwoman, who picked up lovers on all the roads of Hungary, and bounced chambermaids on her bed; or that Gábor who, also, wasn't in the least particular whom he bedded. The Nádasdys were much more respectable: there was, for example, Kátá, Erzsébet's sister-in-law, who lived in a castle some distance away. She was a woman of some culture, and had children. Erzsébet however became more and more bored, and considerably more so during her husband's visits, for when she was alone in the inmost recesses of her private suite, where the dismal empire of her mother-in-law no longer held sway, she was already beginning to lead the kind of life she longed for.

Each morning she had her face painted with great care. The coiffure of her flowing hair was for her, as for most other women, her greatest indulgence and her particular preoccupation. She loved the feel of it when she touched her head with her long and very white hands, for she was always suffering from headaches. She dreamed only of cosmetics to perfect the whiteness of her skin. Hungarians were famous for their special knowledge of plants and their use in the manufacture of fragrant balms. In the antechamber of her bedroom, where an apparatus for heating water had been installed, her personal servants were constantly occupied in stirring pots of thick green ointments on the stoves. These cosmetic substances had been in use for centuries, and the sole topic of conversation throughout the room concerned the efficacity of this or that recipe and the means of perfecting it. While waiting for her creams to be ready, Erzsébet would gaze in her mirror at the intractable set of her forehead, at her sinuous lips, her aquiline nose and her immense black eyes. She was in love with love; she wanted to hear that she was beautiful, the most beautiful of

all. And indeed she was, radiant, with a beauty born of the inexhaustible springs of darkness.

Often unwell, she surrounded herself with a battalion of servants, who brought her drugs and potions, philtres to alleviate the pains in her head, or who subjected her to inhalations of steaming apple of Mandragora to relieve these pains. It was thought that all this would pass with the coming of a child; and, as an aid to bring about this happy event, they encouraged her to take a host of other drugs and philtres, slipping roots vaguely human in shape and talismans of all kinds between the sheets of her bed. But Orsolya watched her sadly all the time, for no word of good tidings passed the lips of her daughter-in-law. After these confrontations Erzsébet returned to her own chamber. And she took her revenge upon the women of her bedchamber, sticking pins into them, and then tiring of that she would throw herself on to her bed and roll about in one of those fits to which the Báthorys were prone, ordering two or three hefty young peasant girls to be brought close to her quivering body, spitting and biting at the soft flesh of their shoulders and chewing whatever came away between her sharp teeth. Magically, in the screaming agony of her victims, her own sufferings disappeared.

Orsolya Nádasdy Kanizsáy died, conscious of having brought about the happiness of her son by fashioning with great labour such a beautiful and excellent wife, but very disappointed at not having held a grandson in her arms before death claimed her.

Ferencz Nádasdy wasn't often at the castle; however, since the death of Orsolya on several occasions he had taken Erzsébet to Vienna where Maximillian II was staying, having abdicated in favour of his son Rudolph. The Emperor was very fond of her and understood her. Was this only because her pallid complexion and her beautiful white hands reminded him of that Spanish style of beauty? Was this the source of his affection for Erzsébet Báthory, or was it not to some extent also because he found in her a reflection of his own taste for magic which Rudolph, his son, had also inherited?

Erzsébet was then nineteen or twenty years of age and it is from this time, more or less, that her portrait dates, that portrait in which there is already revealed in her eyes haunting memories of nights spent in the bloodbath of Blutgasse (Blood Alley). Despite her beauty, people recoiled at her approach and became silent and cringing as she passed, utterly distant, never so much as a glance at them, a strange, solitary figure, moving with a soft clicking of her enamelled necklaces.

Her husband had begged her, time and again, not to worry him

with tales of the servants. He had accepted the girl smeared with honey and exposed in full sunlight to bees and ants; he would shrug his shoulders when he heard tell of Erzsébet's biting girls, sticking pins in their flesh, and other events symptomatic of her habitual impatience. In return he asked only to have this beautiful woman for himself during his leaves: and, all the while, in keeping with the Hungarian custom, he exchanged tender and respectful letters with her. Ferencz Nádasdy seems never really to have grasped just how cruel Erzsébet was; he knew she was proud, authoritarian, and prone to anger *vis-à-vis* household matters; but was this not an indispensable condition of exacting obedience? With him she was gentle and circumspect. When they went to Court together, was she not his regal ornament? That sufficed, or nearly. He was content. Only children were lacking; but, as she told him in every letter she was undergoing a thorough treatment of philtres to make her fertile, he was reassured and remained optimistic. Besides, she had taught him the use of other philtres such as would prevent his being wounded in battle. Thus, whilst they waited for his departure to new battles, at imperial receptions in Vienna they would dance together the very same pavanes which were danced at the Court of Elizabeth of England, and, at Paris, by the fine noblemen at the Court of France. Her visits to Vienna were, however, few and far between.

The philtres had finally proven efficacious. We do not know exactly when Erzsébet's children were born. The eldest, Anna, undoubtedly around 1585, and the last, Pál, the only son, shortly after 1596. The daughters were given traditional Christian names: from the family of Erzsébet's mother, Anna; that of the mother of Ferencz Nádasdy, Orsolya; and finally, that of Erzsébet's sister-in-law (who was probably the godmother), Katerina. On the other hand, the name 'Pál' doesn't previously appear in the family.

Jó Ilona, the old wet nurse, kept and took care of the children. They too were frequently like sick wolf cubs.

As one suddenly becomes anxious, as fire takes hold, as one tears off one's clothes, so, very suddenly the thirst for blood would seize hold of Erzsébet. No matter where she was, she would rise, very pale, much paler than usual, and she would assemble her servants for the journey to her favourite wash-houses, her secluded retreats.

Later on, no one could really say when this practice had actually begun. While her husband was still living, certainly. In her presence, no girl was ever safe. Servants and ladies-in-waiting equally dreaded having to make her up.

The girls of the Nyitra, blonde with blue almond-shaped eyes, were solidly built, but slender. In their coloured skirts and white blouses,

they swarmed about the castle, busy at all hours in satisfying the thousand and one whims of their mistress. But those whom Erzsébet sent at the propitious hour into the forest to pick doronicum to heal wounds, gall-coloured pulsatilla, bitter colchicum, and deadly nightshade planted like a green choir in a rock circle – these were old women, toothless old crones like witches, the very ones she used to post in the corridors as sentinels, behind curtains, there to see everything, to hear everything, and to repeat everything.

Had she so wished, she might have ravaged to her heart's content in broad daylight; and perhaps there would have been less concern. But darkness, the fell and utter solitude of the subterranean passages of Csejthe were more in keeping with the black caverns of her spirit, and were far better suited to the demands of her terrible eroticism of stone, of snow, and of walls. Moonstruck she-wolf that she was, Erzsébet, pursued to the very bottom of her soul by her ancient demon, never felt secure unless she was covered with talismans, or except when she was murmuring incantations which resounded at the hours of Saturn and of Mars.

To those who invited her to their banquets, Erzsébet would often reply in her clear handwriting: 'If I am not ill… if I can come…' And she would remain at Csejthe or at Bezcó, prisoner within an enchanted circle, dreaming of living and yet not living, guarding with her mad incantations this existence of hers, powerless from the very beginning truly to live. She was alien, an alien to such an extent that even in those times nothing could make her one with the rest of mankind.

Despite Erzsébet Báthory's evil reputation, there were plenty of peasant girls who walked up the path to the castle, singing as they went. They were young girls and, for the most part, beautiful, blonde, with sunburned skin, but superstitious and ignorant girls who didn't even know how to sign their own names. Their life at home, especially in the neighbourhood of Csejthe 'where the people were even more stupid than elsewhere', was less enviable than that of their father's cattle. Thus, Ujváry János, Erzsébet's valet, had little trouble in gathering them from the nearby hamlets for service with the lady of the castle of Nyitra. It would be quite enough to promise their mothers a new skirt or a little jacket.

Ujváry János was horribly ugly. He was a local boy, a kind of idiot hunchback gnome, very vicious, but at the same time docile and he had always been entirely at the service of the Countess. He was called Ficzkó for short. He had been brought up by a certain Chetey and abandoned on the highway; someone had brought him up to the castle as it was the law to do with whatever might be found in the land of the lord of Csejthe. Count Nádasdy had handed him over to a shepherd called Ujváry, whence his

name. At five years of age, tiny, all misshappen and ugly, getting in everyone's way, he was already playing the part of the buffoon; and at social gatherings he used to walk on his hands, performing the dangerous double somersault and other tricks. He used to succeed in making even the gloomiest ladies laugh. But when he had reached the age of eighteen, no one laughed at him any more, for he was vicious, as dwarves often are and, like them, endowed with great strength in his arms. He loved to revenge himself in a terrible way upon those who mocked his ugliness, and it was thus that he became one of the principal figures who executed the cruel orders of his mistress. At the time of his trial he could not have been more than twenty years old. He would return limping from his expeditions, followed by two or three girls in brown and red skirts wearing necklaces of coloured pearls, and they climbed up the path as if they were going to pick wild medlars on the lowest slopes. A bird would be singing, the last they would ever hear. They entered the castle and never again issued forth from it. Soon, bled white and dead, they would go to rot beneath the flagstones of the gutter, not far from the little rose-filled garden whose flowers had been transported with such great effort from Buda.

The female acolyte who never left Erzsébet, who satisfied her every caprice without exception, who carried to her bedside drugs for illness and girls to bite, was Jó Ilona, a big strong woman of Sárvár origin who had originally come to the castle as a wet nurse and who, when those services were no longer required, remained in the service of the Countess. She was a frightful sight in the woollen hood always drawn down over her eyes, and utterly evil as well. She was often assisted by another cruel and sinister creature, Dorkó, whose ugliness even excelled that of Jó Ilona.

The Countess, perfumed and beautiful, was constantly framed by Jó Ilona and Dorkó, each one smelling as bad as the other. Counting on their ugliness, trusting in their foulness and unbelievable cruelty, Erzsébet made accomplices of these two pawers of stale blood, of squelched bones, and disembowelled beasts. In complicity with these two creatures, she allowed atavism to blossom, closed her mind to pity, and crushing whatever interior obstacle, she went ahead on her own dire course. All that belonged to the day, all that was bright and shining, was instinctively rejected.

Dorkó, whose real name was Dorottya, had originally been summoned to take charge of the servants of Anna Nádasdy at the time of her betrothal to Miklós Zrinyi, son of a family almost as ancient as the Báthorys, and famous from 1066 onwards. When Anna left to live with the Zrinyi family, Dorottya Szentes, contrary to custom, didn't go with her. Erzsébet retained her in secret, for reasons which a letter to her husband may perhaps disclose:

'...Dorkó has taught me something new: beat a small black fowl to death with a white cane. Put a drop of its blood on your enemy's person, or, if you cannot reach him, on a piece of his clothing. Then he will be unable to harm you.'

Dorkó muttered incantations which she passed on to Erzsébet. And charms too, prepared over the long months in the sombre atmosphere of Csejthe, from which place now Erzsébet seldom went abroad. Ever the same surroundings, ever the same room, and the air of magic grew thick as day by day Erzsébet grew more daring.

Meanwhile, however, Ferencz her husband was growing old in the rough life of army camps. Showered with honours, inclining more and more towards religion, he was gradually withdrawing from the world of action and spending long hours in prayer. Erzsébet made a practice of writing to the Count to give him all the household news, letters of this kind: 'My beloved husband, I am writing to you about my children. Thank God they are all well. But Orisk has something wrong with his eyes and Kato has toothache. I am well but I get headaches and have trouble with my eyes. May God keep you. I am writing from Sárvár in the month of St James (8th July) 1596.' At this time Anna was ten and Pál not yet born.

On the folded letter: 'To my most dear husband, His Excellency Nádasdy Ferencz. This letter belongs to him.'

Situated on the plain, the castle of Sárvár was boiling hot. Rocked in the arms of her nurses, Katerina was teething for the first time, and Erzsébet in the torrid Hungarian summer suffered from those same headaches to which her uncle, the King of Poland, Stephen Báthory, was subject.

Ferencz Nádasdy's health was declining. No longer did he visit Vienna, and never again would Erzsébet shine at the courtly balls. Life for her was becoming more serious. She was the wife of one of the most distinguished men in Hungary, a man upon whom the Emperor himself relied absolutely. She was the mother of four children and was approaching forty. Despite the fact that she no longer possessed that bloom which was inspired by her shining at court, she retained her beauty and was, as always, striking with her pale skin which glowed like mother-of-pearl.

No doubt she had recourse to lovers such as Ladislas Bende whose name has come down to us and who, evidently, ceased utterly to be spoken of once the affair was over. Of not one single passion did she cherish the memory. Nothing of that nature did she remember except what took place on the day when, galloping as was her custom across cultivated land with one of her admirers for escort, on the way home she caught sight of a horribly wrinkled old woman who stood by the roadside. Erzsébet burst

out laughing and said to her cavalier, 'What would you say if I were to force you to take that old hag in your arms?' He replied that it would be a frightful experience. The old woman fled in a fury, shrieking as she went, 'Countess, it won't be long before you're just like me!' Shuddering at the thought, Erzsébet returned to her castle more than ever resolved at all costs to fend off old age and ugliness.

But would herbs and charms be enough? She had summoned even more sorceresses from the forest. She did not attempt to attain that all-powerful and pure melissa from which Paracelsus had discovered the secret of perpetual youth, the resource of the great alchemists. For there were no tubes or phials filled with green elixirs or the colour of vermilion flames in those baleful recesses adjoining her bedchamber. Steeped as they were in the secret lore of black magic, her own shrews were privy to less noble secrets.

Surrounded by the grieving household at Csejthe, Ferencz Nádasdy died on the 4th of January 1604, aged forty-nine. For several days hundreds of candles burned round his coffin to allow relatives to arrive from all over the country to take part in the funeral feast. Along impassable January roads they hastened, on horseback or on sleighs, towards that desolate castle at the summit of the snow-covered rock. Over the ornately dressed corpse, his sword held between his crossed arms, the mourners were screaming devilish Carpathian lamentations. The Regös gypsies, from time immemorial adept in ancient Shaman lore, made their primitive stringed instruments vibrate, together with other instruments even more rudimentary, from which burst the ritual sounds of a lugubrious magical refrain which at the time was customary; 'my magic has ancient laws; I conjure with dirges'. They fell into a trance, and with them the women, their skirts twirling, were dancing around the dead Count, weird death dances, until they fell down exhausted like great dark flowers, exhaling the ancient wail of widowhood, of the uncertain forest, of the blighted treetrunk, of the trapped beast. Sometimes their whirling gait would carry them right into the great chamber draped in black, with its windows closed to the snowy sky. Wailing and weeping, they would rush off and throw themselves at the feet of the Countess, a slim black figure glinting white only at her face, her cuffs, and her hands.

When at last the entire family, clothed in black was met around the broiled herbs of the sinister funeral feast, the pastor of Csejthe, the faithful András Berthoni, supervised the burial of the Count.

Erzsébet remained alone in the winter night looking out over the Csejthe landscape. The rock upon which she had leaned had been taken away from

her: her great lord, whose name was echoed throughout the land, he who, despite his independence had united himself to her, his shadowy wife, was now gone.

To visitors who bowed in silence before her, her posture was rigid, her gaze unflinching; she accepted their homage, prepared already all alone to defend the castle and to take everything upon herself. January. A month most unlike the one destiny had in store for her. A January which widowhood made sinister, but vibrant nevertheless and rich in possibilities: she had her domains to rearrange; her castles had to be kept up, Csejthe and Léká both snowbound in the midst of wolf tracks; her daughter Anna was now of marriageable age and Orsolya and Katerina and Pál, the last of the Nádasdys still small and timid, seated in some far away room, his hand locked in that of his tutor, Megyery the Red.

There had been a time, when Erzsébet had gone dancing at the Court in her long scarlet dresses, when her life had been more gentle; the return to the castle, the visits of her husband, the great warrior, used to temper this extravagant woman. Now, with total power, the time of hardness had come. Presently those forty lonely years were going to assert themselves, stiffening her, like the stem of a plant becoming ligneous; within Erzsébet a dark lava was flowing from the deepest fibre of her being. She was now nothing more or less than this solitary tyrannical widow descending stone stairs to the catacombs below. From now on, everything would be judged in terms of her own wild and capricious dreams. Night entered her soul.

In Hungary, and indeed to some extent all over the country such strange and unhappy events were taking place which would have provided ample opportunity for long conversations between the chaplain and a widow. But the new pastor had enough to think about with the incidents taking place in his own parish. János Ponikenus, who had succeeded the old pastor, András Berthoni, who died at the age of eighty-five, sometimes received a command to officiate at weird nocturnal burials to which it was his duty to bring the appropriate solemnity. At other times, and always at night, he was summoned to bless a little hillock in the corner of a field, without his having the slightest idea about what or who was lying underneath. The Countess herself was never present; only two or three valets and the redoubtable Dorkó lurked in the shadows, along with another woman whose hands and skirt were spattered with earth. Despite the rumours coming from Presbourg and Vienna, at first Ponikenus did not really believe in Erzsébet's cruelty. He imagined he knew her well, and, although he found her severe, haughty, and savage, no doubt harsh with her servants…

what member of the nobility was not? She was an educated woman; and above all, she didn't interfere in parish affairs at Csejthe. Thus Ponikenus was indifferent to the stories of the Countess' doings at Vienna, to which city she would go two or three times a year, and where she was known in the inns adjoining the cathedral and those of the Weihburggasse simply as *die Blutgräfin*: the Blood Countess. There were tales of blood flowing in the streets, of the shrieks of murdered girls, and of the imprecations of monks coming from a nearby monastery.

The chaplain held stubbornly to his attitude right up to the day upon which, after frequent burials of girls dead from some unknown illness, Erzsébet ordered him to perform the solemn rites for Ilona Harczy, whose wonderful voice had delivered so well those poignant Slovak love songs. It was she too who used to sing psalms in the church and ballads in the castle. The Countess had preferred to silence the voice no one could listen to without heartbreak, and to utilise the blood of this girl to lift her off the ground and, as it were, carry her as if on a silver thread, towards the vaulted roof of the halls and the arcs of the chapel roof itself. The girl had come originally from lower Hungary. We are assured that Erzsébet tortured her in Vienna and then brought her, mutilated and wounded to death, back to Csejthe, unless indeed she returned there already a corpse in her winding sheet. Anyway, Erzsébet commanded solemn funeral rites and ordered the pastor to declare in his sermon that her death was punishment for her disobedience. This time, doubtless it had proved impossible to conceal entirely the circumstances of her death. Ponikenus refused to officiate and the burial was a very simple affair.

From this moment onwards relations between Ponikenus and Erzsébet grew more distant. 'Don't meddle in the affairs of the castle and I shall not meddle in the affairs of your church.' This was the compromise upon which the Countess decided. By custom Erzsébet used to pay the church eight golden florins a year, as well as forty hundredweight of corn and ten large jars of wine. This was not a gift, because the Countess had previously seized the parish fields and tithed them.

According to the custom, Ponikenus' predecessor had written in Latin the chronicles of Csejthe, relating events which took place, births, deaths, pleas, and rejoicings of the parish. András Berthoni, it seems, must have been aware of the incredible happenings at the castle, to which the chronicles made only a passing allusion. But he did mention having had to bury nine young girls secretly in a single night, all of whom had died in the castle under mysterious circumstances.

This was all that this chronicle destined for public record contained. After having himself had to celebrate frequent burials, however,

Ponikenus resolved to look more closely into the matter. He knew of the existence below the church of a crypt which contained the tomb of Count Christopher Országh of Giath, *judex curiae*, and counsellor to the Emperor Mathias, head of the Neustadt Committee, who had died in October 1567. Village and castle had belonged to the Count before passing into the hands of the Nádasdys. Accompanied no doubt by his faithful servant Jáno, Ponikenus descended into the tomb. The crypt was enormous and the tomb imposing. When they entered, they discovered several other coffins piled around that of the Count, these former made of plain white wood and containing the corpses of young girls, as indicated in the chronicle. The air in the crypt was unbreathable.

Erzsébet, who had always punished her servants severely nevertheless took the utmost care that her family didn't find out about her cruelty. One day a messenger arrived announcing the impending arrival of her daughter Anna Zrinyi and her husband at the little castle. Erzsébet retained by her side only the most aged and faithful servants. As for the young ones, already several times tortured, she had them conducted to the main castle on the hill (she was at this time living in the small castle) so that they would have no chance to meet the domestics of her daughter, and show their wounds and complain to them about their treatment. But, as she was irritated by the thought of not having them close to hand, she ordered that they be given nothing to eat and drink. Dorkó, as usual, executed the orders to the letter, so thoroughly indeed that the steward of the castle, who normally occupied his leisure time with astronomy, was utterly outraged, and was heard to say that the glorious castle of Csejthe had been turned into a prison for its servants. Erzsébet got rid of this meddler by sending him on leave to Varannó, to the castle of her brother István.

It was only three days later that Anna and her husband arrived, but they stayed only overnight before pushing on to Presbourg and Erzsébet accompanied them. She sent Katá to bring back the servants. Katá returned alone, assuring her mistress that in their wasted condition not one of them could move. It was Erzsébet herself who told the story to the pastor Berthoni. One of the girls died. The others transported by a subterranean passage leading into the village by the old women. The unfortunate girls were given food and drink, but it was too late for most of them after the starvation and the additional brutal treatment which they had received at the hands of Dorkó. Only three survived.

On her return from Presbourg, Erzsébet was not surprised to hear what had happened. She summoned Berthoni to her bedroom, 'Do not ask me why or how these girls died. Tonight, when the village is asleep, you will bury them secretly. Have several coffins made; and put them down

into the tombs of Országh.' And the deed was done.

But besides what he had written in the chronicle, Berthoni consigned his suspicions (or rather, certainties) to a sealed letter destined for his successor, and this he hid amongst documents concerning the parish. Ponikenus often wished to write secretly to Elias Lanyi, the superintendent at Bicse, to draw his attention to these events; but he did not dare do so, for he feared his letter would be intercepted. Conscience-stricken, he finally decided to go and make a complaint personally at Presbourg; but he was stopped near Trnava just before the frontier. Through her servants and the many other women in her pay, Erzsébet always knew what was going on in Csejthe and elsewhere. Besides Kardoska, who was the most efficient, for she would scour the roads like a drunken beggar woman, penetrating into houses and informing herself about everything, Erzsébet had employed several other women: Barnó, Horvath, Vás, Zalay, Sidó, Katché, Barsovny (who came of a better family than the others), Seleva, Kochinova, Szabó, Oëtvos. For the most part these woman were well aware of what was in store for girls recruited for the Countess' service; but they did not trouble themselves about it particularly.

In the face of so many obstacles, Ponikenus kept quiet until the trial.

Chapter Four

In England, under the rule of James I, witches were beginning to be persecuted. They had acquired far too much influence during the reign of Queen Elizabeth, who had great faith herself in magic herbs, the ears of black cats, and thunderbolt stones. But had not England since long ago been a rational country? Flagrant displays of barbarity and the more brutal vices belonged more to the Eastern stretches of Europe in those lands comparatively retarded in development which touched upon the Orient. The Hapsburgs of Germany, Austria, and Hungary had found there a rolling, humid, and unmapped territory in which people left no stone unturned in their search for whatever would safeguard power, life, and love.

By the end of the sixteenth century in Italy and France an entirely new world, at once anguished and dedicated to pleasure, was emerging. A spirit full of defiance towards morality, decency, and virtue. This movement had nothing in common with that of the beginning of the century when the Renaissance in all its magnificence was in full swing and asserted itself triumphantly with pagan force, and when even licentiousness had the purity of a rainbow. The Medicis were no strangers to lascivious ecstasies: they had given themselves up entirely to strange and effeminate practices, taking the utmost pleasure in those luxurious objects with which they surrounded themselves. Evil was done at night, it was dusk before they addressed themselves to their worst cruelties, to the coffin where one suffocated one's victim, to the silk scarf with which one strangled him. The depth of their hearts was nothing more than a shrivelled parchment covered with spidery signs written in an ink compounded of sap and blood. The air was no longer breathable. The narcissism of everyone exceeded all limits. Great public confessions and pagan rhetoric were seen no more: instead there were false avowals, hole-in-the-corner intrigues. Arms no longer knew how to open wide in welcome; they dangled the length of a black farthingale, with two hands limply hanging, snow-white, soft, tapering, clutching the bright spot of colour which was a handkerchief.

A thousand and one recipes for preserving the whiteness of the skin had their origin in France and in Italy; for women, and even many men, prized above all that pallor which contrasted startlingly with the black of their doublets, their swelling sleeves and corselets, and they prided themselves on making the white of other things seem yellow, paler than the candles of the evening, than the linen of their ruffs. This pallor had to be conserved at all costs and the wet nurses and old servants who knew all the secrets of their masters' bodies, armed with viscous leaves and muslin soaked with unguents and barley paste, made war on the races of smallpox.

Legend has it that at the end of a long banquet at which more than sixty maids-of-honour were present, everyone of them beautiful, the fiendish Countess simply locked all the doors and massacred each and every one of them while on their knees begging for mercy. Then, tearing off her furs and her velvet gown, Erzsébet Báthory plunged herself into a tub overflowing with their blood to bathe her dazzling whiteness.

What was the true role of those young girls who surrounded this Countess with her unhinged mind and her wild narcissism, her body at once rigid and tormented with lust, when, during those long absences of her husband, she prowled from castle to castle in the company of degenerates in search of some foul cruelty to commit on her return from the hunt? No moral code or religion ever had any hold on Erzsébet. Nothing hindered her on that slippery path towards pleasure which would otherwise have seemed noxious and perverse: she was always searching, looking for she knew not what, her glance bored and unsatisfied as revealed to us in her portrait, seeking and never finding.

One evening after a feast she was fascinated by the splendour of one of her female cousins. The flaming and brilliant atmosphere of the banquet and the dances, the gleaming of mirrors, possibly the ironic suggestion of Gábor Báthory, who was present, drove them towards one another. The night went on and on; they did not leave one another. What did this exercise in love reveal to Erzsébet, this affair with another like herself, a perfect riposte to her own beauty?

It is easy to discover from a man's life what his erotic tastes were and how he behaved. In the case of Gilles de Rais, for instance, all his appalling passions left a precise trace. A woman, on the contrary, continually projects around herself a nebulous zone in which she is enveloped. Or else, as with some women, they stop halfway. Catherine de Medici, for example, dressed completely in black, made her maids-of-honour strip naked before her, but she had no desire to go any further; this swarm of females was

destined to satisfy the desires, hardly gallant, but normal, of the gentlemen of the court. If Erzsébet Báthory found a flowered seam hastily stitched together, she would order her help-mates to undress the young and beautiful servants who had to sit naked in a corner of the hall while they mended the piece of embroidery, with Erzsébet looking on. Why that look?

We know that Gilles de Rais discovered his own eccentric tastes by having his valet, Henriet, read him the life of Tiberius and other Caesars from Suetonius and Tacitus. Turned into fanatics by their master, saturated in the smoke of the cremation of putrefying corpses in the huge fireplace of the Hôtel de la Suze in Nantes, impregnated during seven years by the odour of skulls preserved in salt, these servants were entirely devoted to the Marshal. The old and hideous servants of Erzsébet Báthory, without knowing her for so long, were simply aware that they had to please their mistress who protected them, and that her witches, culled from the forest and the ancient broken-down temples in the woods, were just as powerful and redoubtable as the pastor of Csejthe himself. Open up a living pigeon and place it on the Countess' forehead to calm her headache, close their eyes to everything that happened during the night in her apartment, it was all the same to them. The idea of looking for an explanation never entered their thick skulls. They were far more occupied with the violent jealousies and the precarious reconciliations downstairs in the kitchens.

Erzsébet Báthory rarely had the desire to sacrifice one of the girls of high rank who kept her company. The pallid vampire does not attack its own kind; it knows how to discern fountains far richer in blood, and makes no mistakes. These obedient young ladies with their blue blood flowing beneath the white landscape of their bodies were there for all other purposes: for dashing off to the hunt, for singing in honour of guests the terribly sad songs of Nyitra, or of their own distant country; they were there to participate in games of chess and, doubtless, contrary or according to their own wishes, for the bed.

They must have been so abashed by everything they saw that they dared not breathe a word of it. Their Hungarian hearts were not particularly soft: while they took refuge in a corner of the room, they must have got into the habit of seeing and hearing people suffer. Their own noble blood was poor; the fact protected them from being sacrificed themselves. It was because of one of them, however, that, one fine morning, Erzsébet Báthory opened the long chill list of her forfeits.

They had just finished painting her face; they had already drawn back the Countess' hair high above her brow, and were passing a hairnet of pearls over it. It was deemed necessary, in making her hair really beautiful, to drag each strand through the diamond openings of the net and then to

curl it in imitation of the rolling form of waves. Expert and well-bred young ladies were charged with this task, for Erzsébet would never have tolerated being touched by the swollen and racked fingers of servants. Erzsébet's abominable witches also sometimes performed these duties, in the same way that they were privileged in the massaging and oiling of her body. The maid-of-honour, with her tapering stick of boxwood, happened to make Erzsébet's hair puff out incongruously on one side more than the other. In the looking-glass in which she regarded herself as usual, absent-mindedly, Erzsébet was struck suddenly by the heresy. Rudely awakened from her reverie, she turned about. Her snow-white hands, long and quivering, on the slender wrists, struck at random at the face of the clumsy girl: and at once blood spurted out, staining the Countess all over her body, splashing across her arms and on to her left hand, which lay in the hollow of her peignoir. The servants rushed forward to remove the blood, but not quickly enough to prevent its congealing on those perfect arms and the slim left hand. When they had washed away the stains, Erzsébet lowered her eyes, and raising her hand, stared at it for a long time in silence. Above the bracelets, on the spot where the blood had lain for several moments, she noticed that her flesh had the translucent glow of a candle illuminated by the light of another one.

The little castle was in fact a large building near the church, set in the main street of Csejthe. It connected with the farm and the country palace: there was a courtyard with a portico, and, lower down, the stables and the domestic quarters, and underneath the ground there were cellars where, behind an enormous vat which was never shifted, a subterranean passage led to the castle on the hill.

Erzsébet had her private apartments in the most quiet corner of the building. Two of the windows gave on to the street, where the villagers went to and fro in pursuit of their daily tasks. The heavy wooden shutters were kept closed day and night. Very little light filtered through the heavy aksamit drapes, a thick damask; on the walls and on the floor, oriental carpets; and on the table burned a silver lamp, its wick drenched in perfumed oil. A hidden cupboard had been hollowed out in one wall, and Erzsébet's jewels were locked up, together with a precious Bible manuscript of Stephen Báthory dating back to 1416, in this recess. The entire atmosphere of this room, in which Erzsébet was always to be found, was oppressive. Following the advice of Katá, the least abominable of her servants, she had decided that, despite her widowhood, she would not wear black; and she seldom did so. The provincial costume of Miawa was more flattering to her figure; at Csejthe itself she wore it always, but in the

chamber of the little castle she would try on more than fifteen dresses a day. She spent innumerable hours closeted alone, naked, her long hair hanging loose, and leaning on her elbows in front of the looking glass, with its frame shaped like a figure of eight. She would hold up her arms to examine the first wrinkles in her flesh, the first signs of flabbiness in her breasts, repeating to herself, 'I do not wish to grow old; I have followed the counsel of people, of books: I have used plants. In May I have rolled at dawn in the dew.' She was thinking about what she had read and about the advice of the sorceress; blood, the blood of girls and virgins, the mysterious fluid in which the alchemists had once thought to discover the secret of gold.

Meanwhile, Dorkó, Jó Ilona, and Katá would be quarrelling. They could scarcely abide one another and were reconciled only in order to combine more effectively in satisfying the caprices of their mistress. They were always stirring up intrigues and they used to take every possible opportunity of exacting some kind of reward from their mistress. Already, Jó Ilona's daughter had had a marriage gift of fourteen skirts and a hundred golden crowns. The other servants didn't have marriageable daughters, but they too were greedy for money. All day around Erzsébet there was a great coming and going of young dressmakers carrying in silent procession, as if there had been a corpse in the house, dresses of crimson silk ornamented with pearls.

It was frequently on account of these dresses that things began to happen: Dorkó, noticing the anxiety of her mistress, would lower her gaze, purse her lips, and find some fault in a hem. She would demand to know who it was among the apprehensive group of servants who had been using string to sew with instead of thread. The dull eyes of the Countess would come to life. As no one would answer, Dorkó used to single out two or three, sending the rest away, and then she would begin to provide her sumptuously attired mistress with a little distraction. First of all, she would cut open the skin between the girls' fingers to punish them for their awkwardness; then, once she had got going, she would strip them naked entirely and begin to stick pins into the nipples of their breasts. This would sometimes continue for hours, and, in the end, there would be pools of blood at the foot of the bed. The following day, two or three sempstresses would be missing.

Dorkó was the most cruel of all the servants, hardened and brutal; when it came to thinking up new tortures she united a diabolical imagination with an endless inventiveness. After spending several hours in the contemplation of the most refined, and sometimes also the most erotic cruelties born of Dorkó's fertile brain, Erzsébet used to display signs of great generosity.

When at Csejthe the Countess would rise early, according to the tradition of the Nádasdys and the Báthorys, and give instructions to her domestics. All the cleaning had to be finished before ten AM. After that, she would set off to visit her farm, mounted on her favourite thoroughbred horse, Vinar. 'The one of good breed' with his glossy black coat, who knew his mistress well and to whom she spoke with great gentleness. This horse was so handsome that once, on the occasion of a hunting party, Christofer Erdodi, son of Count Tomás Erdodi, had offered her several villages in exchange for him. But Erzsébet had refused him.

Turóczi Lazló, the Jesuit who more than a century later wrote of Erzsébet Báthory, said 'she was vain'. And, 'her greatest sin was the wish to be beautiful'. This he noted in his attempt to return to the real source of the Csejthe drama. For Csejthe during the course of that hundred years had changed very little. The earthenware pot which had received the blood of the young and healthy peasant girls still lay in some corner of the cellar. The ghost of the Bloody Countess, of the Beast, of the great wanton, still wandered at night amongst the ruins. Father Turóczi dared say nothing about sorcery: for that would have been a reflection upon the Church itself, which had taken great pains not to be involved in the affair. Protestant or Catholic, for the witch the stake and the fire awaited, and the only death suitable for Erzsébet Báthory would be to have her beautiful head cut off. Besides, she herself would never have recognised that such punishment was lawful. Had she not taken for herself the great rights of the eagle and the wolf? She was, the Jesuit father continued, 'proud and haughty, thinking only of herself'. In other words, she was entirely introverted and a complete megalomaniac.

Sorcery for her had only one aim: the preservation of herself in every pore. Preserve herself from old age, for she was one of those beings who furiously, almost gratuitously, desire to keep always their sombre perfection; to protect herself against such obstacles as enemies placed in the way of her indefatigable 'crusade' into the uncharitable void of nothingness. Thus protected, she could deny life and destroy it, for the sake of that denial and no more.

The Countess did not know how to analyse the causes of her sinister impulses. They forced themselves on her, and, as they were there for the taking, she took to herself the right to seize them. And if, in her more lucid moments, she came to doubt that right, she always returned to the convenient incantation written by a witch on the 'caul' of a newborn child of the village which a midwife in her pay had sold to her. Written into the shrivelled skin, blackened by all manner of plants of evil omen, the

prayer to the earth and its dark powers unfolded in wavering lines. It had been inscribed with a juice extracted from moles, hoopoes, and hemlock found in the neighbouring fields, drafted in a dialect spoken in these mountains, a mixture of ancient Czech and Serbian:

'Isten, give me help: and ye also, O all powerful cloud! Protect me, Erzsébet, and grant me a long life. I am in peril, O cloud! Send me ninety cats, for thou are the supreme Lord of cats. Give them thy orders and tell them, wherever they may be, to assemble together, to come from the mountains, from the waters, from the rivers, from the rainwater on the roofs, and from the oceans. Tell them to come to me. And to hasten to bite the heart of… and also of… and of… Let them rip to pieces and bite again and again the heart of Megyery the Red. And guard Erzsébet from all evil.'

The blank spaces were left to be filled in at the appropriate moment in a special kind of ink possessing the necessary power with the names of the people whose hearts she wished to have rended. Megyery alone was condemned in advance, red-haired Megyery, the tutor of her son Pál, whom she hated because he was the only living creature she feared, the one who knew everything about her, and who was biding his time.

And right at the bottom of the incantation, clearly separated from the rest, was written: 'O holy Trinity, protect me.' But what Trinity was she invoking here?

It was a Trinity of obscure powers borne along by blood, it was the Black Woman of the world, the vital energy which spilt blood restored, free of all restraint. This Trinity is feminine, while the devil is always of dubious sex, a hermaphrodite as he is represented in the old tarot.

And this force, the mother of all phenomena, is meanwhile eternally a virgin since, like the great Moon, it exists only by reflection.

But, was it then necessary to condemn absolutely the gentle sunlight, the aroma of the flower; was it necessary to silence the blood which poured out the long song of Spring, to sacrifice the clarity of the day to the night and, for the sake of nothingness, to abolish the perfume of a rose in the hedge?

It was precisely this which Erzsébet Báthory did; was Erzsébet, therefore, not unjustly called the Beast of Csejthe? This pallid, over-refined, and depraved woman could no longer be a beast. Going to the utmost limits, she had strayed far away beyond the ordinary levels of humanity, but not to fall beneath it. The only thing which mattered to her, wrapped in her trance, a stranger even to herself, was the blood of others which she watched as it spilled. She had remained at the stage of the witches. She lived in a world made up of the nerves, of the livers torn from little animals, of the roots of deadly nightshade and mandragora, heaped up

on the table, and handled by Darvulia, the witch of the forest. But of that other side of the river, there where she had so often forced others to go, of that she knew nothing. She had never knowingly crossed over herself. A thin veil separated her from it; and her terrible cruelty was unable to penetrate the veil and rend it from top to bottom. Each time a strange joy descended upon her; her forces were spent; and an overwhelming lassitude left her nothing but the obscure certainty that it was necessary to begin all over again.

The Achæan priestess of Earth in the Temple of Aegira had to drink a cup of blood from a newly-sacrificed bull before descending into the crypt where, attuned by blood with the Kingdom of Shades, she began to prophesy. It was a sacred act. The Druidess, stabbing the courageous warrior stretched out on a slab of stone within a circle of oak trees covered with mistletoe, was also carrying out a sacred act. The pre-Columbian civilisation of the Indians, based on cruelty, was no less ritualistic. Erzsébet Báthory had only to repeat such acts with an equal piety and rigour. Unlike Gilles de Rais, her only merit was her refusal to compromise with any religion whatsoever, except that of the spirit of all things.

Gilles de Rais, by means of elaborate ceremonies, the organ murmuring in the chapel and the angelic voices of children in his power, tried to make contact with the holy universe so remote from the realm of his orgies, in order that the latter might prove more agreeable to the senses. But the two parallel worlds of Lust and the Divine have for all eternity been forbidden to unite.

Erzsébet's one anxiety was her concern that her 'cattle sheds' should always be full, and that her messengers should ceaselessly scour the mountain paths for prey as far as the villages of upper Hungary. One day a girl whose beauty had been highly praised was made to come from far away, from a village on the other side of Eger, near the great Carpathians, where vampires dwelled and where witches peopled the sides with clouds, and sometimes even with swans. The interplay of mirrors from castle to castle signalled her approach. Her journey lasted one month; and, whereas other girls waited their turn for a long time in the subterranean cellars of Csejthe, this girl was sacrificed on the very night of her arrival.

Chapter Five

There is in Vienna a house full of animals' horns. It is situated in one of the most ancient streets of the town, in the narrow Schulerstrassse, which descends to the bastion of the Dominicans and then, at the bridge, spans an arm of the Danube, which from time immemorial has encircled the north and east of the city of Vienna.

Behind this strange dwelling place, a sort of fortress pierced with hundreds of little doors, and almost crowding on top of it a mass of lofty houses jostling one against the other, with walls two or three metres thick and coats of arms recalling the distant past of the city. This place with its buttresses of grey stone, its lofty cornerstones, torn out and dumped here and there against the walls (some of them dating back to Roman times), its lopped iron gratings, its square flagstones, and its ditch running through the middle, a chill shadow out of the past, is the Blutgasse, or 'Blood Alley'. The whole of one side of this house with saturnian horns is steeped in a dense atmosphere of passion, murder, and phantoms. Trap doors and staircases open on to the courtyards; a lamp burns before an altar which still bears the cross of Malta, a lamp made for protection against witchcraft with a flower motif and an image of the Virgin Mary at the bottom. But the seven cold courtyards surrounded by stone staircases and cloister-like vaulted corridors seem immune to all regret for the horrors they have witnessed.

Before Erzsébet Báthory came there, the house with the horns had been a church benefice, the court and sanctuary of the powerful order of the Knights Templar. In the subterranean chambers the lids of sarcophagi, with Maltese crosses and the vertical pillar carved into the stone are still there, surmounted by the effigy of the founder of the order: the Templar Cross, which is neither anchored nor hooked, but is derived from the Ophidian cross. In these ancient designs, each branch of the cross separates into two serpent heads in profile, their tongues darting out of their mouths.

It seems that the Templars made war on all that was binary, dual,

or feminine, for the sake of the masculine and the unique symbolised by the Pillar. The eight serpents were the image of matter doubly convoluted, positive and negative.

In those crypts without echo which had been the catacomb of the old cathedral of St Stephen, far from the material world which, like the Cathars, they condemned, sat the Austrian Templars, keeping their extravagant secrets. They were not obliged to confess their faults to anyone except the superiors of the order itself: outside, nothing was disclosed. In France, Philippe le Bel (whom the Germans called Phillip the Scornful) had burnt the dignitaries and dissolved the Order. In Germany, under the reign of Frederick III the Fair, the grand Master of the Order was Wildgraf Hugo, who lived in Vienna. Fahnrischshof, in the shadow of the cathedral, was their stronghouse, with its foundations of gigantic stone and its caves and subterranean holds sunk deep into the soil of the catacomb. All the neighbouring houses belonged to them. These were in particular used as their choir schools. The Templars filed through the cemetery around the church between the tombs, their great white cloaks with the red cross fluttering. When he heard the news of the trial and torture of the grand Master of the Order in France, Wildgraf Hugo made all the Knights Templar leave Vienna; they rode night and day until they reached Eggenburg. They were captured by trickery: a church council was convoked and the Knights Templar were ordered to return to Vienna under the assurance that they would be unharmed. They had scarcely entered the town when the gates were closed. They entrenched themselves in their great house; they were trapped in the courtyards and subterranean passages whose every exit was guarded and were then massacred with blows of the *Morgensterne*, those fearful maces shaped like stars. An iniquitous tribunal, itself guilty of the worst disorders, judged them. It was said that some of them were given over to the embrace of the 'Iron Virgin', a sort of wooden mummy case in the shape of a woman and studded on the inside with sharpened spikes which met by piercing the body of the imprisoned victim. The chronicle relates that in memory of the blood of the Templars, of the blood which splashed over their cloaks and trickled the length of the slope that descends the Singerstrasse, the sinister alley became known as the Blutgasse (Blood Alley).

To re-Christianise the area in which pagan cults imported from Asia had undoubtedly been celebrated, a column called the Column of St John had been erected above the tainted cellars on the site of the house of the Templars. For, according to law, the Knights Templar had given over all their wealth and possessions to the order of St John of Jerusalem. It was there, in this horrible, chilling setting – and certainly not by chance –

Erzsébet Báthory decided to settle for a while before she came into possession of a more beautiful and decidedly less haunted house near the Imperial Palace. And thus the woman whose red and silver coat of arms was encircled by the Dacian dragon, the ancient emblem of warriors who scorned womankind, took up house in Vienna in the selfsame street as the Knights Templar, whose emblem was the serpent. The chronicle in fact assures us, 'And very early in the morning the people passing by in the Blutgasse used to say to one another, "Someone else had been quaffed last night!"' Now, there were no slaughterhouses in this district; there were only the vaulted cellars of The House of the Hungarians, of one of the 'houses of the Hungarians' of Vienna. This particular house may very well have been that which belonged to the Emperor Ferdinand in 1547.

From time immemorial, the area behind the cathedral had been Hungarian. The Magyar nobles had their houses there, dark, vaulted, with chambers below ground level, and cellars used for their interminable banquets at which there was so much drinking and merrymaking. These houses, unlike those belonging to Austrians, were decorated in a barbarian style. Enormous animal horns covered the walls; over and above the ill-omened horn, stuffed animals, crows as big as children, giant owls, and a kind of heather cock from the Tatras, huge and bearded, were perched in the ledges; on the first floor, rambling verandahs encircled the ancient courtyard.

An uneasiness still persists in all these stones. Hungarian nobles still own dark houses in the quarter, a settlement particularly barbaric in appearance. Facing the cellar doors, behind the house itself, is that sloping grey alley between lofty houses: Blutgasse. It was to these cellars with their Gothic arches that Erzsébet's gloomy stars led her when she came to Vienna to the court of the emperors. Her dust-covered carriage would enter by the Stubenthür gate, by the bastion of the Dominicans, and would go up the Schulerstrasse. As into a cavern where sunlight seldom filters, Erzsébet, like some dark spider, moved into her element. The lustful excesses, the equivocal cults, and the murders, were as thick as the very stones. Out of the vehicle her servants would take all the celebrated objects of torture, which were preserved until very recently in Pistyán: the irons to be reddened in the fire, the needles, the awls, and the fearful cutting pincers of silver. The memory of the Iron Virgin still clung to the basements of the house. Perhaps it was there that Erzsébet had the inspiration to construct a cage furnished with sharp points where she was later to immure this or that young serving wench.

In the castle at Forchtenstein on the Austro-Hungarian frontier, there is a kind of lantern, workable during the day, which is finished at the

top by a delicate bouquet of curved iron stalks. An iron collar, also rather elegant, encircles the base. Without any doubt, there was space enough inside this lantern for the head of a living person, and at the place where the mouth would come can be seen a complex structure of bars and metal plaques. On the walls of the cellar underneath the house, a whole arsenal of arms for massacring people, dating back to this time, still hangs today.

Returning from Vienna Erzsébet would sometimes stop for a visit or to attend a banquet at this ancient castle, which belonged to the Esterhazys.

At Castle Forchtenstein among other portraits, there is apparently one of a very beautiful and very cruel Countess who in ancient times came down from the Carpathians on her way to Vienna, or to Forchtenstein itself. The halls are large and square, the windows are perched high up in the sky overlooking the countryside. Except for a few chests and a dusty bed surrounded by grey-blue tapestries, there is no furniture. The floors are like those of a grange. Above the castle, sparrow-hawks wheel unceasingly.

On the walls of these great rooms, of which a dozen are still standing, are hung portrait paintings, most of them life-size. They are of Hungarians of illustrious families, and of their wives. Smaller, and more slender in figure than the others, her temples clasped by an orange headband which allows us to see that she has russet hair, Erzsébet Báthory's mother-in-law stands before us: Orsolya Kanizsáy. She had a beautiful face, though its pallor testifies to poor health. Of all the personages there, she is the only one whose appearance gives the impression of kindness. The other princesses in their severity seem haughty and vain, if not stupid. Only one is dressed like Erzsébet Báthory: the same garnet red dress, the same high hairnet, the same broad white sleeves nipped in at the wrist with little cuffs of gold. Only the manner in which the broad band of pearls falls from the neck to the belt is different.

The Báthory portraits are in a hall reserved for the Palatines: István is there, then Sigismund, very ugly, with a beard, then beardless and with the end of his nose deformed and drooping; György Thurzó, the Palatine cousin of Erzsébet; his wife, Erzsébet Czóbor; Gábor Báthory, with regular features, a kind of very handsome Bluebeard whom no woman could resist (and perhaps, it is said, not even his cousin Erzsébet Báthory) and who was nicknamed 'the Nero of the Siebenburgs'. He was Prince of Transylvania, married Anna Palochaj, who became his widow after his death in 1613, a man who conducted himself most outrageously throughout the entire course of his career.

From this series of portraits the Báthorys emerge like emanations

of madness.

In one corner near a window, on a canvas rather smaller than the others, there is a strange conglomeration of bent heads, of backs clothed in velvet and sombrely coloured materials slashed by the white of the sleeves. Face on, utterly lopsided, there is a dais festooned with crimson, and under the dais a king or a prince in red. A broad corner of the table is visible and, on the tablecloth, several round loaves of bread and one or two spoons. From amongst the female figures a wan profile emerges, the skin so pale one might have believed it to be steeped in so much white lead. A nose, badly drawn by the painter, nevertheless brings to mind the slightly drooping curve at the tip characteristic of the Báthorys, and of Erzsébet in particular. It can only be she, with that air so haunted, so cruel, and so absent...

The portraits are badly painted; often the same travelling artist would do the portraits of a whole generation. Chalky colours, the poses stiff and always identical, the left hand hanging between the folds of the skirt, the right spread upon the table. In the latest canvasses, one or two little dogs, with a resigned air, are seated on the folds of their mistresses' skirts...

In this typically Hungarian castle, one realises the importance of the washhouse, a washhouse identical to those which Erzsébet transformed into torture chambers. It consisted of a vaulted hall with an enormous trough which was to be filled with water and a drain. A massive stone fireplace, as broad as a house, sheltered all kinds of hooks, pothangers, and iron rods.

The washhouse was an out-of-the-way place, secret, with its own fire and water. From its door, under the interior rampart, a gully descended to the drains, which were protected by a kind of penthouse and bearing a machine of wood with a treetrunk for a winch. Thirty years had been spent in hollowing out these drains from the precipitous rock, and four hundred Turkish prisoners had died during its creation. Around the washhouse were some cells, probably those used by the domestics of the house. In similar tiny rooms at Csejthe, Dorkó and Jó Ilona kept the girls in groups of six or eight, or even larger numbers, all ready to satisfy the caprices of Erzsébet at moments of crisis. During one particular week it was necessary to sacrifice five servants, one after the other, for Erzsébet.

At this epoch, on the other side of Vienna, on the way to the convent of the Augustinians, Maximillian and then Rudolph II made improvements to the old palace, which one entered by a red, black and gold door; the arch above it was ornamented by the most ancient coat of arms in Europe: silver fesse

on a field of gules, surrounded by other escutcheons bearing animal shapes and crosses.

King Mathias Corvin had acquired a strip of land adjoining the cloister of the monks of St Dorothy, which he used for housing his Hungarian nobles when they came to Vienna. He caused a street to be built through it, which was called the Ungarngasse (today, Plankengasse). That was in 1457. Close by, near a wasteland where pork and charcoal were sold, stood a large house which in 1313 belonged to Harnish, or Harnash; it was called the Old Harnish House. When Mathias Corvin had the quarter built, it became known as the 'House of the Witnesses'. In 1441, Count Albrecht IV had used it as a powder magazine, and in 1531, after it had passed through the hands of various proprietors, it became the property of the Emperor Maximillian and took the name of 'House of Hungary'.

It is situated at number 12, Augustiner Strasse, at the corner of Dorotheengasse, facing the Augustinian convent, whose long façade prolongs the Imperial Palace. It was this house which Erzsébet and Ferencz Nádasdy in the last years of the sixteenth century (it is impossible to know the precise date of the acquisition), used during their sojourns at the Viennese court. The transaction was long and difficult. It was a large house and not a palace, certainly modified and embellished towards the second half of the sixteenth century. The foundations of this house were, however, very ancient; it was necessary to go down four or five storeys to reach the rooms below ground level, with their pointed Gothic arches. It had a courtyard in the centre. The house backed on to another large house which has since become the Lobkowitz Palace, while on the east side it gave on to a muddy wasteland where, during certain days of the year, the cattle and charcoal market took place. In snowy or muddy weather the ground was covered with tracks of slaves which led to the palace. The Augustinian Monastery, established in 1330 ran along the whole length of this. The monastery church was tiny and its façade near the rampart was low. The convent proper, where the monks' cells were located, was built higher and was more important looking, situated more or less directly opposite the Nádasdy house where, at the present time, the large church renovated in 1642 rises into the sky. The left wing of the convent was also renovated at this time and served henceforth as a lodging house. Facing it, on the other side of the street, still narrow at this time, were the rooms of Erzsébet.

The quarter was deserted. Not far away lay the Imperial Palace, enfolding within its walls the sombre chapel of the Hapsburgs, with its splendid choral services and the magical treasures of Rudolph II. Beyond that was the southern bastion, then more open space.

It was to this place that Erzsébet, still beautiful at forty years of age, came with her husband Ferencz; and, after 1604, it was here that the widow arrived from her castle at Csejthe. Red dresses, black dresses, jewels gleamed by the light of torches on the stone staircase which mounts with three landings to the first floor. Narrow and low was the door into her room; there she was made up before being conveyed to the palace, there in the lustre of faded halls, magnificently decorated in barbaric and uneven luxury.

In those nights of snow and mud the spirits of the elements were still virulent; hardy and superstitious were the people whose sledges bore them through darkness, through a darkness pierced by torchlight right up to the scintillating halls of honour in the palace itself. Magic and lechery are closely related: so it is hardly surprising that Erzsébet, returning from the glow of the myriad lights of the palace to her household, crowded with servants, should have felt the urgent desire to find joy in the path of sin. And from her room issued the screams of those young serving wenches, awakening the monks opposite, when they were not muffled within the cellars whose staircases opened on to the central courtyard. On the following day, Jó Ilona and Dorkó would draw out buckets of bloody water into the alley.

At the subsequent trial, the replies of the servants revealed in the cruellest detail what went on in this house. To the question, 'How were the victims tortured?' Ficzkó replied, 'You could see they were as black as charcoal because of the blood which had coagulated on their bodies. There were always four or five naked girls, and boys binding up faggots in the courtyard saw the state they were in.'

After the Count's death the Countess used to burn their cheeks, breasts and other parts of their bodies almost at random, with a poker. Perhaps the most horrible thing she did from time to time was to pull their mouths open so violently with her fingers that the corners split open. She stuck needles underneath their nails, saying, 'the little slut – if it hurts, she's only got to take them out herself!' One day, because her shoes had been badly shod, she called for a burning iron, and herself ironed the sole of the guilty servant's foot, saying, 'There now, you've also got some shoes with pretty red soles!'

It was in this same house that it was found necessary to sprinkle the floor of her bedroom with cinders, for the puddles of blood there were so broad that she was unable to step across them on her way to bed.

In the vicinity of the town proper, in the precincts of the most ancient church in Vienna, St Ruprecht's, whose sad little belfry is lit up by

the light of the setting sun, there were plenty of things to attract Erzsébet. That was still the Jewish quarter. Mandragora was always to be found there, and those same fossilised fish teeth of a jade colour which were so much sought after at that time. All round the ancient synagogue, too, were to be found young Jewish girls. Jó Ilona managed to persuade some of them to enter the Countess' service. One day, an old woman even brought along a twelve-year-old Jewish girl whom she had found wandering about the town. Those shops in which plants, magic stones, and stuffed animals were sold, were hidden away around the Juden Platz, and Erzsébet's litter would often appear between those ancient houses hung with coats of arms. She would come, a dark and glittering figure, personally to choose amulets of quartz and wolf's teeth, or minerals marked by nature herself.

It was here Erzsébet's servants would come to search the quarter, their sharp eyes open for the sight of some unoccupied peasant girl who might be persuaded to follow them.

Chapter Six

Jacob Boehme, at the beginning of his book *De Signatura Rerum*, writes that before anything existed, there was the 'great black wrath trying to give itself form', without the knowledge of how to do it. By means of its quality of astringency, which sought to 'congeal', wrath was able to provide a nucleus in-and-for-itself. It is in this gyration, in the storms of the first will, as yet unconscious, that spirits lose their youthful vigour; those of the permeable air, those of fire, which is the ferment of wrath itself, those of water, which once quieted used to fall back upon matters at last in concrete form, and inhabited by those solid spirits of earth and the mineral kingdom.

All had their own names and still have: winged names for the fairies of the air, liquid names for the water-sprites, traced in the form of one of those patterns the footprints of birds make on sandy paths and the lines drawn by the spikes of the hedgehog.

One still has the vague notion that Saturn is gloomy and austere, Mars warlike, Venus soft. The planets and the gods, however, seem to have lost all link with their great archetypes. During the sixteenth century, the Emperor Rudolph and his alchemists, Erzsébet Báthory and many others, continued to live in this primitive and forbidden whirlwind. For this is, indeed, what we call chaos, that abyss filled with darkness and abortive light, rumblings of thunder and traces of the first sound. It is here that Satan, firstborn of the virgin Lileth, wheels about. Darkness preceded the light, and hell, heaven. And if man wishes to understand the heart of things, he must dare to lean over and gaze into this very abyss.

Female cults of all times have their origins here; from here also male sects spring up to combat them, wanting to ignore the second principle, negative and dangerous; from here sprouts up all fantastic eroticism, all witches and wizards are erotic. All force issues from the primordial Eros.

Prague, where the Emperor Rudolph II of Hapsburg lived, was the multi-coloured refuge of Cabalists, astrologers and mystics. The

Bohemians had brought the most ancient of sciences there, come from none knows where exactly. Vampirism, occultism, alchemy, necromancy, tarot cards, and, above all, ancient black magic, were the fruits of this city of narrow streets which was surrounded by forests. It was here that pedlars came to replenish their stocks of little books with their irregularly printed characters, their pages ornamented with woodcuts portraying devils holding their tail under their arm and looking askance at those who had conjured them up. Books with the various signatures of the minor demons were also to be found here, the manner of drawing the double circles of magic and the sketch of the *'Main de gloire'* holding a candle made from the grease of a hanged man, permitting the thief to illuminate his surroundings while he himself remained invisible.

At the Court of Rudolph II, Bezoars and adder tongues credences were placed on the sideboard and a whole ceremonial was gone through at the appearance of each new dish, of each new drink. The great grey mass of the Bezoar, hanging at the end of its chain, was lowered right above the dish until it almost touched it. If the food were poisoned, the animal stone would change colour.

Bezoars, the imperial *Magensteine*, which provided for those who drank out of them a guarantee against poisoning, are curious greyish coagulations, made up of concentric layers rather similar to bright slate. Rudolph II sent his emissaries to look for them far away in the Orient, where the most effective ones were to be found. Jews sold these stones at Vienna and Prague, swearing blind they were of oriental origin; while, in fact, they were often from the west, like the fawn-coloured Bezoar found in the belly of the chamois. Perhaps the most sought after of all was that obtained from the spice-pig of India.

'Adder tongues credences' resemble bouquets of flowers mounted on golden stems, like those bunches of artificial flowers sometimes to be seen at either side of the altar in country churches; each stem is terminated by an indefinable object: a sort of greenish horn with its edges cut into fine sawteeth, an arrow point in polished flint. But it is still harder than flint and of a tint more subtle than that of Chinese willow green. Its colour would change when this solid substance was brought in contact with a dish into which poison had been introduced. Put above children's cots, they protected the infants from fear. From time immemorial such fossil teeth, known by the name of 'ichthyoglosses', gloss stones, and 'ichthyodontes', were considered magical stones. But people really were persuaded that these strange objects were the petrified tongues of snakes, fitted by their very nature to reveal the presence of poison. No important personage would have touched food or drink without going through the

ceremony of the 'touchstone'.

Undoubtedly, one of these serpents' tongues, pearl-grey blending into green, was to be found hanging with all the other amulets on the bosom of the superstitious Erzsébet Báthory. What poisoned beverage would fill a goblet sculpted from the horn of a unicorn without growing muddy or disintegrating? The unicorn was such a tractable animal that it could even warn its master in the dumb language of things. There were so many other stones, at present forgotten, space doesn't permit one to cite more than one or two of them: like the 'stag's cross', for example, a cruciform bone sometimes to be found in the heart of a stag, and the 'cross stone', yellowish in colour, marked in black with the sign of the cross, which comes from Compostelle. On the advice of his doctor, Maximillian II, conforming to the exigencies of time and the stars, ordered a long search to be made for a toadstone. The principal remedy against the plague employed by the Medici was to sprinkle themselves with the powder of a crushed toadstone. The particular stone Maximillian II was looking for was a 'lapis-bufonites', or borax, a kind of solid knob which forms inside the head of a toad. It is hollow and livid brown or white or black or green or, best of all, striped. It is also to be found under the animal's shoulder in the hollow formed by the joint. It was worn as protection against plague and also against the bites of venomous beasts, itself being made of venom.

Artists added a whole symbolic fauna to those minerals with special powers and these were equally dear to magic: snakes, dragons bearing cups of green jade, sphinxes and unicorns encircling goblets of lapis lazuli with trails of powdered gold, griffons rising up out of goblets of rock crystal. All this provided protection against danger and illness. To drink out of a cup of veined wood, hard, and as finely turned as porcelain, all over anastomosed with darker spots, like the skins of wild beasts, assured one of increased force and vitality. The same went for certain cut glass with thick crystal-like facets, ruby-coloured and encircled by a border of gold against which the lips were placed; and for those enormous drinking horns, too, made from the horns of wild aurochs and mounted on a base representing a serpent of horrible aspect devouring a babe. In all the ancient halls of the palace, under the dazzling colours of the coats of arms of the Dukes of Burgundy, predecessors of the Hapsburgs, magic lurked at the heart of all these objects, immobile, like a crouching animal.

Great significance was also attached to so-called 'noble stones', those stones of which Jacob Boehme has written: 'Let us now consider the highest *arcanum*: that of celestial essence, and the gems and metals of which it is the principal. Precious stones originate in the flash of lightning which

separates life and death, in the great salt nitric crack, at that moment when by virtue of this crack it congeals; that is why they have such great virtues'. There were nine noble stones: sapphire, amethyst, diamond, hyacinth, topaz, ruby, emerald, turquoise and salmordine.

According to the time of day, they have different 'voices'. Undoubtedly the strangest is salmordine found in the Ligurian Sea: whitish, pinkish, milky, veined with red. Its variants are also to be found in Anatolia. The most beautiful have blobs within them which resemble drops of blood. It is this stone which the Anatolians will never touch because good and evil are said to be mingled in it.

Ranging equally with the diamond and the sapphire, the mysterious meerschaum, was also known in ancient times as *Alcyonium*. Light necklaces of them were worn, of a pure and cold white, but soft to the touch. Others were grey, worked into rough little clusters, the colour of clouds heavy with rain. Still another variety was matt black.

It was also called *Milesium*, from the name of the city which provided most of it, Miletus, in Asia Minor. For a considerable time it had been coming to Vienna from the coasts of Asia. Borne up on the waves like a sort of porous earth spawned by the sea, it was then sun dried. Its properties, although disputed, were various. Thus it was the practice to distinguish between five kinds of salmordine: the first, white, and in powder form, was recommended for removing spots from the face; when drunk it would dissolve kidney stones; then the true Milesium, burnt and mixed with wine, caused the hair to grow; the black bitter to the taste, if mixed with salt would cure toothache.

But the magic variety *par excellence*, the kind which was equal to the other noble stones, was salmordine with drops of 'blood' in it, the kind which the Anatolians didn't dare to wear, but which the Hungarian women sought after to add to their other talismans.

Saxon magic and charms dating back to the middle of the tenth century were contained in the 'Laece Book'; its incantations and its long poem on herbs had secretly penetrated into Germany, Finland, and particularly into Hungary. In the eleventh century another book of the same kind was written: the *Lacnunga*. It contains the most ancient empirical prescriptions of the occidental world, the works of Albertus Magnus and all books of magic are derived from it, as well as the science of the doctors of the Medici and the performers of the Valois. It is the book of the first breath of nature. Here is the extraordinary 'Incantation to the Nine Herbs':

Do you remember, Armoise, what you made known,
What you contrived at the great Proclamation
You were called Una, the most ancient of herbs,
You have power against three and against thirty
You have power against poison and against infection
You have power against the hated enemy stalking through our countryside.
And you Plantain, Mother of Herbs...
Do you remember, Camomile, what you made known
What you accomplished at Alorford...

These nine have a power against nine poisons.
A snake comes rearing up and kills nothing
For Wotan [or Isten] took nine stems of glory
And he killed the serpent which split into nine pieces.
Since then the nine herbs have had power against the nine evil spirits,
Against the nine poisons and the nine infections
Against the red poison, against the disgusting poison,
Against the white poison, against the purple poison,
Against yellow poison, against green poison,
Against black poison, against blue poison,
Against brown poison, against crimson poison,
Against the prick of the serpent, against swelling by water,
Against the thorn and that of the thistle,
Against swelling from ice and against that from poison.

If a poison comes from the East
Or from the North or West amongst us
I alone know of a running brook
And the nine vipers who know it also.
Let the herbs push up their roots
Then the seas divide and salt water yields
When I blow this poison from you.

Times were changing, even in Hungary. The countryside was harsh and black with its pine trees emerging from under the winter snow. Harsh too were the laws, especially to the peasants who belonged to their lords in much the same way as the trees did. And yet the paintings which have come down to us, done within the household, painted by Italian or Flemish artists resident there, depict a people full of smiles or in abandoned poses: their eyes seem to open with uncommon interest on the world, the hairstyles were according to the fashion of that day, which left the hair freer: sleeves

of flowing linen, however, remained rigorously Hungarian. Life was bursting forth. When he retired to Bohemia, the Emperor Rudolph carried with him memories of the stiff ruffs and black doublets of the Escurial family circle. The Emperor lived there, reconciled to the last years of the sixteenth century – years in which darkness had been more fertile than light. He inhabited the lofty palace of the Hradshin whose walks were bordered by the first chestnuts brought from the Bosphorus, and by roses which also originated there a long time before. He was obliged to put up with the company of his clumsy nephew by marriage, Sigismund Báthory, whose latest escapade had been his flight to Poland, a young man who had ended up making the decision, perhaps the first in his life, never again to bring public attention upon himself. His Uncle András, to whom, in a capricious moment, he had ceded his crown, was found assassinated on the edge of a precipice in the Carpathians. Sometimes Erzsébet their relative would still have her massive Hungarian coach harnessed to go and attend some grand marriage to which she was invited because of her rank, if not because of the good will of her relatives; or else to go to her Viennese dwelling, the solitary and cold palace of Augustinergasse.

Anna, the eldest of her daughters had been married five months after the death of her father, in 1604, to the noble Miklós Zrinyi, who was mortally afraid of his mother-in-law. Another of her daughters, her favourite, Katerina, had become engaged to a lord descended from one of those French families which remained in Hungary following the fortunes of war. He was called Georges Druget (or Drughet) de Hommona, and he was the only one, when the end came, who out of love for his wife, showed any pity towards Erzsébet.

Erzsébet would arrive in spring or in the early autumn, when the roads had become once more, or were still, passable. The coach passed Sárvár without stopping. Erzsébet tended to avoid this castle where as a child she had spent those years with Orsolya Nádasdy; for her most persistent enemy was residing there, along with Pál Nádasdy, whom he was tutoring: this was Megyery the Red, who had warned Erzsébet that one day he would 'reveal all' to György Thurzó, the Palatine, a relative by marriage of the Báthorys, for this kind of affair was dealt with within the family. But Erzsébet's family had changed a great deal. Exhausted by their own wild behaviour, several of them were already dead, others died in violent or peculiar circumstances. And their children hardly ever lived longer than a few brief years, particularly the girl children. István, Erzsébet's brother, despite his insane eroticism, died without issue, and he was the last representative of that branch of the family. Others were so worn out by their insane existence that, from the depths of their exile, they no longer

gave any sign of life, a life which had never been significant for anything other than its extravagance or anomalies.

Who then of her family regenerated by death or the disappearance of the mad ones would have been able to excuse Erzsébet Báthory? She sensed this, and fled their style of life, their habits, and their feasts, which for her were entirely devoid of interest. Their life had become reasonable and rather pious. That is why Erzsébet preferred her shrews of Csejthe to these earthbound people. Moreover, the former were always around, following the coach of the Countess in the noisy train of carts filled with kitchen utensils and miscellaneous servants covered with dust from the windswept plain. Sometimes they were by her side, telling her tales about the household, to which she scarcely listened, but which were at least familiar, a buzzing at her ears. She might be told of the misbehaviour and faults of such and such a young servant girl. And so, seated upright on several cushions which to some extent softened the jolts and jars of the road, sitting between two impassive maids of honour, Erzsébet stared straight in front of her. When journeys seemed long and never-ending, she would order someone to go to the end of the convoy and pick out the culprit from amongst those who sat on the rumbling cart piled high with chests and pots. When called, the particular servant would jump to the ground, vaguely uneasy, and would be escorted quickly towards the large coach with the drawn curtains. In the gloom of the interior, everything took on the look of those things that are protected from sunlight. It was rather warmer than outside on the roadway, but a different kind of warmth, and the perfumes in the atmosphere were rather surprising. The Countess was there in her creamy linen, and even paler than usual. The croaking voice of Dorkó speaking in dialect quickly enumerated the crimes of the servant; the inquisition had begun. The Countess understood the dialect perfectly, but in such circumstances her voice was never raised to mingle with those of her witches. She was waiting; her trance was about to begin. A moment later she made a sign; one of her maids of honour removed a long pin from her hair and offered it to her. Dorkó would be holding the servant down and everyone in the coach would be dead quiet, the maids of honour lowering their eyes. A cry would burst forth; the pin would have been plunged to half its length, into a leg or an arm, and the desperate battle between Dorkó and the girl would begin, the girl throwing herself about to left and right madly, like a cat driven wild, trying to escape and jump outside on to the road, attempting desperately to get outside and far away from this box of scorching phantoms. But she was firmly gripped and the pin pricked her here and there, causing runnels of blood to flow down and gleam against her solid peasant flesh. And while

Dorkó shook and rebuked the dishevelled servant, by now in total disorder, her hair straggling and awry, the two maids of honour would act as though they were looking out through a slit in the leather curtains, politely, at nothing in particular.

They would reach the Blutgasse when the Augustines opposite were already asleep.

Erzsébet was re-entering the palace in which twenty years previously, she used to take such great pains to adorn herself so that she would shine at Court festivities.

But who, now, would willingly have received this fearsome countess? Pacing up and down dismal halls, rushing suddenly at mirrors, gazing at her own reflection, beautiful but desired by none, incapable of loving and yet made immutably to please, Erzsébet returned again and again to that bottomless realm in which one is forever king in one's own fantasy. In despair, she would throw herself towards the source of things, since things themselves now wanted no part of her.

Formerly, when her husband used to escort her as a young woman to the balls of the emperor, her fits of anger were uncomplicated. A simple delay in the dressing of her hair or in the arrangement of her robes was sufficient to bring on a tantrum which would end in some cruel punishment in a corner of the servants' quarters. That was all. But now...

A blacksmith, well paid and terrorised with dire threats, had, in the dead of night, forged an incredible piece of metalwork particularly difficult to handle. It was a cylindrical cage of gleaming iron blades secured by metal hoops. One would have imagined it was intended for some gigantic owl. But its interior was furnished with sharp spikes. At the appropriate time, and always at night, this strange piece of machinery used to be hoisted to the ceiling by means of pulleys. It was from here there issued those screams which awoke the monks opposite and aroused their anger against this accursed Protestant household.

Some few minutes earlier, dragging her by the heavy tresses of her dishevelled hair, Dorkó had bundled a stark naked servant girl down the cellar stairs. She had thrust the peasant girl into the terrible cage and locked her in; then, without delay, the whole contraption was hoisted upwards to the vaulted ceiling. At this point the Countess would make her appearance. It was as though she were already in a trance. Lightly clad in white linen, she came slowly in and sat down on a stepladder placed beneath the cage.

Dorkó, grasping a sharp iron stake or a red hot poker, would now begin to stab at the prisoner, who looked like a great white and fawn bird which, recoiling backwards, came violently against the points of the cage.

At every blow the flow of blood thickened, dripping down on to the other woman who sat impassively below, white, and barely half-conscious, gazing into the void.

When it was all over, when the girl above had collapsed, folding over on herself within the narrow cylinder, in a faint sometimes, or dying a slow death ('pitted all over with little holes', the interrogator said), Kateline Beniezky, whose job it was to wash away the blood down to the last drop, would arrive. Then the burial party would slip into the cellar with an old coffin. In Vienna, as the victims were few in number, they were buried in the cemetery in the middle of the night, on the pretext that an epidemic was raging in the house; or else Dorkó and Kateline would carry them on the following evening to the nearest fields.

Erzsébet, when she came to herself again, gathered the folds of her long sticky garment in her hands, called for lights and, covered in streaks of blood, returned to her panelled chamber preceded by the two old servants.

Legends sum up the whole situation in a simple way giving form to the constituent facts, a form universally comprehensible. The black dog which scampered out from under the cloak of Gilles de Rais is a case in point; and, here, at the hem of Erzsébet's dress, a she-wolf which tamely follows her. And again, the legend which asserts: 'And every time Erzsébet Báthory wished to be still whiter, she began once more to bathe in blood.' The Augustinians also must have wondered about those blood-baths when, in the morning, they came upon little puddles of reddish water still trapped between the pavingstones of the alley where Dorkó and Kateline had emptied their buckets, just as dawn was breaking above the grey houses to illuminate the spire of St Stephen's church. But neither the monks nor the ordinary people dared to say anything; the name of the Countess was too illustrious, too well protected by the house of Hapsburg.

When, late in the afternoon, the sun was going down, when the town and the shops lighted their lamps and the streets became lively again, Erzsébet would go out, adorned and escorted by her servants, to shop for some new enamels or several lengths of velvet recently imported from Italy. The people saw her, whiter than ever, and ever more beautiful in her black and white mourning dress. A few paces behind her followed Barsovny and Oëtvos, eager to catch sight of some interesting spectacle or other, and greatly interested in the patter of the showmen with their monkeys.

After having thus given free rein to what exclusively she cherished in the most secret part of herself, how could Erzsébet Báthory have failed to be irritated by the obligation to assume once again the familiar mask? Beside her solitary joys, what significance could those long wedding feasts

followed by family reunions retain for her? All those nieces, cousins, members of the different branches of the Somlyó and the Ecsed, the girls like herself engaged at a very young age, provided countless occasions upon which she was invited to marriage ceremonies in every corner of Northern Hungary.

And once there, Erzsébet knew quite well, it was very difficult to get away again.

Nevertheless, she was so pre-eminently beautiful in all her finery and jewels, she had such a regal appearance, that she was sure to be admired wherever she went. She knew also that people were afraid of her and that rumours about her were probably being voiced around. She preferred to forget about this, or to defy destiny, so certain was she of the power of the Báthory name and of the effects of her own magical incantations. She never went without her wrinkled talisman, wrapped up and secreted in the bottom of a red silken bag, and smelling at once of decay and of the incense of plants of the forest. Sometimes, during a banquet, with the tips of her long fingers, she would touch the little bag which was sewn into her corsets at the spot nearest her heart, whilst her deepest eyes ranged questioningly over her fellow guests for a sign which would betray the fact that this one or that had already been warned against her.

When Erzsébet decided to return again to Presbourg, it was a large-scale operation; for she would have to visit there all the families related to her own, and she would be obliged to make the journey with all pomp and ceremony. It was always necessary to take account of possible attacks by brigands, who had a preference for such cover as the forest afforded there in the north, near the Vág. For several days in advance the village would be awaiting her departure; and when finally it had been announced, servants and peasants would all gather in the square to wish the Countess a good journey.

Five Haidouks, handsomely mounted and armed to the teeth, led the procession. Then came the coach, which had been cleaned and dusted several times, gleaming in the sunlight, and drawn by four horses; following the coach, five other vehicles with which the servants had not taken so much trouble, because they were filled with maidservants and sempstresses, seated with their legs dangling upon chests containing all the clothes and the presents. Presents scrupulously arranged and distributed in advance, embroidery or lace, also wine jars filled with the produce of the Countess' own vineyards. Bringing up the rear of the convoy, another five Haidouks, emphasising by their presence alone the high rank of the traveller.

It was Dorkó's job to supervise a group of twelve maidservants, sempstresses and chambermaids. The departure used to take place without overmuch amiability. Before leaving Erzsébet would make the round of her farms to fix the taxes and, back at the castle, she would allocate work for the domestics who were to remain behind: 'And on my return I hope I shall find my orders have been carried out.' This was all in the way of a goodbye that one could hope for from Erzsébet Báthory.

Passing through the towns of Trnava and Modra, she would arrive at Presbourg in the evening. At Racicdorf, five miles from the capital, the castle which dominated the town was already visible. At this point, a Haidouk would come to ask her respectfully by which gate the cortège should enter the city. It was always the same ceremonial and the reply was always identical, for although there were four gates into Presbourg, kings and great lords always made their entrance by the one on the Vienna road: 'Do you mean to say that after all this time you don't know the gate I enter by!'

As they were at the opposite side of the city, the coach had to make a half circuit of the walled town. Finally the long file disappeared at full trot under the Vydriza gate. Although this was the gate of honour, as soon as one passed through it one found oneself passing directly through the brothel area. Then one followed the bastion wall surrounding the great city inside; the streets were very gay, inhabited by freeborn vine growers, proud of their good wine.

One continued by way of the ghetto. The small iron gates had to be opened because, after sundown, Jews were not allowed to enter the town proper, where an entirely different atmosphere prevailed; not a single Christian lived there; the inhabitants, men and women with pallid faces, wore their hair and beards long and they were clothed in shabby, grease-stained garments. They bowed low as Erzsébet passed by, but she never acknowledged their greetings, and she forced them to draw back away from her by means of her armed guards; the meanest of her servants was the superior of a Jew.

The cortège now went by way of the 'long road', which, in fact, connected the Vydriza gate with the Laurinska gate. Close by the latter rose up a tower in which criminals were subjected to interrogation. It dominated a very sinister quarter, a district of prisons and suffering. Not far away a huge inn, 'The Wild Man', stood for the reception of foreign diplomats as well as for such Hungarian nobility as possessed no mansion in Presbourg.

Of course Erzsébet Báthory did own one, but after the quiet of Csejthe no doubt preferred the animated life at 'The Wild Man'. She had

booked in advance an entire floor for herself alone. The Haidouks, the servants, and Dorkó were lodged at the bottom of the courtyard near the stables, and there they led a life far more interesting than at Csejthe: the Haidouks frequented the taverns. They were well dressed and had plenty of money to spend. Dorkó made use of them to unearth places where peasant girls, come to the city in search of a position, were to be found: unknown girls with no acquaintances locally, who could therefore be quietly conjured away to Csejthe. On one occasion she engaged ten of them in this way, ten girls who took their place in the carts for the return journey; others she would choose from amongst the domestics of the great families she met while in Presbourg, speaking about them with the other housekeepers who controlled whole battalions of servants and sempstresses in the houses of Erzsébet's friends; which enterprise occasioned countless confabulations and commercial dealings down in the servants' quarters and backyards.

The Haidouks would carry all the great coffers of clothes and presents and precious objects in their caskets up to the floor which had been reserved for her. Very soon messengers from various noble personages would begin to arrive. Refreshed and carefully adorned, the Countess would receive them in the principal chamber of her apartments. These emissaries were the bearers of letters begging Erzsébet Báthory to honour the mansion of such and such of her relations who possessed places in the town with her incomparable presence. She always refused, with well-chosen words of thanks, flattered by the invitations, but preferring to guard her freedom and her absolute authority in the domain of her own apartments. She also used to love remembering all the great names of the country who, for generations on end, had paid homage to her rank and her family. The owner of the inn would always know who was and who was not presently in Presbourg, and he was well acquainted with all the latest gossip. His information was no less precise for being by word of mouth, and Erzsébet did not disdain to question people of lower station. For the latter were closer to the life of the street, and *au fait* with the ceaseless comings and goings, and had intimate knowledge of the hidden motives behind countless acts, and thus could be extremely useful to her in the practice of her own secret designs. For, whether in the rooms of the inn, or at the balls at which she spent much of her time in the evenings, she was all the time inhabited by the same dark and conspiring thoughts.

In the rooms of 'The Wild Man', at those times during which Erzsébet was in residence, there was always a great stir and bustle as preparations for feasts were made: all manner of fabrics and laces, scissors snapping, sempstresses moving about, mirrors reflecting all the activity.

Whilst she was here, the Countess no longer lived the rustic life of Csejthe, but, never retiring until the early hours, she luxuriated in languid comfort in her bed of state, from which she rose only to immerse herself in esoteric and perfumed baths, or to be fitted for clothes. During feasts, songs composed by gypsies were sung in her honour, praising her beauty in savage and nostalgic similes. Her clothes here were in the fashion of the Viennese court. All she preserved of her country costume was the high flat ruff rising straight up behind the neck, for this was worn by all the great ladies of the court. Then, majestic and glittering, she entered her elegant coach of state and set off on a return visit to one of the great families that were related to her. For the most part, these palaces were situated along the length of a great street which ran parallel to the Danube. At the entrance, a double row of liveried Haidouks held torches aloft. A great stir always ran through the assembled guests when the arrival of Erzsébet Báthory was announced, for her appearance caused a sensation; her legendary pallor, the solitude which she had so consistently sought at Csejthe since the beginning of her widowhood, her motives for which were not precisely understood; indeed everything about her was intriguing and disquieting. The lords of the manor greeted her when she came in with such compliments as, 'For what a long time we have missed you, oh sun of Csejthe!' This was said in Latin, as custom demanded. She replied brilliantly, in the same language. The rest of the time all present conversed in German, not in Hungarian.

Chapter Seven

The marriage of Judith Thurzó, second daughter of György Thurzó, Grand Palatine, and related to Erzsébet Báthory through his second wife, Erzsébet Czóbor, was celebrated in full splendour in November, 1607. Thus, contrary to the usual practice (for marriages generally took place in the springtime), Judith Thurzó's wedding took place at the beginning of those long nights of ice and snow, at Bicse, on the River Vág, a village of woodcutters, its narrow streets lined with little houses of lath and whitewashed plaster, along the river past long trains of trees which came from forests of the Tatras. As elsewhere in the country, the houses of the village were huddled together in the shadow of the castle on the hillside. This ancient castle had been pillaged and held to ransom by bandits in the lifetime of György Thurzó himself. The ransom was by no means insignificant: eighty thousand *Gulden* (florins). But the Palatine was only momentarily impoverished, for he owned a gold mine in the region. The bandits had set fire to the castle as they left and half of it had burned to the ground. This provided the opportunity for rebuilding and it was transformed into a magnificent dwelling full of precious things and usually ringing with the sounds of banqueting. For Thurzó, very much in love with his second wife, wished her to be as happy as possible during those periods when he was forced to leave her behind at Bicse.

Erzsébet Báthory, used as she was to a very exalted and luxurious standard of living, was nevertheless most impressed each time she travelled as far as Biscevár. She accepted the invitation which had been extended to all the relations.

The father of several girls, the Palatine had had a building constructed in such a manner as to be specially fitted for the celebration of their successive marriages. Its principal feature was an elevated chamber into which daylight poured through the many windows: the ballroom. On the first floor, a vast hall with naked stone walls, with beams painted in vivid colours in the Italian fashion. On the walls, draperies of velvet and damask with red designs. A long table filled one end of the room, with seats

round about and cushions here and there. The bedrooms were small, except for the bridal chamber which had two fireplaces facing one another at either end, and, in the middle, a great canopied bed which could be hermetically sealed by drawing the curtains around it. And despite the fires and the candelabra loaded with candles, in spite of the carpets and the bearskins scattered all over the place, it was icily cold in that bedchamber.

Throughout the short winter's day, the grey light had difficulty in passing through the lead-mounted greenish glass of the windows. From high up in the walls the great complex coats of arms, the shapes of scarcely discernible beasts coiling round about them, dominated the hall even down below.

Erzsébet's room too was vast and cold; everything in it was heaped up along the wainscoting and so bad was the light that she could see only with great difficulty when she was making up her face. The marriage of Judith Thurzó, the detailed expenses of which are preserved in the annals of Hungary, brought together several hundred guests, who remained in the castle for nine months, until the first child was born. The bear hunts were interrupted only by the great banquets during which it was considered good manners for each guest to roll a ball of breadcrumbs between his fingers during each course and to deposit the balls in such a way as to form a crown encircling the plate. After thirty courses a pretty crown would be formed, but by that time most of the guests had ceased to be hungry. During the day tournaments, crossbow and javelin competitions were held and ball games were also played and, in the evening, chess.

There was nothing, absolutely nothing in all this to interest Erzsébet Báthory. Sometimes, after a breakfast of warm bread dipped in fiercely hot mulled wine, sugared and spiced with cloves and cinnamon, she would go hunting in the early morning.

When she returned to the castle at nightfall, there she was once more at the dressing-table before her mirror, gleaming in candlelight, taking out her Bohemian opals, her pearls and garnets, her hairpins and chains fashioned of gold balls and enamels. She hadn't yet shared out her jewels amongst her children. At most she had given presents to Anna, her eldest. The servants would bring out the various pots they had transported with such great care, precious concoctions for her complexion, which was slightly weathered by the forest air.

She was made up, the contour of her immense eyes accentuated by the oily smoke of crushed wild nuts, and her sinuous mouth was rubbed with a red ointment. Then Erzsébet was ready to make her entrance in the festive hall, where the table was covered with cloths of gold-embroidered cotton. Thurzó would cast a speculative glance at her. Possibly, before the

Palatine was married for the second time, they had had an affair which would have been brought to an end by Thurzó's great love for his second wife. Certainly, Erzsébet and he had exchanged a brief correspondence, in Hungarian and German. He used to invite her to his house in Vienna. It is not known for certain whether she went but what is certain is that she in her turn invited him to Csejthe and that he visited her there.

The Palatine Thurzó, whose portraits depict him with a long beard, was around fifty years of age at the time; but life had aged him prematurely. He was at once a just man and one inclined easily to anger. Nominated Palatine in 1609, he had spent a decade fighting the Turks; then came political anxieties, for his ambition would never let him rest. His loyal nature, however, made him detest intrigue.

He lived at Bicse, but his duties frequently took him to Presbourg, the capital of upper Hungary. His most valuable aide was his secretary, György Zavodsky, a child of simple, local gentry of the village of Zavodie, but a young man who had received a very good education. As he was an acute observer, a man of prudence and always well-informed of events and intrigues, he was invaluable to Thurzó. With a simple glance he knew how to restrain the irascible Palatine if a discussion was becoming too stormy. It was Zavodsky who, down to the last detail, had arranged the business of Judith Thurzó's marriage, supervising the list of expenses and items to be purchased.

The Palatine wished his daughter to be happy, and that all Europe should realise the daughter of Thurzó and Erzsébet Czóbor had been well endowed. She was marrying András Jacuchic, Lord of Ursatiec and of Preskac, in upper Hungary.

For all those items which had to be bought in Vienna particularly, jewels, fabrics, dresses, furniture, 8,800 florins had been set aside. Twenty cooks had been engaged for the kitchen, the most reputable of the province; for the Palatine anticipated the presence of great lords, of royal envoys, and of princes from foreign lands.

A guard of 400 soldiers, clothed in the blue uniform of the Haidouks of Thurzó, had been chosen to welcome the visitors. The Archbishop of Caloéa and of Gran was expected; six guests from Moravia and Bohemia; four illustrious Austrian and five Polish ladies and gentlemen; eight ecclesiastical dignitaries; thirty-six members of Parliament, thirteen representatives of great cities, and seventeen of towns of lesser importance. And, over and above all these, the Ambassador of the Archduke Maximillian and that of the Archduke Ferdinand. It was also necessary to lodge in the precincts of Bicse 2,600 servants and 4,300

horses.

Prince Johann Christian of Silesia also was expected to come in person; which was a very great honour, for he led a very retired life, more like that of a monk than of a nobleman, and preferred study of matters spiritual to worldly amusements. He arrived with a great cortège, two hundred Haidouks galloping behind his carriage.

There was also one guest whom Thurzó was less anxious to welcome: the protégé of the Catholic king, Cardinal François Forgách. The Cardinal was a perennial enemy of the Protestants; a cabal wanted him to be present and schemed constantly to replace the Protestant Thurzó by the Catholic Forgách.

King Mathias was undecided for the moment. He had, however, charged Cardinal Forgách with the task of making discreet enquiries into certain bizarre goings on which were taking place in upper Hungary; he was to speak of this matter with Thurzó and to instruct him to make a full report. Knowing as he did the close family ties uniting the Palatine and the Countess, he feared the former might be excessively indulgent. To begin with, Thurzó was content to instruct Zavodsky to find out for himself precisely what these rumours were which were being circulated about Countess Nádasdy. Forgách, anyway, detested Erzsébet because she was a Protestant, and because it was rumoured she practised sorcery. Nevertheless, during the course of the festivities, Erzsébet received the most flattering compliments. She was honoured according to her rank by Erzsébet Czóbor, but apparently, solely because of the name she bore. In reality everyone dreaded her. There was something in her comportment, whether she was dancing, or eating, even her mere presence conjured up a strange negation, a halo of haggard solitude which her widowhood alone could not explain.

In the great public room at street level dancing went on all night. The orchestra was composed of gypsies and of flautists specially summoned from Italy. There were fifes, cymbals, bagpipes, and *kobozs*, Hungarian guitars. It was very cold, with the ceaseless comings and goings through the open doors, and so everyone was very warmly dressed. Wine circulated in great jars of red faience, hot spiced wine which was poured from the jars into goblets of tin and gold. Each man wore a dagger at his side, sheathed in crimson velvet. Their hats were decorated with falcon or heron feathers, and they wore necklaces of worked gold, and the buttons of their tunics set with glittering jewels. Everyone wore boots or shoes made of the finest supple leather, so that the sound of all those feet upon the floor was muffled, almost noiseless. Only the music, the excited voices, and the clatter of the goblets were responsible for the infernal din.

This marriage of the daughter of the Palatine György Thurzó made such a profound impression upon contemporary chroniclers that the endless menu has come down to us across three centuries.

In the centre of the long table which, with its surrounding seats comprised the entire furnishing of the hall, there was nothing but three great silver ladles with plates of silver. The guests were served by pages. The glasses were filled up, but it was customary not to begin drinking until after the second course; and the ladies, despite the great liberty which they enjoyed, were not supposed to indulge to excess in the strong wines of Hungary. Sauce was eaten with bread, each guest having in front of him his own round loaf to last throughout the day. It was fashionable to eat quickly, in a virile manner, so to speak. The meat was always very tough and firm, strong jaws were indispensable. The cooks had not been sparing with the salt, nor the onions, the garlic, the paprika, nor the saffron. Among other spices also liberally used were poppyseed, sesameseed, and blue nigellia from Damas, and sage.

In the morning the men had begun by breakfasting on roast pork or grilled slices of *szalona*, smoked fat bacon spiced with paprika which was the ordinary fare of the peasants, but which was indulged in by the nobility as well; all this washed down with a very hot spiced wine. During the meal, singers entertained the guests in various languages and dialects. The songs and ballads of Hungary, whose sound was more melancholic than gay, tended, of course, to dominate.

If, hunched forward slightly, Thurzó looked pensive as he glanced at the proud Erzsébet, who was sitting less than three places below him at table, it was because he feared that very shortly perhaps he would have to take some rather difficult measures in relation to her. He was trying to read in this eternally beautiful face those telltale signs of vampirism about which everyone conversed in whispers. He could see nothing whatsoever of cruelty in Erzsébet's demeanour. Still less of gentleness, certainly. Not a trace of a smile or of joy either. Of course she was known to be haughty and bizarre. She had children; but they were always far away from her. She could have lived with her kinsfolk, Miklós Zrinyi and Anna, or she could have taken her son, Pál, who was scarcely ten years of age, to live by her side at Csejthe, but she dwelt there alone, surrounded by shrews. When the Palatine asked questions, no one would speak up, even his relations replied evasively, saying that she was ill, that she was subject to fits which, from time immemorial, had afflicted the Báthory family; that it was this which made her remote and savage. And the Palatine, who, because of the past no doubt, had excellent personal reasons to spare her, hesitated before the fearsome mixture of hereditary madness and of possible diabolic

possession; he said to himself that after all it was perhaps only a question of capriciousness, of feminine bad humour, exaggerated by the tittle-tattle of the village.

If for several weeks Erzsébet appeared tranquil and at ease, this was because she kept harking back in her mind to the strange novelty of one of her recent crimes and, in the nebulous depths of her spirit, was mulling over the prospect of several other new notions, even more bizarre.

Up to the present she had used needles, knives, whips, and red hot pokers on her victims. She had had naked girls plastered with honey and, with their hands tied behind their backs, they were chased away far into the forest, so that they would be prey to flies and ants during the day before being devoured at night by wild beasts. When, from time to time, the young girls from the mountain villages, despite the fact they were strong physically with solid nerves, fell into a faint, she would command Dorkó to burn a twist of well oiled paper between their legs, 'to waken them up,' she used to say. But, during her journey to Bicse, she had discovered the melancholy and silent powers of snow and ice.

The village of Illáva was white. The castle, square, jutting up out of the snow, seemed to be held fast in the ice of its moats. Erzsébet, come down from Csejthe to be present at Bicse, travelled by coach over the main road upon which the snow was not so deep, and across which darted little animals and birds the colour of ivory, still stippled and touched with brown from last summer. Inside the vehicle, the footwarmers and bearskins kept the women, huddled up in their fur coats, warm. Enveloped in the skins of whole martens, and bristling like a sumptuous beast adorned for the winter, Erzsébet slumbered. She was most annoyed at having to go to this wedding simply because it was her duty, and for whole weeks on end to live the life of a guest of distinction, never left to herself, surrounded by strange servants who would enter her room at any moment. Without counting the mistress of the house herself who might also visit her most inopportunely. Jolted about on this journey to Bicse, she was so irritated that she felt the dawning within her of that strange warning symptom she knew so well and which, in the Báthory family, had always been provoked by anger or a thwarted desire. With no justification whatsoever she gave the order that one of the young servants accompanying her was to be sought out and brought to her. She even mentioned the name of the girl. In her half-delirious state she used to see the faces of the young peasant girls file past under her eyes, those whom she had noticed particularly while they wandered about at their work in the rooms or in the courtyards. Moreover, she used constantly to carry with her a list of the names of these girls. And so, it was this particular one who had to be sacrificed, not any other and at

once.

The girl arrived in tears. She was thrust into the coach before the Countess, who began to bite her frantically and to pinch her all over, wherever she could reach. It usually happened then, as it so often did after she had indulged in such vicious liberties, that the Countess fell into one of those liberating trances which, actually, was the object of her craving.

While her followers thronged about their mistress, who was still in some disarray, the young peasant girl slipped out of the coach, noiselessly through the soft snow, and allowed the ghastly vehicle bearing its vampire to move away out of sight and merge into a horizon that was already grey during that season of brief winter daylight. And so she would remain as night fell, in the dusk with which she was familiar, applying snow to her wounds, meanwhile, listening for the terrifying sounds that would herald the beasts of prey abroad on their nightly prowl. But even now, far down the road, a black mass had come to a halt. And suddenly there was a great coming and going round about this conglomeration, and torches burst into flame in the darkness. The young peasant girl leapt to her feet and fled across the fields. But she was soon captured again, and dragged back to the vehicle, where Dorkó and Jó Ilona were waiting for her. Dorkó shouted at her. But the Countess, bending down, whispered a few brief words into her ear. And when they arrived in the vicinity of the castle of Illáva, which was very near, the servants went to draw water from beneath the ice in the ditches between the winterdried reeds. Jó Ilona had ripped off the clothes of the young serving wench and now held her naked standing there in the snow surrounded by a ring of torches. Water was poured on to her and it froze instantly on her body. Erzsébet was watching at the carriage door. The girl tried feebly to struggle towards the heat of the torches; more water was poured over her. And now she could no longer fall; she had become no more than a tall, rigid stalagmite, and her mouth blue, open in a petrified screech, was visible through the ice. She was buried at the edge of the road in the field, under the snow. The cadaver was thrust a little way into the earth, down there where the bulbs of the wild tulip and the blue grape hyacinth germinated, plants which would flower later in the spring.

Erzsébet had been unwilling to go further than Illáva for this execution; for beyond that, one passed into the territory of Bicse, and she would not have dared to carry out her sinister deed within the domain of Thurzó. The girl of Illáva was the first to be put to death in this fashion. After that, each winter, in the glacial washhouses and the little courts of the various castles belonging to the Báthory family, at Léká, high up on the mountainside, at Kérézstur and Csejthe, this particular torture became

common practice.

That was why Thurzó was gazing with such rapt attention at his beautiful cousin as she sat imperturbable at the banquet table. Indeed, wild rumours about what had taken place at Illáva were already spreading like wildfire throughout the neighbourhood. Erzsébet's majordomo, Benedick Dezsó, was just as reliable as the satanic trio; but the body servants who, day after day, mixed with the staff at Bicse Castle, drinking below stairs, were certainly obliged to invent some story or other to tell; preferably macabre tales which, during the long evenings in the kitchen, were appreciated most of all. Such gossip was a nightly occurrence as Jó Ilona and Dorkó busied themselves with preparations for the Countess' bedtime.

An invisible circle of horror was beginning to form around Erzsébet Báthory. One after another the various villages in the neighbourhood of the castle of upper Hungary began to refuse to allow their girls to accept a position with her. The ruses employed by Dorkó, Jó Ilona and Kateline Beniezky no longer worked; there were no further windfalls. It was in vain that they promised new clothes, that they expounded upon the glory of service with an illustrious family. It proved necessary to open negotiations in regions as yet unexplored, and sometimes in regions so distant that it would be a month before the young peasant girl arrived in Csejthe. And the old women no longer dared to visit the same village twice. The rumours simply spread more widely with the search. There was also talk of murders which the Countess used to succeed in committing even in the homes of her hosts. Erzsébet was passionately involved now in what had become a veritable manhunt. At all times she required a flock of girls to be ready and at hand and, in the three or four castles to which it was her custom to repair now and again, there were always some at her disposal. A team of women from every walk of life was all the time employed in the systematic search for 'servants'. Besides Barsovny and Oëtvos, did those other women, like the wife of the baker Czabo, know what kind of ghastly death was in store for these young peasant girls? Above all, they used to covet the skirt, and the new cloak which the lady of the castle used to have sent to them each time a new serving wench obtained by them arrived at the castle. Amongst these girls there were some who never set eyes upon the Countess except from a distance, across the courtyard, when she was on her way to the hunt, girls who used to stay in the kitchen or in the laundries until that day fell upon which they were summoned to her room. Did Erzsébet draw them by lot from her long list of names? The answer to this must remain in doubt, but that it was primarily the physical beauty of the individual girl which caused her to be chosen that is certain. When in the course of one of her journeys,

The Bloody Countess

their mistress had noticed some girl or other, Jó Ilona and especially Kateline, who was merry and forthcoming in her appearance, did their utmost to persuade the servant girl to quit her position and join them. They even used to go to the village to convince the mother. This happened in particular at the house of Kátá Nádasdy. Jó Ilona returned in triumph one day, followed by a scatterbrained troupe of hefty girls from Eger, all ready to set out for Csejthe. This was in the early days; Kátá Nádasdy, without suspecting anything and simply to please her sister-in-law, had agreed to let her have them. They were locked away in reserve in the cellar and the little stone rooms in which water used to be heated and clothes stacked before they were ironed. Erzsébet was just as anxious to have her prey at her disposal as people, in time of famine, are to have sacks of flour and vegetables in stock in their granaries. She used to enquire after every minute detail, particularly concerning their age and their nubile potential.

Since the death of Count Nádasdy in the year 1604, a very mysterious creature had acquired almost absolute power over the mind and soul of Erzsébet Báthory. She came from the depths of the forest to which, on certain nights, she returned in haste to bay at the moon; and, followed by her black cats which used to return with her to the castle, she would crown herself with dark and silver herbs, of sagebrush and henbane, and dance with her own shadow in the clearing, conjuring up the ancient divinities.

No one really knew anything about her. She was the 'witch of the forest'. Always a sorceress, she once lived in the neighbourhood of Sárvár where for a long time she used to watch Erzsébet from afar as she galloped by destroying the crops. She was called Anna, but for some unknown reason she had chosen the name of Darvulia. She was very old, full of bile and utterly heartless, truly, a terrifying creature. In the eyes of Erzsébet she had recognised all the familiar baleful poisons of the forest, of the insensibility of lunar deserts, and had discerned behind those eyes a spiritual servitude ripe for seeding as black soil.

Tirelessly, she drew her powers from this humus of witchcraft, and it was this instinct which wedded her irrevocably to all that was venomous, to all that was mortal. Erzsébet, with her Saturn-like passivity, gave herself up entirely to these powers; her megalomania and her lust for the total emptiness rendered her always available, disposed to receive, disposed to accept. And it was Darvulia who presented her with the ripe fruits of madness. She did it with magic, and also by the most sordid means, carefully suppressing any external obstacle that might have stood in the way of the Countess and which she feared she might be unable to surmount. The moon being in Capricorn, it was advisable to bathe in the

middle of the night, to the accompaniment of the interminable and monotonous drone of magic spells, in a bath of bitter resin. In a secret underground room like a crypt, Darvulia, with the patience of a practised sorceress, drew circles and signs according to the inner grammar of her necromantic ken, not for an instant straying in that labyrinth of baneful, black geography. Awakening these dark powers within herself, she would live out her own special magic before the spellbound Erzsébet, communing with her in the one single sacrament she wished to share.

In the castle, after the coming of Darvulia, the reign of tears and quarrels was unbroken. Kateline, if not Jó Ilona, struck occasionally with pity, would give a bite to eat to those young serving wenches imprisoned in the cellars awaiting their doom. And one day, when the Countess was ill and was apprised of this clemency, she paid dearly for it; she was called to the bed of her mistress where she too received the bite of the beast.

Ponikenus, the pastor of Csejthe, who does not seem to have been a particularly courageous fellow, was mortally dread of Darvulia and especially of her black cats. In Hungary, if a black cat crosses one's path, it is an evil augury. And, as the castle was full of the creatures, and they darted in all directions in front of him on the stairs, he was scared out of his wits, a fact about which he later testified in open court, adding that these evil feline creatures had even bitten his foot.

Of the natives of Tatras one could demand no matter what kind of work usually reserved for beasts of burden. From the little river fetch and carry in wooden buckets water for the castle perched high on the hillside; clean the courtyards and weed the little gardens where the rose bushes grew, violets and polyanthus; trim the wild vines which climbed the walls filling the air with the perfume of their pollen-heavy, yellow-green flowers; wash the table linen and the bed sheets along with the regular washer-women, Kateline and Vargha Balintne. Of these creatures, used in their homes to a life harder than farm beasts, hardy in their natural surroundings and timorous in the halls of the castle, capable of holding a wolf at bay and of throwing themselves flat on their faces at the feet of the Countess in supplication, around six hundred and fifty of them disappeared. Needless to say, it never occurred to any of them to anticipate the tragic consequences of their petty little crimes. They used to behave like cats and magpies. If they came across something to eat or some coins left lying about, they tended to pilfer them. They would also be careless with the complicated fluting of the famous ruffs, or else they would chatter at their work. At an opportune moment, everything would be reported by Dorkó and Jó Ilona. If Erzsébet was having a good day, merely day-dreaming amidst the heady perfume of the great bunches of violet lilies carried from

the mountainside to decorate her bedroom, everything went smoothly enough; Dorkó would strip the clothes off the backs of the culprits who, under the gaze of the Countess, would continue their work naked and scarlet with shame, unless they were made to stand, naked again, in a corner. They would have preferred almost anything to this unwonted and indecent exhibition of themselves, a kind of incident of which none of them had previously heard tell. Even the valets, when they had to cross the room used to lower their eyes to avoid the sight of them.

But if Erzsébet was having a stormy day or happened to be exasperated about something, then woe betide whatever girl had pilfered a coin or two! Jó Ilona would pinion the arm of the girl so that the palm was open upwards, and Dorkó, or sometimes the Countess herself, would drop that coin red hot from the fire on to the girl's palm from a pair of pincers. Or else, if the linen had not been ironed satisfactorily, it was the pleating iron which was fired red hot, and Erzsébet herself would apply it to the face, the mouth or the nose of the negligent laundrymaid. One day, as Dorkó prised open the mouth of one of the girls with both hands, the Countess plunged it into the throat of the culprit.

And if, during one of those baleful days, the girls were ill-advised enough to chatter while they sewed, the lips of the chatterbox were bloodily and firmly closed by the hand of Erzsébet herself, by means of needles.

Roger de Bricqueville used to say to Gilles de Rais: 'I assure you that I should feel much easier in my mind if we were to kill this girl.'

In the loft of Machecoul Castle, occupied at one time by the lord de la Suze, brother of Gilles de Rais, who had wrested it from him by treachery, the black and desiccated corpses of forty boys lay hidden beneath the hay. They were already in the process of being burned in the grate of the huge fireplace below when the untimely arrival of de la Suze interrupted everything. Thus, they were hurriedly dragged out and up and thrust headlong beneath the hay. When Gilles de Rais had once more taken possession of the castle, a lady-in-waiting to Catherine de Thouars, wife of the Field Marshal de Rais had the misfortune to wander into this particular loft, and stumbled back downstairs shrieking with horror. That was how Roger de Bricqueville came to take her in hand and lead her to Gilles. The latter did not consider it advisable to kill the imprudent girl; but he threatened her so effectively that she kept silent for a long time.

That took place in Poitou, shortly before 1440. Around 1680, in Hungary, in the garret rooms of the castle of Pistyán, attics slatted by the autumn sun, one would have found, if not forty, at least half a dozen cadavers; those of young serving wenches which a horrible old crone had

tried in vain to get rid of by sloshing buckets of wet quicklime over them.

The waters and hot muds of Pistyán had already been exploited in the fifteenth century. The descendants of a certain Bishop Thurzó, to whom these mud baths had originally belonged, used to draw a revenue by imposing a tax which those who sat in them were required to pay; these mud baths being located on the riverbank and consisting of holes into which the bathers were immersed up to their necks.

Erzsébet Báthory was to be found at Pistyán amidst many others. She had gone into retreat there with her usual assorted company, by means of which she counted on relieving the monotonous round of mud baths. Her own castle at Pistyán was quite comfortable and relatively near the river Vág which flowed through the depths of a wooded valley. Each morning the elegant company would cross the bridge and arrive at the other side, either in litters or, following a new convention but lately introduced, in a little one-seater cubicle cart which was drawn along like a rickshaw on its two wheels by a trotting peasant. On the riverbank, at that spot where the hot water springs spurted upwards into the air, the purple and white tents of the Countess and her hosts used to be set up in rows against a leafy background of green foliage. Erzsébet would slip in, sheltered beneath a parasol so that the sunlight reflected by the smooth surface of the water would not mar her complexion, and she would immerse her body in the mud with its medicinal properties only when sheltered by a ring of thick curtains. She would come here seeking alleviation of the painful symptoms of gout and hereditary rheumatism, just like the rest of the ladies and gentlemen round about her, whose blood was excessively rich from banqueting; but she came also for the beauty of her body and her face.

It was probably thanks to these baths at Pistyán that until she was almost fifty she retained so much lustre and held the telltale signs of age at bay. For that is what she dreaded most. At Csejthe she suffered herself to be steeped in poultices concocted from the leaves of deadly nightshade, of henbane and of thorn apple, the very poisonous qualities of which pulpy plants whitened the skin. But here, she came in search of the warmth, the soft envelopment of the spring-warmed mud. She would remain silent and motionless, allowing the pores of her body to be penetrated by those secret powers born of the decomposition of roots and the black earth fertilised by the mouldering potency of dead vegetable matter.

One day Erzsébet's eldest daughter Anna decided that she too required to take the waters of Pistyán; and, as it seems that in Hungary married couples were generally in love with one another and altogether inseparable, she announced the impending arrival of both her husband,

Miklós Zrinyi, and herself. Erzsébet Bathory had always had other things to think about than her children. Only for her youngest daughter, Kátá, can we recognise in her a certain maternal affection. But she could hardly do otherwise than assure Anna and Miklós Zrinyi that they would be most welcome. Nevertheless, she was slightly put out by the impending visit. The family had a habit of turning up at the most inopportune moments. Anticipating the fantasies which the sulphurous spirits could not fail to inspire in her, one night or another, she had seen to it that she was accompanied by Dorkó and by several girls chosen with the most particular care and who, for the moment, wandered at liberty about her in the course of their daily duties. No sooner did she receive word that her daughter and son-in-law were on their way than she had the whole rather too noisy and conspicuous troupe gathered together and, under the watchful eye of Dorkó, she secreted the whole bunch in an out-of-the-way recess in the castle, where no one ever went, ordering her faithful overseer to punish them; for she had been crossed, antagonised by the forced change which would be brought about in her own plans. Then she decided to make herself more beautiful, and spent her time very patiently in making herself pleasant during those long, sensual autumn days and poignant nights so that for a while, indeed, she thought of nothing else. The erotic aura of her guests pleased her. Because for Erzsébet Báthory, the silent one, the haunted one, for whom neither prudery nor religion imposed limits upon her, welcomed whatever might serve to awaken or revive her jaded senses.

Certainly, Anna and her husband were not really at ease in that atmosphere, at least he was not who simply could not understand the ways of his mother-in-law, her exaggerated use of make-up, her morose brilliance which, despite her age and her widowhood, she persisted in. And when Anna spoke to him of these matters, he maintained a sad silence.

The baths, the meals, and the dancing went on. There was no hunting, for the baths were too tiring and much time was spent in the bedrooms, during the afternoon, when the castle was cloaked in hot silence. But away down there in the basements, where no one ever went, beyond thick walls and dark corridors, a group of young serving wenches starved and wailed. For eight days now, Dorkó had given them nothing to eat; and to add to their misery, in the already cold nights they were dragged out of doors and doused in ice-cold water. The first of them died; with dull eyes, the others gazed through the grille of the narrow aperture which gave on to the garden where the lofty sunflowers stirred their heads crammed with seeds, whose insipid but tonic taste haunted their imaginations. The girls were already incapable of moving about. From the narrow chamber in which they were huddled together, they could hear the cries of the

September nights in the gardens and the fields; and, more distant, from the other side of the castle, vague sounds of music and dancing.

Dorkó put the first of the dead under a bed in one of the bedrooms, and well into September covered them with furs to hide them; but she was careful, meanwhile, to be seen carrying food, to give the impression that the prisoners were still alive. The odour soon became quite revolting and Dorkó had the greatest difficulty in persuading a footman to bury the bodies.

When the moment arrived for leaving again, Erzsébet sent someone to find her servants; but the survivors were too feeble to walk. She was greatly put out by this and told Dorkó she had exceeded her instructions; did she have to travel then without her suite and be bored to tears during the journey home to Csejthe? However, the least faint of those who survived was hoisted into the Countess' carriage. She died on the way. As for the others, no one bothered about them; they were left dying in the care of Dorkó, who found the following days some of the most disagreeable of her life. In fact, she had already thrown some of the bodies into the moats surrounding the castle. The corpses had floated to the surface; and thus they had to be fished out again with great haste, a better spot had to be found in which to conceal them. At last Dorkó decided upon a strip of land which had been used to stock vegetables, carrots and a pile of other edible roots which had been stored there against the winter shortage; Dorkó managed to persuade some of the valets to rebury them there. But the long-snouted greyhound which belonged to Miklós Zrinyi, turned them up one day during a walk with his master, and came bounding back to his master with God knows what frightful fragments of flesh trailing from his jowls. From this day onwards, Zrinyi looked upon his mother-in-law with a marked horror, but on this occasion he kept his silence, regarding the facts he could no longer doubt. It was difficult to find excuses. The discovery made by this wretched dog terrified the footmen. They refused point blank to aid Dorkó any more, and she did not dare to go on with the burying of the bodies as long as the guests were still at the castle. She had to make do with pouring quicklime over the bodies which were still concealed in an attic from which percolated such a stench that the valets were no longer willing to go near this part of the castle. Left utterly alone at last, she spent five nights digging ditches in the garden and returned to collect her sinister bundles one after the other. Finally, the task done, cursing death, she set off back to Csejthe, striding like a mountaineer in the refreshing autumn wind which did something to blow away the stench with which she was impregnated.

Chapter Eight

During these years, Erzsébet Báthory, being a widow, had at the same time to defend herself, her children, and her castles against whatever threatened them. Revolt had broken out in Hungary in October, 1605. On the pretext of a quarrel between Protestants and Catholics, Boksay had rebelled against the Emperor. The whole of Transylvania followed his banner. He elevated himself to Prince of Transylvania in the place of the Báthory family, and the Haidouks and the rest of the troops came over to his cause. The Turks, needless to say, were adding fuel to revolt and bribed the Haidouks against the Emperor. The great avenues of Vienna were in flames.

Neustadt was encircled, Presbourg in great peril; for the imperial garrison was resolved on pillaging the town if, in a given day, they were not provided with a huge fête which they had been promised.

Undoubtedly, Erzsébet Báthory must have enjoyed Thurzó's powerful protection, for her castles at Sárvár and Csejthe amongst others were situated not far from Neustadt and Presbourg. Her name alone must have inspired the hatred of the rebels; her cousin Sigismund and her uncle András had governed Transylvania most unsatisfactorily. Like other Hungarians who remained in their castles while their fellow noblemen were at war, she must have reinforced the defences and the garrison, counting upon Thurzó to warn her in extremity, the same Thurzó who, in December, 1609, was to be named Palatine of Hungary by a hundred and fifty members of the Diet. On the pretext, amongst others, of her anxiety she wrote frequently in excellent Latin to the ministers of the Emperor asking for money, taking great care, and using the conventional, polite platitudes underlining her widow's weed and female frailty.

Erzsébet's life at Csejthe was sometimes difficult. The feudal system had evolved. The lord of the castle continued to own his serfs, his peasants and whatever artisans were attached to the estate; but now there were also freeborn villagers within their domains, businessmen and artisans who were under the authority of a mayor and his board of councillors, 'the village fathers'. Despite its smallness, Csejthe had the

status of a free township, possessing the various statutes and privileges of a town, for in the past it had belonged to the Crown.

Thus it was simply not possible for Erzsébet to do precisely what she wished in the village. She could not, for example – even if she had sometimes made the attempt – have a gibbet erected in a village square in which to hang a malefactor as an example to others; for this was contrary to the civil conscience and good name of the village. The local councillors had the right to examine cases and, if necessary, to lodge a protest. In this instance she would have to appeal to the authorities in Presbourg, who, if rebellion were involved, would send two or three hundred German soldiers of the royal army to re-establish good order, to pillage all the stores of the township and to help themselves to the common treasure chest. It was for this reason that Erzsébet preferred to retire to the lofty solitude of her castle where, in practice, she was absolute mistress.

Her pomp, her receptions, her furs, and her jewels cost Erzsébet Báthory dear; and, since the death of her husband, she had been obliged to share several of her fiefs amongst her children, reserving a large proportion for the heir to the name of Nádasdy, Pál, over whose eventual inheritance his tutor, Megyery, kept an eagle eye.

Erzsébet was forever short of money; for, if local produce were abundant, everything which had to be imported from abroad was a costly luxury. And, of course, it was luxury alone which interested her, who used to live in a society in which tastes were highly sophisticated, in which only the extraordinary was considered to be beautiful. Even the furs of the country had to be worked in a special way and this called for the importation of special craftsmen from Italy, and one had to be able to declare that one's jewels came from France, one's silks from Lyons, one's velvets from Genoa and Venice.

As for house furnishings, scant care was given to these; they remained typically Hungarian, black, heavy, and clumsy. Nor was there much comfort; the Hungarian ladies and gentlemen thought nothing of sitting on stools of hard wood, or of enduring the winter cold in rooms in which two fireplaces were scarcely sufficient to combat the perennial chill, far less heat them. But as far as personal luxuries were concerned, that was an entirely different matter. As for the noblewomen, each one was an avalanche of pearls.

In her badly heated, ill-lit chamber, in the midst of a camplike disorder, and with the garish taste of a barbarian, Erzsébet amassed together all she had heard tell of, and, heavily over-dressed princess that she was, would parade about before the great Spanish mirrors which leaned against the oaken tables. On her dressing table, in little parchment-

covered jars, were lined up those specifically Hungarian products bought at the local herbalist and prepared by Darvulia.

Erzsébet Báthory had therefore a great need of money. Several times already, she had applied for funds to the Prime Minister. Finally, obtaining nothing any more, despite her arrogant claims,[2] she did the only thing there remained to do: she began to sell those castles, still numerous, which she owned outright. But soon she began to feel the loss of the tithes she had derived from them. And so, for the lack of a fortune, for the sake of revenge and for the enchantment of her beauty, she now had recourse to magic.

It was Darvulia who, in the same year in which Ferencz Nádasdy died, initiated Erzsébet into the cruellest joys, who taught her to watch people dying and the significance of doing so. The Countess, until then driven by the pleasure of making her servants suffer and bleed, had provided herself with the excuse of punishing some fault or other committed by her victims. But now the blood spilled was spilled for the sake of blood and death executed for death's sake. Darvulia would go down into the cellars, choose those girls who seemed to her to be the most well-nourished, the ones with the most resistance. With Dorkó's help, she would push them stumbling in front of her on the stairs and in the dimly lit passages leading to the laundry where her mistress already waited, sitting rigid in her high sculpted chair, while Jó Ilona and others busied themselves with the fire, the bonds, the knives, and the razors. The two or three girls were stripped entirely naked, their hair unpinned and loose. They were all beautiful and less than eighteen years of age, sometimes only twelve; Darvulia required them to be very young, for she knew that once they had experienced love the magical power of their blood was already wasted. Dorkó bound their arms very tightly and with Jó Ilona working with her in relays set about beating them with a strong twig of green ash which cut deep furrows into their flesh. Sometimes the Countess herself would take over from them. When the girl had been reduced to one swelling wound, Dorkó would take a razor and make an incision here and there. The blood used to cascade over everything; Erzsébet Báthory's white sleeves were stained by the red deluge. She became so blood-bespattered that she had to go and change her dress. The arch and the walls were dripping. When finally the girl was ready to die, Dorkó would open the

[2] In the archives of the city of Vienna is to be found a letter dated the 28th of July, 1605, and sent from Sárvár, in which Erzsébet asks for gifts and favours. This letter, in Latin, is addressed to *Spectabili et Magnifico Domino Ruperdo ab Ellinsky, Cesar Regio Consiliario...* and signed 'Erzsébet Báthory, Vidua'. It refers to Ruprecht Ellinsky, councillor to Mathias II.

veins of her arms with scissors and the last blood from her body would flow out of them. On certain days when the Countess was tired of their cries, she would have their mouths sewn up so that she would no longer have to listen to them. The first time Erzsébet watched a death, she was a little frightened and looked almost wonderingly at the corpse as though she didn't understand what had happened. But this apprehension was very temporary. Later on she must have been interested in how long the death pangs could last; and also in the duration of the sexual pleasure, in the necromantic pleasure.

With a kind of voluptuous assurance of her own impunity down there in the depths of the cellars at Csejthe, she abandoned herself entirely to these fiery, torchlit scenes in which the flicker of flame added much to the various phases of the insane ritual. Happiness. The wings of madness were already beating as she took the last step into the unconscious. For if finally she had not been unconscious, how could Erzsébet have perpetrated such acts!

One can understand the source of this sexual pleasure, multiplied tenfold by the dim light, broken only by the faint light of the torches, there, far underground, where she felt utterly secure. There are numerous sects which give themselves over to their erotic practices in places so securely sealed, places which, once entered, the very doors are almost impossible to locate.

As to the pleasure of witchcraft, the pleasure which brought down the thunderbolt of the ecclesiastical tribune upon the shoulders of Gilles de Rais, and which Erzsébet Báthory was spared, it was the most indestructible of the two. When the body can repent, worn out at last, the spirit pursues the track it has little by little beaten out for itself according to the outlandish logic which has become its own, the logic of sap and blood. Those crimes born of the most terrible passions of the body could be absolved: during the trial of Gilles de Rais, the crucifix was veiled for decency's sake and then wasn't referred to any more. But of the magic circle, that very special universe closed in reverse by antique keys, its carbon signatures which seal, striking and striking again at the soul to make it over into nature's own coinage, alienated as many times as given, what are we to say? And what are we to say of Erzsébet Báthory, superstitious and depraved, with her aquiline nose directly continuing the line of her forehead, with her heavy chin, receding a little, this look evoking the image of the black sheep and of the bird of prey which carried it off in its claws simultaneously; what are we to say about this woman who was always, and in spite of everything, sought after? For it is not the agreeable which

fascinates; it is the unfathomable. If, one day, one was able to love one of these creatures, understanding the very real and profound grounds of her or his existence, fearing neither this being nor the powers which ordained her (his) coming into this world, then surely there would be no place for fear nor cruelty any longer?

As for Darvulia, the sorceress, she was playing. It is because she is playing that the true witch remains a sorceress across the ages and beyond time altogether. Well she knows that nothing can separate her from the forces which she manipulates down here in earth, for all life everywhere is made of nothing but these same forces. Like those believers who die confiding themselves to the vast waters of their eternal God, the witch allows herself to sink away without struggle into the elemental drift; to where, she does not seek to know. In the poison of the plant, in the howl of the wolf, or amongst the elements entering into the conjunction of the malignant star of a creature as yet unborn, what does it matter whither their cinders go; and where would they go if not into the great cosmic womb watched over by the stars, the place of eternal recurrence!

Witches do not desire to flee into the realm of the pure. They are afraid of it: for them, that is authentic death. What they wish to do is to resolve within the spirit of things, to seize hold of them and mould them long before human beings can regard them as irrevocably fixed.

At Csejthe, the field was free for Erzsébet and Darvulia. The province was remote and backward; the inhabitants, physically vigorous but completely apathetic, were ruled by superstitions. The Countess could do exactly as she pleased here; as for Darvulia, everyone was afraid lest she should bewitch the entire family, and the fields and the cattle as well at the slightest provocation. In the minds of such people everything was vague and misty; at bottom, they were sure of nothing.

For Kateline, the necessity of getting rid of the corpses was a perpetual nightmare. Jó Ilona and the mysterious old hag who never spoke used to do the burying without question. In the beginning, this was easy; the funerals were conducted in the ordinary way, from the church. The bodies were washed, clothed, and kept, with everything in order for as long as custom required, to allow the parents coming from far away to arrive for the burial. The latter were given some plausible explanation and feasted well. But one day a mother happened to arrive at the castle unexpectedly to see her daughter. The latter, a very young girl, had been killed two days previously, and a suitable place was at that very moment being sought to put her body upon which various tortures had left their marks. Someone replied, 'She is dead'. The mother was insistent in her demand to be allowed to see the body at least. But it was so disfigured that

the people at the castle refused to show her the body which they hastened to bury, to get it out of sight. The mother was locked up; she was so frightened that she said nothing; but at the subsequent trial she was the first to speak. Meanwhile, more and more of them died, serving wenches who were hastily thrust into the earth in the fields and the gardens. And the rumour, which ran about like wildfire from the moment of Darvulia's arrival, was that the Countess, to keep her beauty, used to bathe in baths of blood.

In the year 1608, Rudolph II, Archduke of Austria, King of Hungary and Bohemia since 1567, abdicated in favour of his brother Mathias, and retired definitively to Prague.

King Mathias had an entirely different character from his predecessors. Under the reigns of Maximillian and Rudolph, ardent Catholics both, the nobles were constantly being persecuted for religious motives and accused of treason. It is quite true that nearly all of them only escaped from the domination of the Turks by coming under that of the Hapsburgs; they used to hate the one almost as much as the other and, at bottom, rendered efficient service to Hungary alone. The Hapsburgs, deeply impregnated by Spanish fanaticism, found it very difficult to swallow the fact that the Hungarian nobility was in its entirety Protestant. At the end of the sixteenth century, a member of the Báthory family was an exception to the general rule: Sigismund of Transylvania; he was a particularly brilliant representative of Catholicism.

Since the 'Tripartitum Law', whose promulgation in 1514 had put an end to the 'Primitive Diet', no one had ever concerned himself with the peasant class, which was considered as belonging part and parcel to the feudal estates. The first thing which Mathias did on his accession was to remember that this class existed and to extend to the peasantry freedom of religion. In contrast to his two predecessors, Mathias was of a positive turn of mind and not the least inclined towards the occult. For him, to combat evil wherever it might be found was a moral obligation. No more easygoing excuses, and especially no more of that shadowbound autocracy which he considered as belonging to a bygone epoch, a menace to his own authority, and he rooted it out without pity wherever he came across it.

If the trial had taken place several years earlier, Erzsébet Báthory would have presented herself alone at the palace of the Emperor Rudolph, her relation by marriage (her cousin Sigismund had married Marie-Christine of Austria). She would have gone to find him where he lived then, at Presbourg, surrounded by his astrologers and engrossed in his books of magic. She would have spoken to him in her slow voice, she would have fixed him with her heavy eyes; and she would have made a point of carrying

with her, in such a way that the emperor would catch sight of it at once, the parchment upon which was inscribed the propitiatory incantation prepared by Darvulia. That would have been quite enough to incline Rudolph to take an indulgent view of the matter, and Erzsébet's penance would have been softened, possibly, to a quite tolerable but quite temporary detention at her own home, together with her promise for the future to indulge herself only in inoffensive witchcraft. But that hour was past; black weapons were no longer of any avail.

Erzsébet had gone too far to retreat; now she had to identify with, to confound herself with her crime. Outside Csejthe, she sensed that everything was a menace to her. Full of anguish, there she was at the onset of old age. Should she not now throw all her energies into the work of drawing a veil over age and over danger? Was it not essential for her, by a complete communion with evil, to rejuvenate those forces which would repel old age and perils?

Tirelessly, Darvulia would hark upon the merits of the red cloak of blood, of that blooming breastplate of flame stolen from the lives of others, a defence before which enemies faltered and decrepitude was arrested. Darvulia was not scholar enough to cite the example of Tiberius and his blood baths, nor of the prancing pythians smeared with gore. But she knew and said with certain knowledge that, thanks to blood, Erzsébet would be invulnerable and would remain beautiful.

And so the great brown earthenware pot was brought out; and three or four girls in perfect health who had been given exactly what they wished to eat were produced, while in another place four others, destined to follow them on the next occasion, were selected for fattening. Without wasting a moment, Dorkó tied up the arms of the first group very tightly with cords and slit their veins and arteries. The blood spurted out; and when all of them, bled white, twitched in their last agony on the floor, Dorkó took the blood which she had kept warm near the stove and poured it over the Countess, who stood there erect and white.

But the opportunity to make a visit to the Duke of Brunswick in his castle at Dolna Krupa suddenly supplied Erzsébet with a new source of distraction. The servants of Csejthe, always seeking to please their morose mistress, had brought back great news from the inn, 'The Three Green Leaves', at Vág Ujhely.

The Duke of Brunswick, who lived in the region, was enamoured of all kinds of machines, and thus of those mechanical inventions which were then in fashion and which Rudolph of Hapsburg himself liked to watch being manoeuvred, with their multitude of toothed wheels cogged

into one another, the counterweight unleashing a terrific noise of clashing iron. The Duke of Brunswick's own hobby was the collecting of clocks, and, above all, German clocks. He had arranged for a German locksmith to come and live there to make for him an enormous piece of clockwork with several different personages and chimes; the locksmith worked in the castle for more than two years and was then charged with the upkeep of this powerful mechanism of his for the rest of his life.

The clock was the great attraction of Dolna Krupa. People came from all over to have the honour of seeing it. And, amongst the nobility, Erzsébet Báthory. Did she converse with the inventive locksmith, describing, following her *idée fixe,* the famous 'Iron Virgin' of Nuremberg with which he would certainly be acquainted? Quite naturally, the idea came to her that she might possess a similar construction herself, an object which appeared to be living but which was none the less implacable, a machine. The iron cage suspended in the vault of her cellar in Vienna seemed quite out of date now. It was from Germany, and probably with the clockmaker of Dolna Krupa acting as intermediary, that Erzsébet ordered her 'Iron Virgin'.

This idol was installed in the subterranean hall at Csejthe. When not in use, it lay in a chest of sculpted oak, carefully locked up in its coffin. Next to the chest a heavy pedestal was erected upon which the uncanny female figure made out of iron and painted with flesh-coloured paint could be stood firmly. She was entirely naked, made up like a pretty woman, and ornamented with motifs which were at once realistic and ambiguous. The mouth opened by clockwork into an idiotic and cruel smile, revealing human teeth, and the eyes moved. Down her back, falling almost to the ground, were cascaded the locks of a girl which Erzsébet must have chosen with infinite care. Rejecting the heads of dark hair which would have been only too available, Erzsébet had found locks of platinum blonde for her. Had this long cinder-coloured hair belonged to the beautiful Slavonian girl who had come from so far away to be a servant at Csejthe where she was sacrificed as soon as she arrived? A necklace of encrusted precious stones ran in a loop down over the chest. And it was precisely by touching some of them that everything was set in motion. From the interior would issue the loud and sinister noise of moving clockwork. Then the arms would begin to rise up; and soon their relentless grip would close again; brusquely upon anyone who happened to be within their reach, and nothing could break their hold. To the left and to the right, two large shutters slid sideways, and, just where the painted breasts were, the chest opened, allowing five pointed daggers to emerge slowly, stabbing cunningly the girl clasped in the fatal embrace, her head thrown wildly

backwards and her long hair streaming down her back just like that of her iron lover. By pressing another gem in the necklace, the arms fell away, the smile was extinguished, the eyes clicked shut, as if sleep had suddenly taken possession of her. It is said that the blood of the girls so stabbed mortally then flowed down into a drain leading into a heated bathtub. It is more probable that the blood was collected in the notorious big-bellied pot, that it was then poured over the Countess who sat upright in an armchair permanently installed in that underground chamber.

But Erzsébet soon got tired of things; and in this ritual she could not participate. Besides, the complex clockwork broke down and rusted and no one knew how to repair it. Tortures of a more lively and varied nature succeeded these too stylised murders.

The judges during the trial, and King Mathias in his letters, considered it an aggravating circumstance in the case that all these crimes had been committed upon 'the female sex'. They must hastily have spied a depth of perversity, mysteriously sensual, which shocked them utterly.

Chapter Nine

Around 1440, in France, a nobleman of an illustrious family, most handsome and brilliant personally, son of Guy de Laval and Marie de Craon, Dame de la Suze, seldom left his own estate any more, Machecoul Manor, a sad and gloomy building, whose towers still rise up into the blue and grey sky above Poitou. Drawbridge raised, portcullis lowered, doors locked shut. None entered here but the most trusted of domestics. At night a light used to gleam suddenly in one of the tower windows, and such hideous shrieks issued from it that the very wolves in the forest bayed. Nevertheless, the estate of Gilles de Rais was not situated in wooded mountainous country, but rather on stony ground from which the castle walls reared up, their silhouette doleful in the luminous air of the west country. Tiffauges was very ancient. In summer its pinkish walls still flower with a mass of wild carnations. The crypt of Tiffauges still exists, very cool under a vault sustained by half broken columns; in the middle is a rectangular slab. That must have been the altar. As for the towers of Machecoul – towers pure in line – they rise up from a rounded butt of cut grass, formerly surrounded by moats. Dark and dolorous strands of ivy, the leaves, rustling in the wind, ceaselessly beat against the north wall. It was there, in the year 1440, in this unhappy retreat of Machecoul, that Gilles de Rais, Marshal of France, was arrested. Justice in the person of Jean V, Duke of Brittany, had been set in motion by the angry and obstinate behaviour of the lord of Rais in trying to take by force one of his last castles which he had sold to Geoffroy Le Ferron, treasurer of Brittany. Meanwhile, during the two months it lasted, the enquiry into the murders of young children which had been ordered by the Bishop of Nantes, had made great progress; the Marshal had to face the accusation of having evoked the devil and of having bathed in the blood of children which he had sacrificed to rejuvenate himself. The accusation took a more serious turn still when it was learned that, not only had the spilled blood been used as a philtre to maintain youth, but that the victim had been offered as a sacrifice to the devil.

In this era, such a charge constituted one of capital murder. The body was capable of suffering; this was a great pity, particularly when a man was innocent, but after all, death would carry him back to that kingdom of his virtues. And, as Gilles de Rais was to say himself at the end, 'Death, it is only a matter of a little pain'. But to use this blood, which as it spilled out carried with it the souls of those who had been sacrificed, to enscribe around the circumference of a magic circle the names of certain minor devils, and to nourish them with this divine stolen substance until they were breathing, whimpered and made their appearance in the form of a black dog, that was absolute evil, the unpardonable sin beside which those erotic practices of Gilles de Rais counted for very little. And what, more than everything, drove the mothers to despair and made them howl with grief, was to learn that the figure of Satan had actually appeared engraved upon the heart of one of their children, and that the right hand of another was anointed with the fat of cursed animals, for Gilles de Rais had ordered that a talisman should be made of it, to prevent his being hurt by steel, water, or fire, as long as he should wear it upon his person.

Gilles had it searched for everywhere, this talisman, when the armed emissaries of the Duke of Brittany entered Machecoul. Poitou, his valet, was to say, 'As Jean Labbé came into Machecoul, my master cried out, *"Vie qu'on me cherche mon chapeau de velours noir à double rebras, car la est ma liberté, mon honneur et ma vie."*[3]

It was this hand of a child, dried over glowing carbon which one evening he had himself carried in a fold of his cloak to François Prelati, while the latter was discoursing with the spirits of darkness. However much they searched, they found nothing. The devil had taken unto himself his own.

When she heard the Palatine and his men at the drawbridge of Csejthe, Erzsébet Báthory rushed towards the nameless, deformed and yellowish object, rolled up and crumpled, which was the incantation prepared in the most profoundly secret depths of the forest by Darvulia. The names of the judges and the princes who at this moment threatened her were inscribed thereon in full. Darvulia was no longer there. Nearly blind, she had plunged once more into the forest, and doubtless had died there one night in the moonlight.

Dorkó looked everywhere for the object. Jó Ilona turned all the dresses inside out. Panting with fear, Erzsébet watched them upturn

[3] 'Quick, you men, find my black velvet hat with the double brim, for there is the source of my liberty, my honour, and my life.'

everything, repeating over and over again as she watched the words of the long imperious litany. But the words by themselves were no more than pale voiceless mirrors. The devil required flesh which had been dried upon this earth, something which had lived, from which blood had flowed, if he was to write the pact. Communion of the spirit was for him no more than a bothersome simulacrum, and his cult is founded upon tangible objects: a hand to take hold of and manipulate, a heart to beat with life, a mysterious membrane to protect the life which was coming into being.

And, in fact, when all the boxes had been opened, and every hem of every dress had been ripped apart, all pleats felt thoroughly, and corset busks examined, the talisman was no longer there.

The Church insisted on taking the trial in hand. From this moment on, Gilles de Rais was lost. The Bishop of Nantes, Jean de Chateaugiron, and the grand seneschal of Brittany, Pierre de L'Hôpital, harassed the Duke with continual requests to obtain the necessary authorization. It was only with great regret that Jean V finally gave the order for the trial of a marshal of France who bore such an illustrious name to commence; for he knew well that 'the spiritual court of the Church is supreme and that it judges according to the crimes, and never according to the involved', as the Bishop himself so solemnly affirmed; and Pierre de L'Hôpital demonstrated that he was far more preoccupied with the crime of magic and witchcraft than with all those others, which were in fact far more abominable.

Gilles had needed gold. Like Erzsébet Báthory, he needed especially to live a life entirely different from the rest of men, because such a life bored him to extinction. He used to pass his time high up in his famous room, in the company of François Prelati, his Italian astronomer; and while the latter traced great red and black circles on the flagstones, Gilles de Rais, in a handsome dark-coloured doublet, drew designs on the walls, rather like coats of arms, representing two heads, two brockets and two crosses. Once, when his valet Poitou, one of the few people who were allowed to enter his master's rooms, came in unheralded, Gilles cried out, 'Get out of here and don't come back, for *he* is coming!' Down below, almost immediately after he got there, Poitou heard a great owl's cry, and then something like the steps of some large beast which might have been a dog or a wolf. There was a shriek, 'Oh! Oh! The Devil!' The Marshal appeared, white as a sheet, and bearing a bloody wound on his cheek. He said, 'Master François may very well have lost his life there.' – 'The Devil, Monseigneur, did he really appear to you?' – 'Yes, he truly did, in the shape of a massive, mangy black dog, with his muzzle dripping blood.'

Magic circles, relating to the planets and their temporal aspect, had been drawn all over the place. Sometimes it was necessary to go far into the night to invoke the demons of hidden treasures. In the meadow of the Risen Stones, in the Machecoul countryside, François Prelati, using a blood-soaked knife, and calling for 'Barron', drew such a circle. Then he planted the knife, point upwards and exposed. All that night there was thunderstorm and rain lashed down. Gilles could see nothing; but an immense dog hurled itself against his legs and sent him sprawling. There must have been treasure buried somewhere in that meadow.

Another invocation was made in a place known as Hope Meadow, in a field below Machecoul, close to an isolated farm where *la Picarde*, a prostitute, used to live. This time it was a visitor at the castle, a man called *maître* Jean l'Anglais, who drew the circle, and he had taken the precaution of surrounding it with dried hemp and holly leaves, a barrier which ghosts feared to cross. Despite the preliminary offering of the hearts of five children, nothing came.

At night many things used to happen in these distant farms, around which traces of such great magical circles would remain until they were gradually obliterated in the morning dew. A woman called Perrine Rondeau used to keep an inn of evil repute in the district, a meeting place to which François Prelati and another Italian, the Marquis d'Alombara, frequently repaired. They had rented a first floor room whose luxury, if glimpsed from the landing, would have been in striking contrast with the sordid filth of the rooms below. They used to sleep there with four pretty page boys. Everything went well until that day upon which the Marquis, returning from a journey to Dieppe, brought back with him a young fisherman who was more handsome than all the others. From down below, Perrine heard quarrelling conducted in a very florid Italian. The Marquis hastily removed the pretty fisherman elsewhere to a place of safety. François Prelati, too, used to live shut up with a certain gentleman, Eustache, in another gloomy spot, an isolated little farm which had once been a brothel. When they went to interview him, the place was empty. Nothing was to be found except cinders and ash 'of a most evil odour', which was recognised as being that of the remains of children, together with a little bloodstained smock of coarse cloth which had been concealed at the bottom of a trough.

They used all of them to meet frequently at Tiffauges, a residence at once gracious and sinister. There, in a vast chamber above the crypt, they were in the habit of using a book written in blood 'to invoke Aliboron'. Charcoal was used to sketch a magical circle on the flagstones, a great circle with signs and crosses all round it. The demonologist would step

inside, bearing a certain book full of the names of devils written in red in strange characters. He would read from it, sometimes for as long as two hours, and summon demons who were in no hurry to appear. For Gilles had pledged all to Satan, science, riches, power, but he had wished to part neither with his life nor his soul; and Satan didn't come. One day, however, the latter gave way, demanding simply that some hands and hearts and also eyes of children should be offered up to him. He would overlook the rest. And so he appeared in the form of a great serpent in the large chamber at Tiffauges. On another occasion 'Barron' materialised in his favourite guise: a huge black dog which fled away, growling. Meanwhile Henriet and Poitou saw toads and grass-snakes which 'seemed to have come up out of hell' slipping out of the room through the crack under the door.

While he was living at Tiffauges, François Prelati had impregnated the place so profoundly with magic that invocations could be accomplished there more easily. He had serious altercations with Gilles whom he reproached with impatience and lack of confidence. One day during a visit to the king's court at Bourges, when he was sick to death of finding himself again and again unsuccessful, had not Gilles thrown a certain vermilion chest sent him by the Italian into a well in the hotel Jacques-Coeur? The chest contained a pouch of black silk, which harboured in its turn a silver-coloured object. When he returned, Prelati had told him that in that act he had sacrificed his happiness. How otherwise could the Devil come and show himself freely? Daily, Gilles heard several masses. And even during the great invocation of the 'Savage Hunt', he found the means here and there to interpolate a prayer. One particular time, at the moment of invocation he said an *Ave* and instantly saw a gigantic thing pass across the circle, leaving Prelati half-dead.

A Norman woman, who came to tell his fortune with cards, told him one day that he would never get anywhere 'if he did not pluck his heart away from his orisons and out of his chapel'. Thus Gilles, to please the Devil, obtained more and more right hands for him, more hearts, more locks of hair. He would shut himself up in his lofty room and when he came out of it he was ever sad and down-hearted. A page who was passing by the half-open door caught sight of the instruments of magic, the small furnaces and pincers, the phials of red liquid and a dead hand grasping a bloody dagger. Someone came out. The page was thrown out of the nearest window into the moat where he drowned.

It was because of these stories that, unluckily for Gilles de Rais, his trial was transferred to the tribunal of the Bishop of Nantes. If the trial of Erzsébet Báthory did not arise from the decision of any ecclesiastical tribunal, this was not at all because Protestants were more indulgent

towards crimes of sorcery: not long afterwards, in England and Sweden, witches were systematically persecuted. In Hungary pastor and priest outdid one another in the eloquence with which they denounced this most detestable of all evils. King Mathias II in particular frowned upon occult research. It is very probable that the Palatine Thurzó did everything in his power to prevent the interrogation he was directing from taking such a dangerous turn. In this, his behaviour was the more commendable considering the fact that he had recently escaped a more or less magical poisoning planned certainly by his cousin, Erzsébet. Had Thurzó not followed this line, people would not have been content to erect four symbolic scaffolds for Countess Báthory, she would have burned good and proper at the stake, in infamy.

The difficulties in the procuring of young and beautiful prey were the same for Erzsébet as for Gilles de Rais. The same little villages where all is known, even if spoken of only covertly, in a whisper; the same old grey-clad hags combing the countryside where the shepherds watch their sheep, the distant farmsteads with children left unattended, the outskirts of small country towns where street-urchins throw stones to bring down the ripest plums, or are sowing flax. The woman in grey, so ugly and old, so unpleasant and bad-tempered, Perrine Martin, was purveyor of pages to Milord. She had been seen at dusk in distant hamlets, holding little boys, all of them most handsome, by the hand. At Saint-Etienne-de-Montluc she had come on the wandering little beggar boy, the orphan, Janot, and she had led him away in the direction of Machecoul. This person had been noticed as she passed, this unknown woman, 'vermilion-faced, in a grey dress and a black hood worth scarcely a *sou*', and wearing a linen coat over her dress. One day, at Nantes, she had met a child who appeared to be abandoned; thinking the child's beauty would please her master, she had immediately taken him straight to l'Hôtel de la Suze. Gilles de Rais was great taken with him and sent him forthwith to Machecoul where, it appears, he maintained his 'reserve stock' just as did Erzsébet Báthory at Csejthe.

Sometimes, it was the two valets, Henriet and Poitou, who undertook, by one means or another, the task of attracting young boys to the castle. One day when he made a halt at La Roche-Bernard, Gilles, leaning on Poitou's shoulder at a window, caught a glimpse of a passing boy who pleased him greatly. 'That little fellow has the beauty and grace of an angel!' he said. Nothing more had to be said. Poitou immediately took leave of his master and spoke with the mother of the boy who entered the Marshal's service as a squire. When he had taken up his post, even a new outfit and a little horse was bought for him. At the inn someone said to

Poitou, 'you have a nice little page there.' Others shouted, 'Don't you believe it! The kid's not for him, he's bound for the gullet of our own good Prince!'

Later on, at Nantes, the little horse was recognised. But it was ridden by someone else. This came to be known at La Roche-Bernard. Perrine Loessard, the mother, questioned some of the Marshal's men-at-arms, when they were passing through the village, asking where her son was. She got the answer, 'Don't worry! If he's not at Machecoul, it's because he's at Tiffauges, or else at Pornic. Or somewhere else. Or gone to the Devil.'

Finally, casting aside all prudence, the master began to choose his own victims while playing tennis in the courtyard of the castle. One evening, having noticed an eighteen year-old apprentice tailor who was sewing the Marshal's wife's robes, Gilles began to dream of him.

Gilles de Sillé, a cousin of Gilles de Rais, and Roger de Bricqueville were also involved in this occasion. When they went to order falconer's gloves for hawking, they saw the apprentice, this very pretty little Gandron. They sent him to the castle with a message for Gilles' valet. 'And beware!' they urged him, 'Don't go by the Upright Stones Valley. The old and the ugly are killed there, but they hold on to the young and the beautiful.'

Even the scullions in the kitchens, when the valets went down there, were not safe. One evening, a handsome lad who was turning the spit was caught sight of through the smoke by one of the Marshal's body servants. On the day after the one following he was gone from the kitchens and he was never seen again there. Nor anywhere else. Of the two Hamelin brothers, one was far more handsome than the other. Gilles chose the former, but killed them both.

It was on almsdays especially that children used to disappear. On such days the drawbridge was lowered and the castle servants distributed alms to the poor: food, a little money, and clothing. When they noticed several children more handsome than the rest, they used to pretend that these had not had enough meat to eat and they would lead them away to the kitchens ostensibly to get them some. However, every trick to appease the curiosity of the local populace had been worked to death; each year they would be astonished at how many young boys had disappeared, even taking into account wolves, black men, sickness, and drownings in the swamps.

And so Gilles de Sillé spread abroad the rumour that the English, who had made a prisoner of his brother, Michel de Sillé, kept on and on demanding a ransom of twenty-four male children, the prettiest to be

found. He had sent them away from Machecoul, he said, but seven times the number of local boys had been sent from Tiffauges. The people were certainly most grieved to hear this, but at least they believed they had found a rational explanation, hostages and ransoms being the scourge of the age. Besides, not a single girl was missing from the villages where, just as frequently as their brothers, they would play around the fountain. Not even the most insignificant beggar girl had disappeared.

Only once will Poitou, in his confessions, speak with horror of a 'female child, one day when the Master had no boys.'

Anne of Brittany, so prudish, so bigoted, and so circumspect, commanded that the minutes of Gilles de Rais' trial should be deposited in the archives of Nantes.

The companions of Gilles de Rais, his cousin, Gilles de Sillé, and Roger de Bricqueville conducted themselves with great cowardice. At the first hint of trouble, they leapt upon their horses and fled away from Machecoul. No one remained at Gilles' side save his two valets who confessed only in the last resort, 'in order that they should no longer antagonise God and be forever precluded from heavenly grace'.

It was mid-September of the year 1440 when they came to arrest the Marshal. On their arrival below the walls of Machecoul, the Captain of the Escort, Jean Labbé and his men demanded that the drawbridge should be lowered for them, who carried arms in the service of the Duke of Brittany. On hearing Labbé's name, Gilles crossed himself, kissed a relic, perhaps a talisman, and said to Gilles de Sillé, 'Worthy cousin, this is the moment to turn to God'.

A long time before that his astrologer had predicted that his death would be announced by an abbot; and also that he himself would be a monk in an abbey. Prediction which came true. But it was only as a corpse that Gilles rested in a sepulchre of the Carmelites of Nantes.

Jean Labbé called upon the Marshal to follow him. Henriet and Poitou wished to escort their master. But the others saved themselves by flight on horseback.

Jean V had forbidden any search of the castle, in order to gain time before the evidence became too conclusive. The Marshal mounted his horse and, his lips moving in prayer, followed the man of Brittany. Suddenly, there arose cries of malediction from both sides of the road where it ran through the villages on the way. On arrival at Nantes, instead of heading towards the château de la Tour-Neuve where the Duke was staying, Gilles, to his great astonishment, was conducted to the sinister castle de Bouffay, seat of justice in the Dukedom. Happily, he was not left alone there. Besides his valets, he was permitted to retain his organ-player,

even though there was certainly no organ in his prison, as well as an archdeacon, two singers and two choirboys.

From the Archbishop, meanwhile, the command came forbidding him all confession and all communion; and this was most painful for him.

It is incumbent upon or it is a function of the ecclesiastical tribunal to know all of the human soul, and to know the soul by the conduct of the body. For it is essential to know through which derangements of the senses precisely Satan appears in the human being.

To save his soul, Henriet spoke firm. He recounted how, having had to go to Chantocé one evening about eight years previously, he came across the works of Suetonius and Tacitus in the library of Gilles de Rais' uncle. On the instructions of Gilles, who happened to be very bored, Henriet, translating from the Latin, read aloud to his master of the crimes of Tiberius, Caligula, and other Caesars. That very same night, his blood hot from wines and spices, he found a few victims and committed his first erotic crimes. Afterwards, he confided in his cousin de Sillé and Roger de Bricqueville his friend. During that year, one hundred and twenty children were killed. Henriet repeated what he had said: it had all begun because of the reading.

In order to condemn Gilles de Rais once and for all the ecclesiastical tribunal was looking for the opportunity of charging him with a crime allowing of no appeal for divine mercy. This pagan initiation into the vices of the Caesars of Rome constituted a very satisfactory beginning for a trial relating to witchcraft. They began by having the crucifix veiled under which Henriet, in French and sometimes in Latin, was giving his evidence. From his testimony, his master was appearing as a sumptuous, sensual, and slightly histrionic man. On coming out of the great chamber from his crimes, he would strut about like some great black and violet-plumed bird, relating to the bed pillars and to his assistants the details of the delights he had just experienced. He had to have a background of candles, flames, and tears. Then, suddenly prostrate, he would fall back on the more sordid questions of blood to be washed away and bodies to be disposed of. He was the sensual sadist, the exhibitionist libertine for whom a public was essential. The lords de Sillé and de Bricqueville, were involved just as much as he, or almost, but without bringing to the affairs so much formality, so much wordiness to sensual delight, to remorse. They were all soldiers, cruel, and each, many times eye-witness to the horrors of the sacking of a captured town. But in all this, Gilles alone used to allow himself to be carried away by an extravagant dream of oriental barbarism and the purple of ancient Rome, in which he would plunge and writhe in a spreading lake of blood.

The lechery of Erzsébet Báthory was of a quality far more savage and unfathomable. She did not dream; she was moonstruck. In his portrait, the glances of Gilles de Rais search, shift, change. In hers, the eyes of the Bloody Countess have found what they were looking for. In her sinister wash-house she had need of no confederate to share her voluptuous pleasures. The servants were there, for they were indispensable for stoking up the fire, pouring water, and ordering the whole spectacle which, standing rigid and alone, she would watch, but in the setting up of which she dabbled rarely. And then, while at Machecoul screams of pleasure mingled with sobs of remorse, Erzsébet maintained the silence of the stone of Csejthe. She indulged in no grandiose demonstrations of repentance, at no time asked either for grace or death. There are letters of hers, written in prison in a firm and tiny black script, which deal with the sharing of property, health, with everything in fact save the sordid and ignominious imprisonment of a Countess Báthory, niece and cousin to kings.

It is true that she had escaped the worst, the inquisition in which all favouritism is minutely examined, in which the most secret tastes and the ways of satisfying them are methodically dragged up out of the darkest soil of the unconscious, in which all that is erotically abnormal is torn out from the shadowy mantle of Satan.

For Gilles de Rais, nothing was left in obscurity. First Henriet and then Poitou, more reticent, were forced to describe in every detail what happened in their master's chamber. They spoke of overspiced meals and aphrodisiac wines, enumerating in minute detail the various sadistic pleasures, the insensate crimes, insisting on the acute pains and immense fatigues they had involved. They spoke of oaths made on pouches of velvet containing heavy talismans, of corpses which had had to be dragged up with hooks from the wells into which they had been thrown: of the hasty transfer by night along the rivers of heavy chests full of dead children with their heads severed from their trunks, 'eaten up by worms and rolling about like balls'; of the faggots they had to heap up in the fireplace of the Hôtel de la Suze, at Nantes, and which were shored up by poker-thrusts to make them burn, with thirty-six corpses piled up on top. All of which the Assistant Procurator found hard to believe, for, 'Just think what it's like when the fat from a roast drips down on to the charcoal in the kitchen!' But the fire, by dint of constant poking, burned brighter and it took only a few hours to dispose of the whole lot. After much lamentation and when he had prayed for the mercy of God, Seigneur de Rais would stretch himself out upon his bed while the conflagration increased, and with great delight he would inhale the frightful odour of burnt flesh and bones, all the while discoursing upon his sensations.

Eight-hundred children massacred in seven years. A good third of the nights during those seven years, from 1433 to 1440, were spent in murdering, rending, and burning; and the days in carting up and down the bloody and mutilated corpses, in order to hide them dry and charred black here and there, under hay or in odd corners, and in throwing the ash into the water in the moat, and in washing off the blood and other impurities, so as to repeat upon the following night this monstrous mass-murder.

Gilles de Sillé and Poitou had the job of bringing the children to the chamber of the Marshal in the evenings. The pageboys and the choirboys too used to 'lend themselves' to 'the master's pleasure'; they were showered with expensive gifts to make them hold their tongues.

All this became a veritable routine and, throughout seven years, the same people undertook the same actions with indifference. Henriet would build the fire and prepare the buckets of water to wash the floor. Poitou knew the exact moment when he had to step forward and cut the child's jugular with a neat stroke of the knife, so that the blood would spurt out in just the right manner and soak his master who was meanwhile kissing his victim. They looked without seeing too much, they saw without noticing the intertwined bodies twitching in a corner of the room, and barely heard the stifled moans, for they had first stopped up and gagged the child's mouth so that they wouldn't hear his screams. And whilst Gilles, at the very last moment, made an incision in the boy's neck to make him more 'languid' and the better to profit from his final jerks, they used to stand by to remove the body, that their lord might fling himself on to his bed without hindrance and get on with his litanies. Or else they had to keep watch to make sure the children were not left too long hanging from the great hook in the corner of the room. For even in that way Gilles de Rais got pleasure out of them. When it was all over, they were brought down and their necks were severed, and he used to shout to show him the head to see if it was beautiful. On certain days, he was seized with diabolic fury and would require a whole batch of children whom he would abuse first in the most bestial ways and whom he slaughtered afterwards. He used to wallow in seas of blood, would open up his victims and roll himself in them. Sometimes he would kneel before the bodies while they were burning and watch the faces lit up by the leaping flames; he used to love to contemplate the putrefying heads which were conserved in salt in a chest, 'the most beautiful ones, to keep them fresh', and he would kiss them on the lips. It was Poitou who used to undertake these macabre curing practices.

Throughout all this butchery and hanging and in the midst of his pleasures Gilles de Rais would never stop murmuring prayers to God and

to the Devil simultaneously, and to enjoin his victims to pray for him in heaven. The following day a high mass was conducted for the victims.

There is a mad, or very cunning, letter from the Marshal to the King, in which he confesses that he had to go into retreat at his estates of Rais because, for the Dauphin of France, he had conceived 'such passion and unholy lust that one day I might have been driven to slay him'. He begged the King at the same time to grant his plea that he might go into retirement with the Carmelites.

The result was that the King, who knew very well that Gilles wasn't mad, wished to be left out entirely of the criminal proceedings against one of the highest officers of the crown.

On the 24th of October, the prisoner entered the chamber of pleas at the castle de Bouffay. He wore the habit of a Carmelite, and he knelt down and began to pray. Hidden behind an arras, the apparatus for ordinary interrogation had been prepared: racks, wedges, and cords. Gilles believed that the Duke of Brittany was there, listening behind this curtain. Pierre de l'Hôpital called upon him to confess. Then Gilles appealed to the King of France. The grand seneschal cried out to him that his own servants had already admitted everything. The confessions of Henriet and Poitou were read aloud to him. Pale as death, Gilles replied that they had spoken the truth, that he had taken children from their mothers, that he had used them in the manner described, and had sometimes opened them up to look at their entrails and hearts: he described several of them, calling to mind their beauty, and admitted to eight hundred murders in seven years, plus three magical evocations; one in the great room at Tiffauges, another at Bourgneuf-en-Rais, and still another he didn't know where, for it had taken place at night, and by chance.

So unequivocal were the proofs of the crimes of witchcraft and sodomy, which crimes came under ecclesiastical jurisdiction, that the trial was immediately transferred to the tribunal of the Bishop of Nantes. Everything was ready. On the orders of the bishop a herald appeared in the room and called three times upon Gilles de Laval, sire de Rais, to make his appearance at once before the bishop's tribunal.

Gilles did not appeal to the president of Brittany against the legality of the proceedings, but followed his destiny and appeared under escort before the bishop.

The trial lasted only a few hours. The preliminary investigation, carried out in secret, was over. There remained finally the crime of treason against God, and against humanity too: murder, rape, and sodomy. But above all, 'sacrilege, impiety, casting evil spells, and other perverse works of devilry, magic, alchemy, and witchcraft.'

Finally, when the bishop was advising him to prepare himself for death, Gilles defended himself: relative by blood and marriage to the Duke of Brittany, supreme officer of the crown of France and principal nobleman of district, he could be judged only by his peers, and with the approval of the King and the Duke of Brittany.

Jean de Chateaugiron answered thus: 'The court of the Church is sovereign and judges according to the crimes, never according to the persons involved. Besides, the duke and the King of France agreed that the judgement should be carried out.' And so Gilles de Rais pulled himself together. 'Gentlemen, pray now that I die a good and saintly death.'

The verdict was: 'Hanged and burned; and, after execution, before the body falls apart and is consumed in the fire, it should be withdrawn and carried in a memorial casket to a church in Nantes designated by the condemned man. Henriet and Poitou shall be burned alive and their cinders thrown into the Loire.'

The following day, the square in front of the castle de Bouffay was packed with people. Gilles appeared all in black, with a hood of velvet and a doublet of black damask trimmed with fur of the same colour. Calmly and firmly, he repeated that he had told the truth.

On the 26th of October, at nine o'clock in the morning, priests, bearing the Holy Sacrament in procession, visited all the churches of Nantes, followed by the people praying for the three criminals. At eleven o'clock, Gilles de Rais, Poitou and Henriet were conducted to the meadow at Biesse on the outskirts of the town, upstream from the bridges of Nantes, on the banks of the Loire. Three gallows had been erected, one higher than the other two. Below, faggots and dry broom had been spread.

The weather was fine. The sky was reflected in the river; the leaves of the poplars and the willows were rustling in the wind as usual. Round about, an immense crowd. Chanting the *De Profundis* slowly, the condemned men arrived; and everyone took up the chorus. The echoing sound of it all reached the Duke, shut away in his castle so that he would not have to accord mercy to the prisoners. The tragic *Requiem* followed the *De Profundis*. Gilles kissed Henriet and Poitou and said, 'There is no sin so great that God will not pardon it if the man who asks it of him is really contrite. Death itself is but a moment of pain.' Then he doffed his hat, kissed the crucifix, and began to utter the prayers for the dying. The executioner adjusted the noose, made Gilles mount the raised platform, and a lighted torch was applied to the faggots. The platform swung down, Gilles de Rais fell; the flames licked upwards around his body which swung to and fro at the end of the taut rope. Then, to the continuous tolling of the cathedral bells, the crowd surrounding the scene of expiation, which

towered orange and black against the pale sky, intoned the *Dies Irae.*

Six women clothed and veiled in white and six Carmelite nuns moved forward through the kneeling crowd, bearing a coffin. One of the women was Lady de Rais; the others belonged to the most illustrious houses in Brittany. The hangman cut the rope; the body fell into an iron cradle which had been placed there earlier, and this apparatus was now hoisted from the fire before the body had been consumed, in accordance with the sentence of the tribunal.

The white-veiled ladies bowed low and grasped the six handles of the coffin. The corpse, only very slightly charred, with its red hair and black beard, seemed to be staring through glassy eyes at the light grey-blue sky. The chanting was silent now. The woman at the head gave the word. Slowly, they set off once more with their load towards the Carmelite convent at Nantes.

Right up to the moment of his death Gilles de Rais was polished, elegant, and lyrical. The air, imbued with this death in the meadow of Biesse, circulates amongst the willows and the poplars, into the shimmering tendrils of flame, and floats, transparent screen in front of the water of the river. The atmosphere resounded with bells and the chanting of human voices. Gilles must have felt his heart rending at the thought of leaving this life of ease, for he was in no wise a despairing man. He was sensual, vicious, overwhelmed by great waves of sadism; but he was very much involved in this life, and he tasted its pleasures, indulged in crimes, felt remorse. It cannot be said of him that these heinous crimes of his were uncontrolled; on the contrary, they were meticulously planned. There was nothing gratuitous in his conduct, nothing deranged; his most terrible acts retained something of the colour of the Loire, something of this earth, of this sky, of this water.

Pale grey starred with gold; and if he opened his doublet, a belt of scarlet with a dagger of grey steel hidden in a red sheath. The elegance of a Venusian bird, but evil, and one which, like the peacock, struts around on show, before himself, before the world. He did not belong to that race of men who can plunge irrevocably into chaos. Besides, can a male being ever allow himself to slide down to the ultimate of absolute negative depths? His repenting was a reaffirmation of the manhood of Gilles de Rais.

He and his assistants could still understand each other. The real human terror is not death; it is that primeval chaos bearing the void in its wake. The public repentance of Gilles de Rais, there on the October grass, the fire which glowed red on the leaves of the trees, the fear and the suffering, all this transported him back to the world of the living; for everything that lived reasserted its kinship to him and, in the hour of his

last steps, reassured his spirit. The mob understood that he had been evil, a wizard, a murderer, but despite all this, he was flesh and blood like themselves.

The death of Erzsébet Báthory was a display for herself alone. The last of the Ecseds expired like the rest of her line, like those of the distant and hard race whose progenitor was Canon Peter Báthory.

And she carried off this mad, cruel, passionate race intact in her own hands, like a pebble unwashed by repentance; and with her, it, too, was forever engulfed.

Chapter Ten

At Miawa, a tiny village nearby in the mountains, a notorious witch used to live, Majorova, sorceress of the forest. After the death of Darvulia, no one remained any longer whom, without logic, without imagination, Erzsébet could consult; none but brutes, Ficzkó, the idiot dwarf; Jó Ilona and Dorkó whose malevolence was purely material; Katá, who slipped into the torture chamber only to remove the corpses; and the demonic black cats on all the staircases.

Erzá Majorova thus took the place of the late Darvulia.

Not only did she effect curses by means of philtres, foretell the sentimental future of girls and heal the wives of the peasants; the local gentry too used to call for her services. She became the appointed healer in Erzsébet's house. It was said that she had made a pact with the Devil; she was well versed in the secrets of poisonous plants, knew how to lay a spell on people and how to put a fatal curse on livestock. Dark rumours used to circulate concerning her. Nevertheless, the ladies of the various castles used to go to see her, for she possessed mysterious recipes for baths perfumed by magical plants which were said to heal the scars of smallpox and burns. Majorova, too, had sometimes collected girls and brought them to the castle.

Whenever someone became a nuisance to Erzsébet she would straight away order Darvulia to make some of the famous 'cakes'. Darvulia would immediately go in search of poison to Majorova. One day the pastor, Ponikenus, received cakes of this kind, brought to him in a basket by a peasant-woman. But, forewarned of the feelings the Countess bore towards him, and convinced that she wished him dead because he had known about her for so long, he threw them to a dog, which died of them. The witch used to concoct her poison from the plants of the forest; deadly nightshade, hemlock, and aconite found on mountain slopes.

One evening when, in the gloom of the bedroom, she was arguing with Erzsébet, who was lamenting the loss of her celebrated beauty, Majorova had assured her she knew why the blood baths remained useless.

Indeed, the Countess was beginning to show her age; even her body, reflected in that so often consulted mirror, was revealing its blemishes. 'You lied to me!' she shouted at the witch. 'My misfortunes? You are the worst of the lot! Your advice never works. Even these baths in the blood of girls have had no effect whatsoever. And before that it was balsamic plants! Not only have they not given me back my beauty, but they haven't even delayed the withering! You had better find a way, or I'll kill you!' Majorova had immediately retaliated, promising she would meet the Countess in the depths of hell within one year to the very day if she so much as laid a finger on her. Then she had declared, 'Those bloodbaths have been useless because it was the blood of simple countrygirls, of servants not really different from beasts of burden. It doesn't take on your body; what you need is blue blood.'

Fascinated, Erzsébet understood at once, and asked if she would have to wait a long time for the effects. 'In one month or two you'll begin to experience them.' It all seemed so logical to her that a hunt for girls was undertaken at once, throughout all the districts of Hungary, the girls to be the daughters of the lesser aristocracy. And this time the hook was baited.

The spies of Csejthe went from village to village. They travelled far. Jó Ilona got lifts on peasant carts passing along the road; Dorkó, tall and strong, trekked for a long time with her giant strides; the old drunken woman, Kardoska, between siestas in the ditches, never lost an opportunity to find out what was going on in the house of such and such an impoverished gentleman.

The ruse Erzsébet had lighted on to attract the daughters of the lesser aristocracy to her house was very simple. Her servants were to announce in the flowery Hungarian manner, but clearly all the same, that the 'Lady of Csejthe' found herself alone in the castle as the time came to face another winter; that she was ready to take the daughters of noble families into her house to initiate them into the right ways and good manners of society, and also to teach them languages. She demanded nothing in exchange except their company throughout the long winter at the castle of Csejthe.

Erzsébet was getting a good bargain; for the Turkish Pasha of Nove-Zamki had to pay the value of six horses for each Christian girl delivered for his harem.

By dint of combing the roads and the villages, the old women brought back at least twenty-five girls. After all, hadn't they made very valuable promises to the parents? What risks did they run, these baron's daughters, at the side of a woman of the highest nobility?

They had scarcely arrived at Csejthe before two of them

disappeared. The others had been taken to Podolie, on the outskirts of which village the Countess owned a mansion whose cellars served as a depot for girls. They came there from Csejthe to fetch them, and they carried their corpses back there for burial in the cemetery without the mediation of Ponikenus.

Two weeks later, there remained only two of the twenty-five *zemans'* daughters, and one of those was dead in her bed. Of her, the servants said, 'that her entire body was riddled with little holes, but without a drop of blood to be seen'. The last of them was accused of killing the other so that she could take a golden bracelet. She escaped across the courtyard as far as the castle gate where she was recaptured. She committed suicide in her prison with a kitchenknife. The suspicion lingered that Erzsébet had stabbed her herself, for several moments before she had been seen going into the cellars.

Jó Ilona, Dorkó, and Kardoska, rather nonplussed by such a rapid slaughter, were again faced with the difficulty of finding girls of noble family; and so they put their heads together and agreed they would employ country girls and pass them off as girls of blue blood. They came back to the little castle down below with five girls in a carriage, and led them straight to the domestics' quarters at the end of the courtyard. Here they washed them, painted them, and applied themselves especially to the task of whitening and softening their hands. Then they dressed them as best they could in the fine clothes of the dead girls, and, in the dead of night, they took them to Erzsébet. Dorkó explained that they had found them at Novo-Miesto while they were holding a *'priadky'*, that is, in the act of keeping one another awake while spinning wool by singing songs and telling stories. Even the Haidouks who stood guard outside the chamber and who witnessed the arrival of the girls were not taken in; but they didn't dare to say anything in front of Erzsébet. This affair took place in December, 1610.

Presbourg was at this time the capital of Hungary. In this particular year there was to be a great sitting of Parliament, presided over by King Mathias himself. The palatines of the provinces, the nobles, and the high magistrates were all summoned to attend. Csejthe happened to lie upon the road which led from northwest Hungary to Presbourg. And thus several illustrious persons, who had to be present at the sitting of parliament, had solicited Erzsébet Báthory's hospitality during the Christmas festivities.

The pretext of a family reunion would not have been sufficient. For Thurzó left Bicse and endured the separation from his beloved wife only with the most profound regret. Megyery, for his part, had made a

detour to come from Sárvár where he had left Pál Nádasdy. And there were still other gentlemen as well as their entourages and, above all, Mathias II was expected to come in person.

This company, from which women were almost totally excluded, had a distinct resemblance to a tribunal. Erzsébet felt threatened. She sent out invitations to all the neighbouring castles, to swell the company at the dining table and to fill the ballrooms with a glittering crowd to distract the minds of her more serious guests. Then she turned her mind to her own adornments. To receive all these important guests she was entirely alone. But even so, what had the widow of the great Ferencz Nádasdy to fear? Black and white, and in the brilliant light sparkling amidst all her maids of honour, all graceful and smiling, she would make her appearance, a venomous flower, and, as always, inscrutable.

The position of György Thurzó, Grand Palatine of Upper Hungary and a man esteemed highly by the King for his bravery and honesty, was nevertheless constantly menaced by intrigues, the most serious coming from Cardinal Forgách, who would have liked the Palatine to be a Catholic and not a Protestant. In addition there was this infamous accusation brought against his kinswoman, Erzsébet, widow of his best friend, Nádasdy, and it was beginning to take on wider proportions. For a long time now, certainly, there had been gossip about underground prisons at Csejthe, about the 'Iron Virgin' and diabolical servants; and some talk of a much more guarded kind, no doubt, about baths of blood. But the castellan of Csejthe and Pastor Ponikenus had, both of them, reported precise facts: under mysterious circumstances the bodies of four girls, bearing traces of torture, had lately been thrown into the snow over the castle ramparts and had been left as food for the wolves. The village of Csejthe had even dared to complain and demanded that there should be an enquiry. And above all, the King had been informed by Megyery, one of his councillors, and by Cardinal Forgách.

Parliament was due to reconvene immediately after Christmas. Erzsébet wasn't greatly disturbed by that, for at Presbourg, authority was in the hands of Thurzó. She feared Vienna, and the King. At this time, when her fall was imminent, she was more than ever obsessed by the idea of murder, of projects relating to blood baths, and by the desire to blot out at all costs those who happened to be in her way. She wished to have done with Csejthe and perhaps she would even burn the lower castle down in the village. Like those criminals who at a given moment believe they have attained a state of impunity, and are in touch with a wonderful new life, she was piling up one imprudence upon another, in such a way that her downfall was inevitable. In the meantime, the old beggar woman,

Kardoska, brought her back two girls whose caste she had not even bothered to find out. Snow was falling; the wind was like ice.

The little castle down in the village bad been considered too small to contain all those who had been invited to the Christmas feast, together with their retinues. Too small and too modest, although it was far easier to heat than the lofty Csejthe on its rocky spur and battered on all sides by the mountain wind; but, above all, too near the heart of the village and hemmed in all round by human habitations.

Erzsébet had given her orders hastily; 'Let the upper castle be cleaned and make sure it's ready by December when I shall move in and live there again, for I wish to leave Csejthe immediately after the New Year.' Although she had the presentiment of something baneful, she was scarcely thinking of anything other than retreating up there on to the lonely mountainside, between walls which stifled all screams, to try the supreme prescription which would save her beauty. She was also preparing a whole series of new taxes, and forbade the proprietors to sell their wheat and wine harvests before those of the castle were sold. 'I shall need a great deal of money before my departure,' she said.

Indeed, she was making all the arrangements necessary for leaving for Transylvania. She wished to go to her Báthory cousin Gábor's place, a gentleman almost as cruel as herself. A massive castle awaited her there; and there she would find shelter to continue a life dedicated to the outlandish, the weird, and to murder.

Thus, while the sledges were carrying treetrunks to burn and water from the river, the Countess, muffled up in black and white furs had once more moved up nearer the savage wood, near the wild animals which emerged from them at night to come and roam about under the ramparts of the castle.

Again she entered her ancient chamber, vast, lofty; its atmosphere chill, an icy chill scarcely at all relieved by the smoking damp moss burning atop the faggots of oak and ash in the two fireplaces. The mirrors were in their place. The less precious of the Viennese dresses were hanging there, deep purple and sombre velvet. The others were lying full length in their chest like so many women who had fainted; the pearl encrustings, the yellowed satin lay there steeped in vague odours, like things benumbed.

Erzsébet was fifty years of age; meanwhile, a vampire not living her own life, she had become an impersonal being. Everything was in the past. As far as her four children were concerned, she had freed herself by the settlements made, she had been present whenever she could not very well be absent, speaking little, uttering only a few lugubrious words. She had inspired love; but always, very soon afterwards, she had abandoned this

bleak flame which seemed unable to burn her.

Amidst those old women servants who, from her point of view, mattered little, except in so far as they were bent to her every caprice, all that remained to her was her underground kingdom where she became intoxicated with her own glory, in which, without struggle, she was able to abandon herself to her own truth, a solitary figure milking the blood of others that she might receive it upon her own rigid beauty.

At the winter solstice, Erzsébet knew the night had come upon which Satan is favourably disposed towards witches. And now she had to confront this fateful night entirely alone, for her servants were fully occupied in moving furniture, in dragging the benches across the great flagstones, and in hanging the walls with crimson stuffs and greenery, garlands of ivy, and deep shades of yew. To tell the truth, the Presbourg Parliament had chosen a most unfortunate time to sit. This very same night, Erzsébet should have set out on horseback and ridden away far into the depths of the forest to the spot where smoke rose up from the witch's hut, muttering all the while special formulae reserved for the night of Christmas Eve.

When the sorceress of the wood came to bring the milk to the castle, Erzsébet had the word passed on to her that she wished to confer with her in her bedroom. There, when they were closeted together alone, she asked the witch if she could prepare a large magic cake for her, for the night of the Devil's feast. The witch enumerated the utensils she would require and assured her that she would bring the rest herself at nightfall. She calculated the hours which separated the planets: at the tenth, Saturn would be master of the heavens and smiled on works of hatred.

On the night before Christmas Eve, at four in the morning, in one of the stonewalled cellar rooms, all was ready; the fire had been lighted, the utensils of glazed earthenware and of polished copper were spread on the floor. Some river-water was heating in a cauldron; to one side of it stood a trough for preparing the dough.

Armfuls of deadly nightshade lay on the flagstones. The plants were dry now, but as late as September they had been growing in the forest, tough plants with juicy stems, transparent like water, their drooping flowers a livid brown, with glistening fruits. Growing in the Carpathians since ancient times, they used to be pulled up by the roots and cooked whole in milk and sometimes in wine. They were used to send women suffering in childbirth to sleep, or soldiers who had to undergo an amputation. In front of their mirrors women would massage the juice of the plant into the skin of their faces to make it whiter. Mixed with the deadly nightshade were 'alraunes', mandragora which the wise women of

the Scythians made use of, burning the leaves, the smoke of which intoxicated their audience, while they were foretelling the destiny of the tribe.

At the heart of that magic night, Erzsébet made her way down to the bowl of witchcraft where, *pêle-mêle*, the powers awaited conjuration. The cellar was misty with vapours. She breathed in the odour, threw off her furs and robes, and stepped into the kneading-trough. Without spilling a drop of the thick green brew of solanae, the sorceress poured it over her body; the sludge fell on it as on a slender poisonous loaf. All the time this was going on, she babbled something in an ancient dialect, weaving around herself and the Countess a strange circle of verbiage, within which, at regular intervals, the same four names kept recurring. When the Countess was saturated with the fluid, she, for her part, repeated her own name: Erzsébet Báthory over and over again; the woman removed half of this enchanted fluid to knead the dough with. Later on, she carried the rest back to the river, careful once again not to spill a single drop of it. For that drop frozen on a stone of the path, however minute the particle of ice, it would still have been Erzsébet Báthory. The river would take back the water unto itself, and the spell, and would continue to flow on its way to the Vág between the motionless trees, glistening with the hoarfrost of night.

By torchlight and the light of a lantern, the witch kneaded the cake, calling upon the spirits of the earth and Saturn to be her accomplices. The hour was long. Everything, in that hour at the end of December, was there in store; the growth of young trees in the course of the year, the unfolding of insects' wings far away and asleep at that moment beneath the stones, the future place of nests, and the invigorating sleep of beasts hibernating under the swelling volume of their furry pelts. And in the substance of that dough was amassing, by dint of her conjuring, evil spells against King Mathias, against Thurzó, the Grand Palatine, and Cziraky and Emerich Megyery, against all those who could hurt Erzsébet Báthory.

The following day was Christmas Eve. Guests from the less distant castles were arriving. The courtyard was filling up with sleds and harnesses from steaming horses. There was singing everywhere, savage Hungarian airs whose final notes wavered in the winter atmosphere. From afar could be heard the approach of more sledges, more sleighbells, and the hammering of sabots on the well-brushed pavingstones of the path leading up to Csejthe. Night fell quickly. King Mathias had arrived as well as Thurzó and Megyery. The orchestra was playing tirelessly, on and on; and, under the lights, the crowd surged about, along corridors lit by flaming torches held in position each by a spike which protruded from an iron wall-

plaque. The celebrations were due to last three days. Whole tree-trunks were burning in the fireplaces, adding the light of their great red and blue flames to the more moonlike glow of the wax candles. Objects in general and particularly jewels took on a more lively and distinctly harder gleam than they did during summer feasts; the colour of the dresses, so sharply delineated in that light, excited a breath-taking, almost painful surprise as might a perfect flower come upon suddenly above a puddle of ice. Everything appeared rather outlandish in this constant stir, in this winter universe, and all these loud-talking people coming and going with their pink faces and their eyes like black stars looked a little like so many seething handsome corpses.

Erzsébet Báthory headed the table at the banquet. She was beautiful, with the black band encircling her forehead tightly as a token of her widowhood; for Christmas was a family reunion and she was receiving in Ferencz Nádasdy's own residence. During this holy Christmas Eve she gave hardly a thought to her safety; she was conscious simply of her rights and of her determination. Meanwhile, accustomed as she was to living on the fatal side of things, she sensed a threat in the atmosphere. Thurzó and Megyery? Who would dare to pit himself against her? King Mathias himself, this tedious king, a moralist and a man to whom one could speak only of the rational? They were dangerous, and obtuse. Erzsébet, as she awaited the cake made with her bathwater and the spells it contained, relived the previous night, feeling her whole being still impregnated by philtres, by the faint echo of fairy sounds. And how far away she felt herself to be from all these beings laughing and eating round about her! They could save or damn themselves, for they were living beings. But, as for herself, she had never really been herself; of what should she repent, she, the utter denial, the void of all repentance?

Was there some poison or other in the dough of this cake which had been kneaded with enchanted water? Poison drawn from some enormous striped toad which basked with its belly in the mud? It was of little moment to Erzsébet. What was essential was that the King, the Palatine, and the judges should become favourably inclined towards her, disarmed in spite of themselves, and that the hidden menace from such miserable motives, should disappear. If they refused to give way to the spell, if their human will should, in some ridiculous way, turn out to be stronger, then the spirits of yesterday, those of the great night of the Earth, would avenge themselves. Against these things one could do nothing. The guests devoured everything, those who ate of the magic cake were ill, as if fire had broken out in their stomachs. But neither Thurzó, nor Megyery, nor King Mathias, before all of whom the cake had apparently been set,

partook of it. Erzsébet would have had enough time to order another dish for them particularly. But she was exhausted; the time for it had run out; there were too many people about her. She didn't dare begin all over again.

Meanwhile, she now knew why they had all made this detour to spend Christmas at Csejthe. The King, Thurzó and Megyery had been informed. Thurzó was in possession of the explanatory letter of András Berthoni, the old pastor who had preceded Ponikenus, the letter having been found at last by the latter in the parish archives.

On the advice of the King, Thurzó took advantage of his visit to demand an explanation from Erzsébet. In the beginning, he had hoped to come to an understanding with his cousin and hush up the whole affair. Zavodsky, the Palatine's private secretary and, in accordance with the custom, necessary witness to what passed between them, stationed himself in the next room. Thurzó was severe. 'In this letter you are accused of having assassinated the nine girls buried under the church of Csejthe round the tomb of Count Országh.' – 'Mad lies!' she cried. 'It's my enemies, to begin with, Megyery the Red, who invented that horrid story! Of course, I did tell Berthoni to bury those nine girls secretly, but it was because a dangerous and contagious disease had broken out in the castle. We had to prevent contagion at all costs: no one was allowed in. Besides, Pastor Berthoni was old and didn't know what he was saying!' – 'But there's talk about you everywhere! They're saying you tortured and killed several girls in particular, and worse, that you bathed in their blood to stop your growing old and to remain beautiful!' Erzsébet denied everything with ferocity, even though Thurzó told her that at Csejthe itself there were several witnesses. He expressed his regret that his first wife, Sophia Forgách, had been Erzsébet's friend and that the brave Ferencz Nádasdy should have had a criminal for a wife.

At this point, Erzsébet pointed out to him in her haughtiest tone that, even if she were to admit having done all that, he had no right to judge her. He replied to her, 'Before God, you are responsible, and before the laws which it's my duty to see are respected! If I weren't thinking of your family, I'd obey my conscience and imprison you on the spot, and then judge you.'

In council with Zavodsky, who also served in that capacity, he decided to convoke a meeting at Presbourg of all the members of the Báthory family who happened to be there, and to order them to keep Erzsébet under close watch to prevent her from adding to her list of crimes. Kinsmen of the Countess who took part in this family council were: György Drughet of Homonna, Chairman of the Council of Zemplin, and Miklós Zrinyi who, ever since the day upon which his favourite

greyhound, at Pistyán, had begun to dig up something which bore a sinister resemblance to the body of a girl in the kitchen garden, had no illusions about what was going on. They were both of them saddened when they thought of the reputation of the family. Their beautiful wives, Erzsébet's daughters, beseeching them to spare their mother, they uttered a vow that this affair would be hushed up as far as was possible. The decision upon which the families agreed was as follows: 'The Palatine, to spare the honour of our name, had decided to convey Erzsébet Báthory secretly from Csejthe to Varannó, to keep her there for a certain period of time, and then to place her in a nunnery. He regrets being forced to take such measures, but he hopes that they will be satisfactory to the judges and the King.'

Thurzó was risking his position as Palatine in this; but although he knew that Erzsébet at the end had gone so far as to try to poison him, he did not wish to do anything further. The kinsmen were satisfied. For himself, Thurzó thought his cousin would have been judged by the tribunal, but he wished to avoid the public revelation that she was a murderess, and more still.

In fact, Thurzó was not alone in possessing proofs. The King had his own, from other sources.

Since the Peace of Vienna in 1608, the unification of Hungary had been progressing, and the actions of individuals could no longer be dissimulated in that shadowy zone formed in the middle of the sixteenth century at once by the terror of the Turkish invasion, the domination of the Hapsburgs and feudal privileges. What, fifty years previously, could have gone on without risk of exciting too much complaint, was nowadays punished, particularly if it got to the ears of King Mathias.

The King was not the first to hear the echoes of this horrific story; undoubtedly, as Erzsébet had suspected for so long, the first to hear of it was her son's tutor, Emerich Megyery. On that ragged, much-used parchment of her incantation, Erzsébet had now completed the list of names, thereby bringing them all under her wild curse, of those who, her instinct told her, might be able to destroy her. 'Thou Little Cloud, protect Erzsébet; I am in peril... Send thy ninety cats, let them hasten and come and bite the heart of King Mathias; and also that of Moses Cziraky, the high judge; and that too of my cousin, Thurzó, the Palatine! May they bite and tear apart the heart of Megyery the Red...'

It has been contended that the fiancé of a maid of honour, when he had asked to see her and had received no reply, had gone and complained to the Palatine and had told him of his suspicions. Thus described, the incident is certainly not true to the facts: the lives of the maids of honour of Erzsébet Báthory were never in danger. The young man who went to

complain, not to Thurzó, but to Megyery, was a peasant braver, or simply more indignant, than the rest. His girl-friend was a young peasant whose only task was to come down from Csejthe, and to return to the castle with two buckets filled with river water. One day he didn't see her passing along the stony path which led to the castle; he waited for her on the following day; another girl had taken her place and told him his fiancée had disappeared. He understood what that meant, and at first he intended to go and tell everything to the Palatine, to tell him of the rumours which for years had been growing round these continual disappearances. Perhaps he was afraid, and rightly so, that he would not be granted a hearing. Presbourg wasn't far away, and Pál Nádasdy was there at the moment; did the young peasant in his great distress entertain the idea of going and throwing himself at the feet of the Countess' son and begging him to free his fiancée? Whether or not that is so, when he arrived at Presbourg, it was Megyery who received him. When he had listened to his visitor, Megyery, with evidence at last against the woman he abhorred, did not lose a minute in placing it before the King.

The celebrations were over. The sledges had left again, full of sumptuous robes glittering under tightly closed furs and red and gold uniforms. Erzsébet Báthory, amidst the last remains of a powerful odour of melted wax, had remained alone before the fireplaces where great heaps of cinders had climbed high above the logs.

At last she had been able to let fall the mask of the gracious hostess she had worn for three days. Her face was drawn, her eyes haggard, and the fit of fury which followed such occasions chased the terrorised servants to the most out-of-the-way corners of the castle. She had to purge herself of her fear on the spot, of all the pain and anger that was choking her. It had always been thus with her frenzied ancestors, when something had thwarted them.

She called Jó Ilona forth, that woman who, knowing her of old, had remained within reach of her voice, and required her to provide a serving wench guilty of some misdemeanour within the hour.

She was told that a certain Doricza had arrived about a month ago from a distant village. She was a big blonde girl, as beautiful as a statue, a peasant girl who had previously never imagined that a castle could contain such splendid and delicious things to eat. Moreover, in the course of her duties she had stolen a pear, doubtless one of those pears steeped in honey, tiny and firm, and considered a choice dessert. The matter of the theft was of little significance. What counted, what burned within Erzsébet, was the thought that King Mathias, Thurzó, and especially this detested Megyery, had gone away again, sound in mind and body, for the meeting of

Parliament at Presbourg, and that the spirits, through a slippery ruse, were turning away from her.

And the living also were abandoning her, moved, perhaps by the presentiment of the evil fate which for the moment seemed to be growing thicker and blacker like a cloud above her head. The time of her desertion was at hand.

To be abandoned, to be deserted held no fears for Erzsébet. Indeed, her sumptuous and autocratic life was a desert. Between herself and others, even in love, the gulf had never been crossed; for she was not born to unite with others, but to haunt herself. Like a bat she kept to the castle where, by birthright, her power was unlimited, black, dark, thinking of nothing except lolling slowly and watching the blood flow, continuously. In part of herself she knew she was lost; in that part of her which was her destiny. And, so as to force the issue, she hurled herself before it.

At the approach of disaster, she had Doricza taken into the sinister and glacial wash-house, scarcely warmed at all by a brazier. There, no one would hear the screams. In the heart of her castle and from the depth of her loss, she wished, one more time, to taste her habitual ecstasy, to feel herself transported for a short moment from reality.

It was a dismal and bloody routine down there in the underground chamber at Csejthe. Erzsébet, with her linen sleeves rolled up, her arms red with blood, and big stains of it on her dress, shrieked and laughed like a mad woman, and would run towards the hidden doorway and come back through it, flying along close to walls, her eyes fixed on her prey. The two old women got on with their work of torture, with their various appliances: pincers, red-hot coals, pokers. Doricza was naked, her blonde hair swept down in disarray over her face, her arms tightly bound. Erzsébet herself gave her more than a hundred strokes of the cane, until she was exhausted. Then she commanded that two other girls be brought in and, after a short respite, subjected them to the same treatment. Half-dead, Doricza was looking at her unconscious companions, at the Countess, and at the blood-spattered walls. Erzsébet too was covered with it; her linen sleeves were sticking to her arms. She changed her clothes and returned to Doricza. There was thick blood on the floor at the feet of the girl who, in spite of everything, had no wish to die. Then Dorkó came, according to custom, to cut the veins of her arms; and at last Doricza fell dead in a final spurt of blood. The other two were dying in agony as the Countess left the laundry, foaming at the mouth and howling curses at the echoing walls. Everyone was so cowed and exhausted on that day that the walls were not washed with the customary care, nor the flagstones.

At Presbourg, Parliament heard the governor of the castle

speaking in the name of the town of Csejthe; it listened to the complaint which Megyery had set before it, despite the efforts of several gentlemen to prevent his speaking; 'The act accusing Erzsébet Báthory has impressed Parliament. And what has stirred up the greatest indignation is the fact that the "Lady of Csejthe" was not content with the blood of peasant girls, but that she also required that of the daughters of Hungarian gentlemen. Undoubtedly, for a long time now, there have been rumours current in Presbourg about her; but the fact is that no one could really credit a tale so utterly horrible.'

For three days Parliament was occupied with this affair. The Palatine found himself under the painful obligation of taking action without yet knowing what action to take; in all conscience, he had to render justice, but, at the same time, he felt he had to spare the honour of the ancient names of the Nádasdys and the Báthorys. Thurzó consulted his secretary and his friends, deliberated, and arrived again at his original decision.

But an emissary arrived from Vienna with a message from the King; and Thurzó couldn't hesitate any longer. This message politely required the Palatine to go forthwith to Csejthe for the purpose of satisfying himself about precisely what was taking place, to head an enquiry and to punish those to blame on the spot.

He received this command before he was able of his own accord to choose the date of his return to Csejthe. Did he wish to give Erzsébet time to flee into Transylvania, aware as he must have been of this project of hers because of the comings and goings at Csejthe, the preparations of the servants? The kinsmen of the Countess and Thurzó did all they could to delay the journey. But Megyery was there, and he insisted that Thurzó should go, in accordance with the royal command, as soon as possible. They entered the castle by surprise, and nothing impeded them.

Everyone wondered what could have brought them back so soon. The house was still in great disorder after the festivities; and vaguely it was realised that somewhere or other a corpse remained to be buried, that the Countess herself was ill. Snow and ice surrounded the castle where nothing seemed to be living. A great lassitude lay heavy over everything.

Thurzó, well aware his proud cousin was capable of defending her castles tenaciously when she judged it opportune, had seen to it he was followed by a delegation protected by armed soldiers. The Pastor of Csejthe had come too. They went right through the castle and, accompanied by people bearing torches and acquainted with the entrances to the most secret staircases, went down to the cellars where the crimes were committed, from which arose a stench of corpses, and at length entered the torture chamber with its blood-spattered walls. Some of the

clockwork of the 'Iron Virgin' was still lying about, cages and instruments, close by unlit braziers. They came upon dried blood at the bottom of big pots and a sort of vat; they saw the tiny cells in which the girls were imprisoned, low and narrow stone chambers; a deep hole through which they used to get rid of people; the two branches of the basement corridor, one leading down towards the village and coming out into the cellars of the little castle, the other winding off to nowhere in particular into the hills near Visnové; finally, a staircase leading up into the rooms above. And it was there, lying at full length near the door, Thurzó saw the big naked body of a dead girl; she who had been such a beautiful healthy creature was now no more than one gaping wound. In the torchlight, the marks left by the instruments of torture could be seen; the flesh cut to ribbons, the breasts slashed, the hair pulled out by the handful; and in places on the legs and the arms there was no longer any flesh upon the bones. 'Even her own mother wouldn't have recognised her,' a witness said. It was Doricza.

Flabbergasted, Thurzó at last had proof of the crimes, there, under his own eyes. He went further in and came upon two other naked girls; one was in her death agonies, the other was still trying to hide herself, but as she was entirely covered by a dark cloak of blood, nothing of her could be seen. In the depth of the cellars in an airless cell, a terrified group of girls, those reserved for the next time, was discovered. They told Ponikenus that they had first been left to die of hunger, and then they had been forced to eat the grilled flesh of their dead companions. Moreover, they spoke of a secret doorway which led up into a little room to which they were summoned two or three at a time.

Leaving the guard in the corridors, the Palatine and the chaplain themselves undertook the climb upstairs; it was there that Ponikenus was attacked and bitten on the leg by the demonic cats.

Erzsébet Báthory was not to be found in the castle. She had barely finished committing her last crime and awakened from her strange trance, than she had herself rapidly conducted down below to the little castle, leaving behind all that terrible disorder and her victims to be dealt with by Jó Ilona and the old burial woman. Cold and lassitude had chased her away. Thurzó found her in her new retreat, haughty and proud, denying nothing, but, on the contrary, proclaiming that all this she had every right to indulge in as a member of the highest nobility.

'And so the moment has come, my noble Lady, to remind you quickly of your magical invocation, of the prayer in Slovac your witch of a milkmaid taught you, the one to bring your cats running!' With his patiently woven nets, Megyery the Red had encircled her, and she had been caught. The heart-rending prayer to the little cloud from the depths of the

forest was, after all, only an illusion.

In the already loaded coach which was waiting behind the castle, ready to carry the Countess off into Transylvania, to her cousin Gábor's residence, implements necessary for torture were found: irons, needles, and scissors for the mutilation of the nose, the ears, the lips, and a great deal more.

All these objects have been preserved in a corner of the little museum at Pistyán, there where Erzsébet used to go to take her mud-baths; likewise, the dress-silks which used to accompany her every step with their iridescent shimmer.

And then, without anger but nevertheless pitiless, the Palatine announced his decision, 'Erzsébet, you are like a wild beast. You are living your last months. You don't deserve to breathe the air of this earth, nor to see the light of God; you are no longer worthy to belong to the human race. You are going to disappear from the world and you shall never return. Shadows will surround you for as long as you live to repent of this bestial life. May God forgive you for what you have done. Mistress of Csejthe, I condemn you to perpetual imprisonment in your own castle.'

For Erzsébet, it was a terrible judgement. Later he turned his attention to the two servants; 'You shall be judged by the tribunal'; and he ordered them to be put in chains, and that everything possible should be done for the two girls who were still alive. Finally, he had Erzsébet conducted to her own room. Then, he left with his suite.

Thurzó was angry; his heart was full of disgust for what he had seen with his own eyes. He told the Countess' kinsmen that he regretted if they found his judgement too severe, 'I should have killed her on the spot if I had obeyed my own instinct!' he said; nevertheless, he added: 'In the interests of the descendants of the house of Nádasdy, everything will be done in secret; for if she were judged by the tribunal, all Hungary would get to know of these murders, and to let her live then would be to seem to flout the law. But after having seen the crimes she committed with my own eyes, I had to give up all idea of simply sending her to a nunnery.'

Megyery and the mandatory of the King objected that this judgement would not satisfy the King. They too had their evidence: a little notebook found in the Countess' bedroom and written in her own hand. This item described her victims – six hundred and ten in all – listed their names and their peculiarities, such as, 'She was small', or, 'She had black hair'…

Even when confronted by this damning proof, Thurzó refused to hand over the 'Lady of Csejthe' for public trial. 'As long as I am Palatine, that will not happen. Families which have distinguished themselves in battle

shall not be dishonoured by the shadow of this bestial woman. The nobles and the King will approve too, of that I am certain.'

Erzsébet had been escorted up to the main castle, to her room and left without servants: some were dead, the others had been taken to Bicse by the Palatine's men. On the evening of the arrest, the Pastor of Csejthe gathered round about him in the hall below the people who had come up from the village, and with his wife he began to pray for the prisoner. But from the very beginning his prayers were interrupted, in a manner in which later he described in a letter to one of his friends, Lanyi Elias, superintendent of Trencsen, Arvá and Lipto: 'As I began to pray, I heard the cat's mewing on the floor above. It wasn't anything like the mewing of an ordinary cat. I tried to go and see what it was, but I couldn't find anything. I said to my servant, "Come and look with me, Janó, and if you see any cats in the castle courtyard, trap them and kill them. Don't be afraid of them." But we couldn't find a single cat. My servant said, "I can hear a lot of mice in the little room." We went there at once and we didn't run into anything there either. So I went down the three or four steps which led to the courtyard and, all of a sudden, six cats and a black dog were at me, trying to bite my feet. "Go to the Devil!" I shouted at them, and I chased them with a stick. They escaped out of the courtyard; my servant ran after them, but he couldn't find one of them. So you see, Monseigneur, it's really a case of the "Dragon". But there is another thing I must tell you about.

'The night before Christmas Eve, a woman-servant from Miawa, a witch she was, bathed the Countess in a bath of magical plants, and she was ordered to use this water to make a cake which was intended for the Countess' enemies. But someone talked and they were warned in time. And so Satan was caught in his own trap. Besides, this peasant-woman is now taken ill.'

Pastor Janós Ponikenus had the unfortunate idea of going up to see Erzsébet to offer his condolences and moral guidance. He came upon that savage creature within the great glacial chamber, her person covered with furs and glittering with all the jewellery she had wished to carry with her to Transylvania. He did not dare to enter alone; one of his acolytes was accompanying him. 'The moment we were admitted to see Erzsébet where she was imprisoned in her room, she greeted us with the following words: "So there you are, you two bastards! See what your good offices have done for me!"

'I told her that I had nothing to do with it.

'"If it wasn't you, it must have been someone else in your Church who spoke about me!"

'Once more I assured her that I had never done anything, that I

had never said anything about her.

'"But wait!" she went on, "you, you will be the first to die, for you are the cause of my imprisonment! What are you thinking about? Don't you know they're already all prepared, on the other side of the Tisza, to put everything to the fire and the sword? My cousin, Gábor, is coming from Transylvania to rescue me."

'She shouted all this wildly in Hungarian, a language I didn't understand but which my companion translated for me.

'I believe,' he continues, 'that all the time she was calling upon the Devil and the spirits of the dead to save her. But we know particularly what happened in 1610, before she was arrested. She lost her incantation, the one which had been made by Darvulia. That witch must have written it on parchment one night when the stars were favourable. She took Erzsébet with her into the forest. After having ascertained the positions of the stars and the clouds, the two women began to chant the prayer to the Little Cloud. Previously, the other woman, Dorkó, had given her the secret of power over one's enemies, the spell of the Black Hen.'

And, moved by a sudden inspiration, Ponikenus cried to Erzsébet, 'Christ died for thee!' To which she replied, 'What a revelation, indeed! Even the labourer in the field knows that story!' He wanted her to accept a prayer book. She refused, saying, 'I do as I please!' The Pastor who, as far as Erzsébet was concerned, had certainly something on his conscience, even if it was only the fear he had always felt, asked her timidly, 'But why do you believe I was the cause of your arrest?'

'I have nothing to say to you: I am your Mistress. How could your question, coming from one so low, so humble, reach me, who am so exalted?'

'It appears,' Ponikenus continues, 'that the flesh of the poor girls was cut up into small pieces, like mushrooms, and served as food to boys. And sometimes, the girls themselves were forced to swallow a grilled hunk of their own flesh.

'That of some others was cured to serve as food for those who were left. That went on for a long time: sometimes, at night, the bodies of unknown girls were buried in the cemetery; other priests spoke of this amongst themselves... It is a good thing the Palatine has seized her; justice has been done, we are at last rid of that Jezebel!'

Before reaching Bicse once more, the Palatine had preferred to spend the night at Vág-Ujhely rather than at Csejthe. On the following morning he set out to prepare the interrogation of Erzsébet Báthory's accomplice. He had taken time off, during the night, to write to his wife:

Vág-Ujhely, 30 December 1610.

Happy to be writing to you, most belov'd wife. I have had Erzsébet Nádasdy seized, this evil woman down in the lower castle at Csejthe, and now she is being taken up to the castle itself, where, from the first of January she will be imprisoned. The others, the cruel young man and the witches, I am sending them to my castle at Bicse. They will be in your charge; see that they are locked up most securely. You can leave the women in the village; I have had them chained; but young Ficzkó goes to the castle dungeon. When my men arrived at Csejthe, they found one dead girl and another dying of her wounds. We discovered one, very ill, and covered with wounds, and several others being kept in reserve for the next sacrifice.

The Palatine had the judges called together at Bicse. The trial began in that town on 2nd January, 1611, and it was over on the 7th. Nothing was asked of Erzsébet Báthory and she did not appear at the trial. The enquiries were conducted by Gáspár Bajary, Castellan of Bicse and the Clerk of the Court, Gáspár Kardosh; the minutes of the proceedings were written by Daniel Erdog. The Judge Royal, who came from Presbourg, was Théodose Sirmiensis (in Hungarian, Zrimsky). The ecclesiastical judiciary did not interfere, and the sole representative of the Church was the Pastor of Bicse, Gáspár Nágy. It was purely and simply a criminal trial, with twenty judges and thirteen witnesses. The same eleven questions were quickly posed in Hungarian to each one of the accused: Ujváry Janós, called Ficzkó; Jó Ilona, the wetnurse; Dorottya Szentes, called Dorkó; Kateline Beniezky, the washerwoman. Sometimes the accused didn't understand, for they knew little Hungarian beyond their own dialect. The replies were quite confused, and the judges had been instructed not to press matters.

On the 6th of January, 1611, the tribunal met again in the council chamber of Bicse Castle. The judge Royal was presiding, with the Palatine and the King's envoy on either side.

The judge caused the castle governor to be brought in, and the Clerk of Court and the scribe. He asked the Clerk of Court to read the minutes of the trial. The reading was carried out with great solemnity, and the listeners heard the monotonous enumeration of nameless horrors perpetrated throughout more than six years no doubt, in the rooms, the wash-houses, the cellars and the underground passages of the castles belonging to the Báthorys.

When they had heard this in silence, they were astounded and utterly overwhelmed. The King's envoy spoke first. 'In these interrogations, everything is still not quite clear; there are crimes to which no more than an allusion has been made.' The castle governor was hurt by

this remark, for it was he who had led the interrogation. But the Palatine interrupted suavely, 'Everything is quite in order'; for it was he himself who had enjoined his castellan to say nothing of those crimes committed directly by Erzsébet and particularly about the baths of blood. From his point of view far too many allusions had already been made to those horrors for which she herself was directly to blame.

The royal envoy was insistent: he was not satisfied, it was impossible for him to consider the proceedings at an end. He requested that certain new questions should be posed to the accused, amongst others, this one: 'How many daughters of gentlemen were amongst the dead?' He recommended, too, an enquiry into the bloodbaths. During the interrogations, other accomplices had been mentioned; they would have to be brought forward to clarify their part in the general guilt and to ensure that they would be punished accordingly. The Palatine replied, 'There is no point in that. It would simply delay matters, and I am to have this affair over and done with as soon as possible.'

They argued for a long time about this. The King's envoy demanded that Erzsébet should appear too and be tried by the tribunal. Thus the Palatine cried out angrily, 'I am perfectly well aware what I must do, and I flatter myself I shall be able to convince the King that I have acted rightly.'

Then the witnesses were heard. The judges deliberated far into the night, whilst outside in the great square of Bicse, the Haidouks were building the stakes and the scaffolding for the executions.

The whole countryside wished to be present at the executions. On the following morning, the 7th January, 1611, very early, the clocks began to ring. The judges presented themselves in the place of execution. When they arrived, the executioner, clothed in red and wearing a cowl, was waiting in front of the stake whose faggots had already been set alight. Behind him, Ficzkó, Jó Ilona, and Dorkó, surrounded by soldiers. The executioner plunged the pincers into the fire and laid the sword on the block.

And so, the Judge Royal read out the act of accusation and condemnation. 'We are congregated here together at the command of the Palatine György Thurzó Betlemfalvy, chief of the council of Drava, north of Bicse, and in the name of His Majesty King Mathias. The secretary, György Zavodsky directed the prosecution against Jan Ujvari Ficzkó, Jó Ilona, Dora Szentes and Kateline Beniezky. It is clear that His Majesty, by the will of God, elected György Thurzó Palatine to defend the good against the evil. That is why the Palatine, in the public interest, convoked the tribunal, and ordered the enquiry to ensure the condemnation of the crimes of Erzsébet

Báthory, widow of the most celebrated and just Ferencz Nádasdy. The truth of the accusation has been demonstrated by the testimony of the household servants. When the Palatine learned of these crimes, he went posthaste to Csejthe with Counts Zrinyi, Homonna, and Megyery. With his own eyes, he saw those things to which the witnesses have testified; finding a girl named Doricza dead through torture, and two other girls badly tortured in another room. His excellency the Palatine, was filled with anger to find Erzsébet Báthory was such an impious and blood-thirsty woman. Caught in the act, the Palatine has condemned her to perpetual imprisonment in her own castle. Her accomplices, Ficzkó, Jó Ilona, Dorkó, and Kateline have, in front of the judges, made confessions; and for the satisfaction of justice, the Palatine recommends the supreme penalty.

'Then we proceed to hear the witnesses, as follows:

'György Kubanovic, citizen of Csejthe, who has taken the oath. Present latterly at the castle, he saw the corpse of a murdered girl, and saw how this girl had been tortured and burned.

'Jan Valkó, Martin Jancovic, Martin Krackó, András Uhrovic, Ladislas Antalovic, all witnesses living at Csejthe and footmen at the castle. Then, Thomás Zima, who has testified to the burial of two girls in the cemetery of Csejthe and one at Podolie, and who specifies, "When Pastor Ponikenus began to accuse Erzsébet of her crimes, the dead were then carried to Podolie, the neighbouring village, to be interred there."

A certain Jan Chrapmann spoke to a girl who had succeeded in escaping, and who told him the tortures and assassinations had been carried out by the Countess herself. She had seen her one day in the process of torturing a naked girl whose arms, tightly bound, were all bloody; and only one woman, disguised as a boy, was there with her. But she didn't know that particular woman. That was confirmed by András Butora of Csejthe.

'Suzsa: this was a girl who had served for four years at the Countess' and to whom nothing happened, because she was the protégé of the castle governor at Sárvár, Bichierdy. She testified under oath that Erzsébet committed these frightful crimes, with the help of Jó Ilona, Dorkó and Darvulia, and of Ficzkó, who executed her orders. Katá was good-hearted: if she beat the girls, it was against her will; she used secretly to bring food for the imprisoned girls to eat, at great risk to herself. Suzsa has said that Jacob Szilvasi found the list of Erzsébet's victims in a small box, that they were six hundred and ten in number, and that it was the Countess herself who had written this figure. This evidence was confirmed by Sara Baranyai, widow of Peter Martin. She added that during her own four years of service in the castle she had seen eighty dead girls.

'Ilona, widow Kovách, in the service of Erzsébet for three years,

recounted that she had seen thirty dead girls. She spoke also of the constant preparation of poisons and cursed spells. By such poisons and diabolic invocations, the murders of the Palatine and Megyery were attempted.

'Anna widow of Stephen Gonczy: among the dead was found her own daughter only ten years of age, and she was not admitted to see her.'

The Tribunal, after having heard this evidence, has delivered the following sentence:

'Whereas the confessions and testimonies have demonstrated the guilt of Erzsébet Báthory, it is known she has committed frightful crimes against female blood; whereas her accomplices were Ficzkó, Jó Ilona, and Dorkó, and it is known these crimes deserve punishment, we have decided that as for Jó Ilona, and as for Dora Szentes, their fingers shall be ripped off by the executioner's pincers, because they have by means of these fingers committed crimes against the female sex: they shall further be thrown alive into the fire.

'As for Ficzkó, his culpability must be considered in relation to his age: as he did not participate in all these crimes, we have decided upon a more lenient punishment. He is condemned to death, but he shall be decapitated before his body is cast into the fire. This sentence will be carried out immediately.'

The population was frightened by the severity of the judgement. The soldiers led the criminals to the executioner: first, Jó Ilona, who fell into a faint as her fourth finger was torn off; the soldiers conveyed her forthwith to the bonfire. Dorkó fainted on seeing Jó Ilona tied to the stake. Then Ficzkó was led towards the block, and the executioner lopped off his head with one blow of the great spade-like blade, the great executioner's sword.

A hundred and sixty years after these events, the minutes of the trial came to light amongst a pile of old debris. The paper on which it was written was so damp and had been gnawed by rats that the last page of this bloody history of Erzsébet Báthory was scarcely readable. This original copy of the account of the trial went from hand to hand, was conserved for a long time in the Archives of the Chapterhouse of Gran, and was to be found more recently in the National Archives of Budapest.

Zavodsky, Thurzó's secretary, wrote in his journal on the 7th of January, 1601, of the 'tragedy of Csejthe', the arrest of the Countess and the trial which followed:

'At the very end of the year, the Palatine, my Master, having gone to

Presbourg, heard talk of the affair, and resolved to make a search at Csejthe, in the presence of the magnificent but more than horrible lady, Erzsébet Báthory, highborn widow of Count Nádasdy, who was guilty of unspeakable cruelties of every conceivable kind upon persons of the female sex. These things had been going on for a long time, and around six hundred girls had been tortured. The magnificent lords Nicolai Zrinyi and György Homonna came, and also the knight Emerich Megyery, and these gentlemen caught the Countess *in flagrante delicto*. They found one girl in a desperate state and the other dead. His Most Illustrious Lordship condemned Erzsébet Báthory to perpetual imprisonment in Csejthe. Also condemned were: Ficzkó to have his head cut off; Helena and Dorothea, who had been the executioners, were consigned to the flames, as just punishment for their crimes.

(Bicse, 7 January 1611.)'

It was not long before Thurzó received an indignant letter from King Mathias. Headed, Vienna, 14 January 1611, which is to say, thirteen days after the arrest, this letter enumerated in detail the bloodthirsty crimes of Erzsébet Báthory, the widow Nádasdy.

'…at least three hundred girls and women, nobly born as well as commoners, who had done nothing against the interests of their mistress, were put to death in an inhuman and cruel manner. She cut their flesh and made them grill it; afterwards she would make them eat bits of their own bodies… One widow, Helena Kocsi, has even revealed that moreover she used to administer magic and poisonous potions to them. The prayer of these Virgins cried out to Heaven, and it reached Us; through Us is manifested the wrath of God.'

The King reproached the Palatine for his excessive indulgence, and, meanwhile, gave the order that Erzsébet should be guarded secretly at Csejthe.

A contemporary historian, who could not find words to match the beauty of Erzsébet and her Venus-like contours, regrets being unable to deny that this most attractive of female creatures had taken baths in human blood, which actions led to her being imprisoned in perpetuity.[4]

[4] 'Elizabetha S. Francisci de Nádasd Agazonum Regalium Magistro nupta, foemina si suae unquam venustatis, formaeque appetentissime. Eam cum humano sanguine persici posse sibi persuasisset, in codem per coedes, et lanienas expresso balneare non dubitavit. Tanti criminis damnata, perpetuoque carceri inclusa, ibidem expiravit anno 1614 die Augusti.'

Bohm, in a manuscript in Latin which is in the Archives of the State at Vienna, reports the same facts, and does not hesitate to mention the baths of blood; for, not being of the family, he had no need to tamper with the facts.

The 'Beast', as she was known in the village and throughout the neighbourhood, was locked up in Csejthe. She had shouted with rage, but showed signs neither of weakness nor of repentance. For the last time her sledge brought her up the steep slope leading to the castle. She was alone. Her maids of honour, relieved of their duties, had left; and her body servants too, in chains. She crossed the drawbridge and entered, passed through the icy rooms, amongst the debris of the festivities which was still to be seen. Men at arms conducted her to her room. Here too, there was nobody. She knew that this was the end; her incantation was lost, it couldn't be found anywhere. When its disappearance had been noticed, she had called in a witch who had immediately set about copying the ancient formula, the true one. But inks and philtres cannot be improvised. Her power was gone from her and her beauty would soon follow. She was of the race of those Báthorys who had always won and then lost. Not one of them remained to save her. They were far away, carried off by their tragic or mad deaths, as they themselves had always carried off life, in a storm of lechery, glory, wrath. Those who still lived in these lukewarm times, what could they understand of tempests and of audacities? They were locked up in their fears and their bargainings, even with Heaven itself, if it existed.

A prisoner now, she would listen to noises; the noises of the fierce cold on the roof and the battlements, which, even in normal times, the voices and the daily household sounds could scarcely cover up. In the distance, the wolves. Her room remained the same, with its great mirrors reflecting the grey January day. Who would come? She heard men's footsteps and horses in the courtyard. Besides, did all this have a meaning, was all this going to dissolve like other dreams, perhaps?

Meanwhile, at Presbourg, her two kinsmen and Thurzó were doing everything in their power to avoid a scandal. The Palatine wrote to Prague, where King Mathias happened to be in transit. The King replied immediately: 'Erzsébet Nádasdy ought to be executed.' But Thurzó wrote another letter, insisting upon the fact that she was 'widow of a soldier, noble and of an illustrious family, and that her name, one of the oldest in Hungary, ought to be spared.'

From the 12th February 1611, the appeals on Erzsébet's behalf began to arrive. The first was from her kinsman, Miklós Zrinyi, and it was followed by another from Pál Nádasdy to Thurzó, requesting grace for his mother (letter of 23rd February).

On the 17th April, 1611, the King finally replied from Prague:

'Because of the loyalty of the Nádasdys, and after having heard the pleas of the Magnificent Pál Nádasdy, her son, of the Counts Miklós Zrinyi and György Drugeth de Homonna, her kinsmen, we have decided that she shall not be executed.'

At Presbourg, the parliament wished to confiscate her castles and her goods; but the family opposed this as did also the Commission of Enquiry. The same reasons were always invoked: her family, her husband, her name.

In March, the Royal Magyar Chamber had sent King Mathias an address denouncing the excessive complaisance of the Palatine. The King, who finally allowed himself to err on the side of indulgence because he remembered the great services rendered to the Hapsburgs by the Báthorys, replied that Thurzó had done everything in accordance with his duty.

But the real reason Erzsébet was condemned to perpetual imprisonment rather than to the sword of the executioner is to be found in another address from the Royal Chamber to King Mathias: 'The choice is yours, O King, between the executioner's sword and perpetual imprisonment for Erzsébet Báthory. But we advise you not to execute her, because no one really stands to gain anything from this alternative.'

Indeed, Erzsébet was not beheaded because nothing was to be expected from such a gesture, apart from what would amount to a very dangerous censure of her family and her class. In this particular case, the King was unable legally to touch the third of the goods of the condemned person which would normally have fallen to him; for Erzsébet had legally left everything to her son, Pál Nádasdy. This testament, drafted at Kérézstur on the 3rd of September, 1610, shared her goods and her jewels amongst her four children; but, finally, it was her son Pál who would become the sole possessor. Since the year his father died, Pál had been Grand Officer of the county of Eisenburg. He was engaged to be married to Judith Forgách, daughter of one of the greatest families in Hungary.

And so it was found that the High Court of justice could not condemn her to death, because she had not been responsible for the deaths of girls of the nobility, but only for those of servants; which was entirely untrue, on the avowal even of King Mathias himself, who had written to the contrary in his secret letter.

Erzsébet was thus condemned to be immured in perpetuity at her own castle. Everyone, no matter who, was forbidden to communicate with her, even the Pastor. Anyway, she didn't claim this right. She would be able to collect only the tithes of the peasants of Csejthe; her other castles would be shared amongst her children.

When the judgement was irrevocably given, some stone-masons came to Csejthe. One after the other they walled up with stone and mortar the windows of the room in which Erzsébet was imprisoned, and so, she saw the light, little by little, progressively diminish. The prison rose up round about her. They left only a narrow band of daylight very high up, through which she was able to see the sky where, already, the days were lengthening. After the windows were thus sealed, so that from without one no longer saw anything but the blind façade behind which someone was living, the workers began to build a thick wall in front of the door of the room, leaving only a slit to permit passage of food and water.

And when everything else was finished, four scaffolds were erected at the four corners of the castle to show that inside lived someone condemned to death.

The castle was deserted; all the servants were gone; only the masons came sometimes to make some indispensable repairs in this corner or that, and making a muffled noise which penetrated vaguely to Erzsébet through the stones. Then they would go away. Otherwise, she would hear nothing but the kites and the wind. The heavy window slot would open and the strict necessities of life would be pushed through the wall to her by someone who, at long intervals, climbed up to the castle. No fire; never the least glimmer any more. The rays of the sun and of the moon fell regularly, according to the season and the night. A mortal cold. Finally, a swallow came, high up at the slit above the window; it looked down inside into the green daylight of the room. Once a woodpecker came, the bird which knows how to make holes in shutters; but he, so used to the feeble light falling from above into the hollow treetrunk, nevertheless could not decide to make his nest there. In their turn, the barn owl, the little owls and the big, showed their wise-eyed heads at the strip of nocturnal sky which Erzsébet used to see, blue on top of shadow. Upon what moonbeam could she slide upwards? Where was Darvulia? Where was the forest? Cloud, little cloud or swan, if only I knew how to become these, and go hence from here... and her beautiful pale hands, which she never washed any more, would be held one against the other in a prayer-like gesture, the furs which had remained there drooped from her shoulders. All the day and all the night long there was nothing to be seen any more except this long black beast, bristling with its gleaming fur and with two ever-haunted immense black eyes, set in a face of grey wax, always those same haunted eyes which had marked her out when as a child she had arrived at Csejthe, a child, but already cruel, this creature of complex and insane lecheries, dominating everything with her great dark beauty. Would she see again what had once

been reflected in these now tarnished mirrors, the evenings, the torches on the tables, so many feasts with people all about her, her maids of honour who would approach carrying things in their hands, dresses the colour of dusky roses; and all of it for her and for her alone? And below, in the subterranean part of the house, old women chaperoning packs of naked servant girls. After which, did she still know? Who was it sitting there, in a trance, contemplating the cut fingers, the lacerated naked bodies, the opened veins and the all-enveloping blood which finally gushed forth? So who was this personage possessing the rights of Erzsébet, the last of the Báthorys, and whom I have never been? Why am I here, so harshly accused, to expiate what my desires did, but which I, myself, never felt I had done? My desires satisfied themselves outside of me, without me; my desires have missed their goal.

The forest began immediately behind one of the walled-up sides of her room. The path still led upwards towards the scattered, still extant huts of the witches.

But neither plants, nor the aromas of plants, nor the dawns, could ever cross the barriers raised by those stone walls. To the beseeching glance of her ringed and hooded eyes, which betrayed her avid and corrupted soul, no answering window opened like a gentle eyelid on to the great clemency of springtime, on the innocence of flowers at the edge of the woods.

These flowers, the eagle from high up could see; the she-wolf during her nightly prowl would brush against them. She alone, the human being, in her human condition, to whose fate human intelligence was the key, was locked up.

And this destiny, bequeathed to her by her great ancestors, passed among the harsh rocky hills of Swabia, engraved on those escutcheons circumscribed by dragons; this destiny she bore without flinching. Her last letter, of the 31st of July, 1614, in which she altered her will in favour of her daughter Katerina, whose husband furnished her with food, this letter written in German in her tiny sad wilful handwriting comes from a mind that is still perfectly lucid.

Erzsébet lived firm on her lands, on her rights, on her tithes, upon what the earth and the country, from heredity, granted her. It is for this reason that she didn't understand; it is for this reason that hers was a physical courage, of the body not of the spirit.

The bats which, so insistently and in great numbers, passed into the room by the slit seeking darkness, went to sleep hanging from the crimson curtains. Their odour of little graveyards added itself to that of the

room. By the heat and the more vibrant bands of light, she could tell it was summer; when the days declined and the cold came on, that it was winter. There was also a perfume, of hawthorn, the merry warbling of birds; then odour of moss, an odour of rain, and the melancholy cries of departing; all this was hardly perceptible.

Above the cellars, above the subterranean level where the echo of the screams and the appeals still stagnated, Erzsébet Báthory would pace the length and breadth of her room, walking in this dismal light of walls.

She continued to live thus for three and a half years, without hope nor request, half-dead of hunger. It was always in extremity that the Báthorys took refuge; they died on the edge of glaciers, died in the fury of passion, on the battlefields, or victims of their own mad fantasies and cruel to themselves. Neither did Erzsébet, in the name of all that was wild and untamed in the world, ever regret or repent. But she could not put up with this seclusion, nor especially with the intense cold of these winters without fire. She died slowly without calling to anybody; nor was any note left on the edge of the hatch by which the bread was pushed through, asking for divine consolation. She did not write a single request for mercy, but only her will, which she changed a month before her death. This will, in which she bequeathed more to Katerina (specifying that her husband, György Drugeth, must return it to Pál following his wife's death) on the condition that she would send her enough to prevent her dying of hunger there in prison, was redrafted in the presence of two witnesses who, however, did not see her and could give no description whatsoever of her afterwards.

'She asked to write her last will; we sent two witnesses: Kaupelich András and Egry Imre. They swore that this was really her testament, given at Csejthe, and that she had redrafted it being in sound mind and of her own free will. She gives Katerina her castle at Kérézstur (in Abaujva), but only temporarily. She does not wish to give it unless György Drugeth takes care of her in prison. The rest of her goods remain divided between her children, reverting eventually to Pál Nádasdy.
Done this day of St. Peter, Sunday, 31 July, 1614.'

She died on the 21st of August, 1614. She died at the end of August, when Mercury, in the ascendant, does evil to those whose spirit he has poisoned. No one was present.

There are two testimonies about her death: one in Latin in the journal of Thurzó's secretary, Zavodsky György who previously gave an account of her arrest:

'This day of 21st August, 1614. Erzsébet Báthory, wife of the magnificent gentleman, Count Francisci Nádasdy, who remained a widow, after three and a half years of detention in a cell in her own castle of Csejthe, condemned to perpetual imprisonment, has gone to appear before the Supreme Judge. She died towards nightfall, abandoned by all.'

And Krapinai István, for his part:

'Erzsébet Báthory, wife of the great lord, Francis of Nádasdy, Magistrate of the King and Grand Master of the Horses, who remained a widow, and infamous and an homicide, died in prison at Csejthe. Dead suddenly, without crucifix and without light, the 21st August, 1614, at night.'

It was bad weather that day. There was a furious wind; it seemed as though witches had died.

Without a crucifix and without light... The ruins of Csejthe are still haunted by her. The day of the shrieks and groans is not yet over. And even her castle in the village below, even there, a short while ago, someone in the dead of night in the very same room encountered her bejewelled ghost; it pointed its finger at the wall. The little hidden cabinet was opened; she had locked up some of her jewels there before fleeing: heavy bunches of garnet, topazes, pearls.

Appendix

Extracts from the trial of Erzsébet Báthory: the interrogations of 2nd January, 1611; at Bicse, in the castle of György Thurzó, Grand Palatine of Upper Hungary.

Portions of this trial of Erzsébet Báthory were conserved in the Archives of the Chapter of Gran (Esztergom), then in the Archives of Budapest, *Acta Publica fascicule No. 19.*

There were twenty judges and thirty witnesses. The same eleven questions were put in Hungarian to each of the accused, who were:

1. Ujváry János, called Ficzkó
2. Jó llona, the nurse
3. Dorottya Szentes, called Dorkó
4. Kateline Beniezky, the washerwoman

First accused: Ficzkó.

1st question: How long did you live at the Countess' castle?
Reply: For sixteen years, arriving in 1594, brought forcibly by Martin Cheytey.
2nd question: How many women did you kill?
Reply: I don't know how many women, but I killed thirty-seven girls; the Mistress had five of them buried in a hole, when the Palatine was in Presbourg; two others in a little garden, beneath the caves; two others in the church at Podolie, at night. The latter two were brought from the castle of Csejthe and it was Dorkó who killed them.
3rd question: Who did you kill? Where did they come from?
Reply: I have no idea.
4th question: Who brought them?
Reply: Dorkó and another woman went to look for them. They told the girls to come with them and they would be given good positions in the Countess' service. We had to wait a whole month for one of the latter girls

to arrive from a village far away and she was killed straight away. In particular, women from different villages would conspire together to supply girls. Even one of their own daughters was killed; then the mother refused to bring others. I myself went six times in search of girls with Dorkó. There was a particular woman who did not kill, but who only buried. The woman Ján Barsovny also went off to engage servants from the Taplanafalve region; then a certain Croat woman from Sárvár, and also the wife of Mathias Oëtvos, who lives facing the house of the Zsalai. One woman, Szabó, brought girls, even including her own daughter, although she knew she would be killed. Jó Ilona also got hold of many of them. Katá did not bring any, but she used to bury all the girls Dorkó murdered.

5th question: What tortures did you use?

Reply: They tied the hands and arms very tightly with Viennese cord, they were then beaten to death until the whole body was black as charcoal and their skin rent and torn. One girl suffered more than two hundred blows before dying. Dorkó cut their fingers one by one with shears and then slit the veins with scissors.

6th question: Who helped to torture them?

Reply: Dorkó, for one, did the stabbing. The other one, Jó Ilona, attended to the fires, made the pokers red hot, and applied them to the face and nose, opening the mouth and shoving the red iron inside. When the seamstresses did their work badly, they were led into the torture room to be punished. One day, the Mistress herself placed her fingers in the mouth of one of them and pulled until the corners of her mouth split.

There was also a woman called Ilona Kochiska, who tortured the girls. The Mistress pricked them with needles more or less all over; she killed the girl from Sitkey because she stole a pear. She was tortured at Pistyán and got rid of afterwards.

At Kérézstur a certain young Viennese lady was killed; the old women hid the corpses and buried them; I helped them to put one in the earth at Podolie, two at Kérézstur and one at Sárvár.

The Mistress always rewarded the old women when they made a good job of torturing the girls. She herself used to tear open their flesh with pincers and slit the skin between their fingers. She had them led out into the snow, naked, and doused in frozen water; she poured the water over them herself and they died in consequence. Even here at Bicse, when the Mistress was on the point of leaving, she forced one servant to stand in frozen water up to her neck; she tried to escape to Illáva and was killed.

Even when she did not torture them herself, the old women did it; sometimes the girls were left for a whole week without anything to eat or drink; we were all forbidden to give them anything. For some fault or

other, sometimes up to five naked girls had to work at their sewing under the eyes of the boys, and also make up faggots in the courtyard.

7th question: Where were the corpses put and how many of them were there?

Reply: It was the job of the old woman, who did the burying, to look after that. I myself buried four. They were buried in several castles: Leztitczé, Kérézstur, Sárvár, Beckó, in all these places people were buried. They were frozen alive by pouring water over them and then taken outside. One of the girls escaped, but was recaptured all the same.

8th question: Did the Countess do the torturing herself?

Reply: Sometimes, but more often she got other people to do it.

9th question: Where did all this take place?

Reply: At Beckó they were tortured in a storeroom; at Sárvár, in a part of the castle where no one entered; at Csejthe, in a room where the vats were situated, and in the cellars underground; at Kérézstur, in a little dressing room. In the coach, when the Mistress was travelling, she used to pinch them and prick them with needles.

10th question: Who were the people who knew and saw all this?

Reply: The Majordomo Dezsó Benedick knew about it, also the valets, also a certain Jezorlavy Istok, called 'Ironhead', a very strong man who has since fled to Lower Hungary and who knew about a lot of things, because he amused himself in voluptuous pleasures with Erzsébet Báthory, with the knowledge and even in full sight of others. He buried many girls, but no one knew where.

11th question: For how long did the Countess treat the girls thus?

Reply: She began when her husband was still alive, but there was no killing done then. The Count knew and took no notice. Only after the arrival of Anna Darvulia did the tortures become more cruel. The Mistress had a little box with a little mirror inside, in front of which she made incantations for hours on end. The sorceress Majorova, from Miawa, had prepared a certain philtre which she brought to Erzsébet and bathed her one night in a trough used for making bread. Afterwards, she took some of this water back to the river. When she had bathed her for the second time in the water that remained, she made in the trough a certain cake which was to be offered to the King, the Palatine, and Megyery. Those who did eat it became ill.

Second accused: Jó Ilona.

The same questions were posed one after another. She lived in the Countess' service for ten years, having come originally as wet nurse to the

three girls and Pál Nádasdy. She did not know how many girls had been killed, but said there were a great many. She neither knew their names nor where they came from; she had killed about fifty herself. She knew that the sister of a certain Grégor Sanosci had been murdered. Also two girls from a noble family from Vechey, one of whom was still alive – and again two other *zeman*'s daughters from Chegber. Barsovny also brought in a noble girl one day, tall and beautiful. Others were provided by the woman Ján Szalai, by the woman Sidó, and by a Slovak woman who lived in Sárvár. The wife of Ján Liptai engaged two or three other girls, knowing perfectly well that they would be killed, because Erzsébet had threatened her.

The little Kiseglei, who came from Barsovny, is still alive. She also brought a tall girl (the Mistress liked them tall) and she searched for girls for the castle with Daniel Vas; but they only found small ones, at Vechey.

She beat the girls cruelly, and Darvulia put the girls in cold water and left them like that all night. The Countess herself dropped a coin or a key made red hot in the fire into their hands.

At Sárvár, Erzsébet, in front of her husband, Ferencz Nádasdy, stripped a young girl related to him, then smeared her with honey and left her in the garden for a day and a night to be stung and bitten by ants and insects. She, Jó Ilona, was given the task of placing oiled paper between the girls' legs and then setting it alight.

The woman Szabó, who lived in Vepa, engaged many girls in exchange for money and skirts, likewise a certain Horvar. Silvachy and Daniel Vás saw how the Mistress stripped and tortured girls. She even killed the woman Zitchi, from Ecsed. Presents were given to the women who brought along young girls, one would be given a little jacket, another a new skirt. Dorkó cut the veins of the arms with scissors; there was so much blood that it was found necessary to throw cinders all around the Countess' bed, and the latter used to have to change her dress and cuffs. Dorkó also made incisions into the swollen wounds of girls and Erzsébet tore the flesh of their bodies with pincers. One day, near Vranov, she killed a girl whom Jó Ilona was forced to bury immediately. Sometimes they were buried in the cemetery amid chanting, sometimes beneath the eaves. Even in her palace in Vienna, the Countess sought a place where she could torture them in safety; it was always necessary to wash the walls and floors.

When Darvulia became ill with the onset of paralysis, the other servants took over the torturing.

She did not know where all the corpses were buried, but at Sárvár, they put five in a hole hollowed out to keep corn in. At Kérézstur, it was the students on holiday who had to bury the dead girls, being paid for doing it.

Everywhere Erzsébet went, her first preoccupation was to find a room where she could torture. At Vienna, the monks opposite threw potsherds out of the windows when the heard the cries of pain. At Presbourg, the Countess also ordered Dorkó to beat the girls.

Balthasar Poki, Stephen Vagi, Daniel Vás, and even the other servants knew what was going on; likewise a certain Kosma. She did not know how long all this had been going on, for when she had entered service ten years previously, it had been like that. It was Darvulia who taught Erzsébet the most serious cruelties, they were very intimate. Jó Ilona knew and had even seen Erzsébet burn the vagina of certain girls with the flame of a candle.

Third accused: Dorkó.

She had been there for five years, serving Anna Nádasdy before her marriage. Jó llona had arranged for her to go into service, with a good wage. The girls came from various places. Barsovny and a widow named Koechi who lived in the village of Domolk supplied many of them. To preceding accusations, she added that the Countess tortured the girls with red hot spoons, and ironed the soles of their feet with a red hot iron. She tore their flesh in the most sensitive spots, the breast and elsewhere, with little silver pincers. And, when she was ill and had them brought to her bedside, she used to bite them. In one single week five girls died; Erzsébet ordered them to be thrown into a room and when she had departed for Sárvár, Katá Beniezky had to bury them in a hole used for storing corn. Sometimes, the corpses were buried by the pastor when they could not be hidden. One evening, along with Katá and a valet, she carried a girl to the cemetery of Podolie to be buried. Erzsébet used to torture her servants wherever she went.

To the other questions she replied as the first witnesses.

Fourth accused: Katá Beniezky.

Arrived in 1605, after the death of the Count, as a washerwoman; came from Sárvár, where the mother of the pastor Varga had engaged her. Did not know how many girls bad been killed but would say about fifty. Did not engage them herself and did not know where they came from. She herself had killed no one, she had moreover sometimes brought something to eat to the prisoners and the Countess had punished her for it. Among the women who were charged with recruiting girls was a certain Liptai, also Kardoska. But Dorkó had brought in the majority. She confirmed that it

was Darvulia who taught Erzsébet the most cruel kinds of tortures. Erzsébet always shouted out while it was happening, 'Still more, harder still!' and thus had several killed. Katá admitted that Erzsébet had given fourteen skirts to her two daughters. The Countess preferred the advice of Katá to that of the other servants. Once, Erzsébet had sent the young servants to the castle, when the Countess Anna Zrinyi came to Csejthe. Dorkó imprisoned them and caused them to die of hunger, and also poured freezing water over them. Another time when the Countess had gone to Pistyán, one of the girls died in the coach; and when this happened, Erzsébet had her held upright by the servants, although she was dead, and continued to beat her.

Dorkó had killed five girls, and had made Katá throw them under a bed in a room and carry on bringing food to them, as though they were still alive. Then Erzsébet left for Sárvár and told Katá to tear up the floor and bury the girls there in the room. But Katá did not have enough strength to do it. The girls remained under the bed and the stench spread right through the castle and even outside. In the end they were put into a ditch used for keeping corn. Dorkó buried one of them in a ditch, and Katá knew that she had, in one brief spell, killed eight girls. In Vienna, Ilona Harcai, who had a lovely voice, was tortured and killed.

One day Erzsébet was presented with two sisters, out of whom she chose the most beautiful to be killed. Barsovny also brought to her, in Vienna, a tall and beautiful maiden who was the daughter of a titled man. There were other young girls from noble families among those who were sacrificed at Vienna or elsewhere; and it was the same woman, Barsovny, who found them, always under different pretexts: usually saying that after a short time in the Countess' service the girl would be given a dowry.